3 dimensions

Publishers logo, designed by Karel Appel
for Hugo Claus, 1950.

Babylonian image of the symbol of
heaven; a snake curled up to a spiral.
From 1950 it was published in different
Cobra publications as a sign of the
movement.

Snake symbol on one of the two golden
horns found in the 17th and 18th century
respectively. It was used in Cobra-editions
as an image.

Publication on the occasion of the
exhibition 'Cobra and Sculpture' in the
programme of the Cobra 50 Manifestation
at the Cobra Museum for Modern Art
Amstelveen, 8 November 1998 – 10 January
1999.

The Cobra 50 Manifestation partly has
been made possible by KPMG, Amstelveen

Cobra 3 dimensions
© 1998 V+K Publishing, Blaricum
© 1998 Cobra Museum for Modern Art
Amstelveen
© 1998 Stichting Beeldrecht, Amstelveen

Published in 1999 by
Lund Humphries Publishers
Park House
1 Russell Gardens
London NW11 9NN

British Library Cataloguing in Publication
Data
A catalogue record for this book is
available from the British Library

ISBN 0 85331 758 5 (Lund Humphries)
ISBN 90 6611 562 9 (V+K Publishing)

Distributed in the USA by
Antique Collectors' Club
Market Street Industrial Park
Wappingers Falls
NY 12590, USA

3 dimensions

Work in wood, clay, metal, stone, plaster, waste, polyester, bread, ceramics

Dr Willemijn Stokvis

10

REVUE INTERNATIONALE DE L'ART EXPÉRIMENTAL

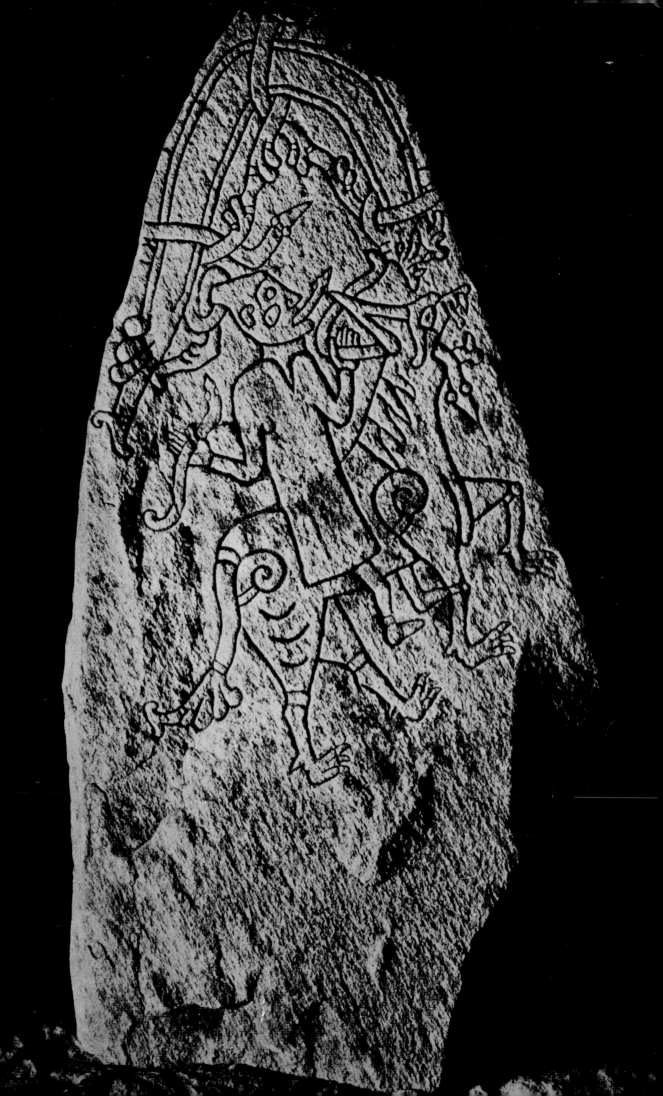

Contents

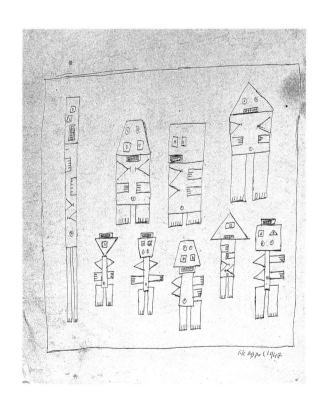

1 Cover of tenth edition of Cobra
(Brussels, November 1951) featuring the
so-called Jelling stone, a rune stone near
the village of Jelling on Jutland, Denmark,
a major source of inspiration for
sculptor/painter Henry Heerup.

Karel Appel
2 Sketch for Wooden Sculpture, 1947,
ink on paper, 47 x 40 cm.

Preface

1998 is the fiftieth anniversary of the foundation of Cobra. In many places throughout the world, this anniversary has provided an opportunity for commemorative exhibitions featuring work from the three turbulent years of its existence, underscoring the movement's art-historical importance.

The recently opened Cobra Museum for Modern Art in Amstelveen has accepted the responsibility to ensure that interest in Cobra continues to grow, organising a special programme of events for the anniversary year. The Cobra 50 celebrations have focused especially on sculpture, providing Dr Willemijn Stokvis with an opportunity to explore and specify various avenues laid out in her earlier publications in greater detail. Here, in her own infectious style, the author has explained the importance of Cobra in sculpture.

Cees List

Director of Cobra Museum for Modern Art, Amstelveen

Preface

With the approach of the fiftieth anniversary of Cobra the thought struck me that it would be interesting to focus on the three-dimensional objects made by artists associated with the Cobra movement. This met with an enthusiastic response at the Cobra Museum for Modern Art in Amstelveen. With the backing of various members of the museum staff, it proved possible to realise the plan in the shape of an exhibition and an accompanying book. For this my profound thanks. The opening of the show, together with the presentation of this volume on 8 November 1998, marks to the day the fiftieth anniversary of the founding of Cobra at Café Notre Dame in Paris.

Concentrating on the three-dimensional work produced by Cobra artists, I arrived at a number of new insights. I was also able to review a large amount of material unavailable to me when preparing my dissertation on the Cobra movement, which I completed in 1973. I therefore see this volume, the result of that research, as complementary to my earlier work.

I received enormous encouragement and support in this venture through my work with various students whom I was privileged to supervise in project groups and theses on subjects relating to Cobra, Primitivism and Dutch sculpture in my capacity as tutor at the University of Leiden. Some useful conclusions resulted which, where appropriate, are quoted in the text.

Dr Willemijn Stokvis

The Cobra Museum for Modern Art

Amstelveen

Introduction

Cobra was an international, multi-disciplinary art movement. It grew from the enthusiasm of a group of artists who shared a belief in their own pioneering contribution to the development of a future society in which everyone would enjoy the freedom to express themselves creatively, leading to the emergence of a new folk art. Through mutual influence, the artists who joined this movement created a common visual (Cobra) idiom, resulting principally from contacts among groups of artists from Denmark, Belgium and the Netherlands. In particular, many elements of Danish art from before the Second World War were to have a major impact on the Cobra group, which was formed in Paris on 8 November 1948 and continued until the final exhibition of November 1951 in Liège. Not unjustly, it has since been the paintings of this group that have received the lion's share of attention. After all, the movement's great pioneers, who achieved international fame with their work in the 1950s, are principally known as painters. Yet a closer examination of the work of the artists involved in Cobra soon reveals that they produced many works which obviously belonged to the world of sculpture. Hardly surprising, given the manner of working they stood for and the sources of inspiration they chose.

Of the Danish artists, Ejler Bille actually began as a sculptor, later devoting his efforts entirely to painting. Henry Heerup, Sonja Ferlov, Erik Thommesen and the wartime member of this group, Robert Jacobsen, are in fact principally known for their three-dimensional art. Moreover, much of the œuvre of the main inspirational force behind this movement, philosopher-artist Asger Jorn, can be properly labelled as sculpture. Carl-Henning Pedersen was also to focus for a short period on this medium, although it was not one that attracted him for long. From Belgium, it was not only sculptor Reinhoud, but also the photographer-film-maker-painter-ceramist Serge Vandercam who contributed in a major way to the three-dimensional version of the burgeoning Cobra idiom. And not to be forgotten in this context is the ceramic work of Pierre Alechinsky. In the Cobra years, art in Belgium was still largely dominated by Surrealist ideas and the three-dimensional work created in this period comprised mainly Surrealist objects. It was only photographer-painter-sculptor Raoul Ubac who approached the Cobra idiom in his slate reliefs. In the Netherlands, it was primarily Karel Appel who was to remain intensively involved throughout his artistic career in the creation of sculptures or assemblages. Two œuvre catalogues have already been published on this aspect of his work alone![1] Tajiri was and remains a sculptor. Although he has not been averse to other disciplines, it was as a sculptor that he contributed to Cobra. Of the other Dutch artists, Eugène Brands and Constant created many works that are considered sculpture, while Corneille also contributed, although on a more modest scale. Towards the end of his life, Lucebert focused for a short but intense period on ceramics. One artist whose sculpture unambiguously articulated the Cobra idiom was the sculptress and artist Lotti van der Gaag, who associated with the Cobra group in Paris. Other Cobra artists were also occasionally to produce work on a three-dimensional plane, particularly in the form of assemblages and ceramics.

A total absorption in fantasy and the conjuring of vaguely mythical creatures can certainly be called the hallmark Cobra experience. Its natural corollary was a complete absorption in the artist's selected or found materials. Here, in a sense, the material took the lead. It stimulated fantasy and interplay, releasing what lay hidden in the material itself. In this way Cobra formed part of a new trend that emerged internationally during and after the Second World War in which the properties of the material played a dominant role in the work itself. Jean Dubuffet began in 1944 to mix grit, sand and other materials in his paints, turning his paintings almost into reliefs, giving the suggestion of a rough wall. During the war years, Fautrier made so-called Otages (Hostages) in the shape of hautes pâtes, (thick pastes), in which the substance of the paint emerges in plastic form, vaguely suggesting the head of a hostage or the place where he was sitting just before being executed. In a sense, it was a period in which the material itself acquired a voice.

This relationship between artist and material is, in my view, an aspect of Primitivism, which in the early years of the twentieth century played a crucial part in the emergence of Modern Art, and in particular Expressionism.[2] It was Primitivism's longing to find the source, the search for inspiration among so-called primitives, naives, children and mentally handicapped, that finally brought the artist in touch with animal

nature and eventually with the material. This is clearly seen in the second, broad wave of twentieth-century Expressionism that emerged after the Second World War in which Primitivism again played a fundamental role. The material, regarded until now as the least interesting aspect of the creative process, entirely subject to the artist's wishes and able to be shaped at will, was now seen as a mysterious element with hidden powers, a significance impossible to put in words and arousing an endless succession of associations. In the work of some of these largely abstract painters who mixed and combined their paints with all kinds of materials, it began in the 1950s to acquire such a dominant role that they became known as 'material' artists.

That the Cobra artists and their associates enjoyed a more-or-less animistic relationship with their material seems clear. It is the same kind of relationship found among primitives, children and the mentally ill whose artistic expression fascinated these artists to such an extent that they were able to empathise with them.[3] Not just paint, but any found object and every kind of material was a potential trigger for the imagination. Dadaists and Surrealists had already explored this terrain, but with their sense of a profound contact with the material the Cobra artists took it a stage further. To an extent, in their sculpture, as in their paintings, they allowed the material to speak for itself in abstract compositions; but they also used the materials to conjure up fantasy creatures. These objects and sculptures have little of the alienating, depressing ambience that much of the Surrealist œuvre radiates: in their three-dimensional work, most Cobra artists broke with the hitherto dominant Surrealism. Their art is more properly described as a vibrant Expressionism.

Two forms of three-dimensional expression in the visual arts – on the one hand objects made of a single material, on the other assemblages of various materials – cohabited, and were even combined in the Cobra movement. Some of these artists had been exploring these possibilities long before the start of Cobra and they were to continue after the Cobra period. Remarkably, for a long time few people were interested in their assemblages of found objects. Even the artists themselves considered these pieces less interesting. Only a few were ever featured in Cobra publications and they were rarely exhibited at Cobra shows!

For a long time, ceramics, a medium through which many Cobra artists entered the three-dimensional world, had been considered a marginal area and was associated until well after 1945 with crafts rather than art. But clay was an ideal material in which to create the mysterious and humorous fantasy creatures that, especially with the addition of a little colour, are unmistakably Cobra.

The Cobra idiom as I have defined it in painting and which ranges far beyond the strict temporal boundaries of the movement itself, is in my view also evidenced in the three-dimensional work of these artists, especially in the sculptures in which fantasy creatures emerge. In Denmark this can be traced back to the early 1930s![4] In the following narrative, the various countries involved in the Cobra movement are not discussed in the order of the group's acronym CO-BR-A, based on the first letters of the capital cities Copenhagen, Brussels and Amsterdam. Instead, the development of this idiom is examined chronologically: from its beginnings in Denmark, to the Netherlands and eventually to Belgium.

1 Roland Hagenbos and Harriët de Visser (ed.), Karel Appel, The Complete Sculptures 1936-1990, New York, ed. Lafayette, 1990, and Donald Kuspit, Karel Appel Sculpture, A Catalogue Raisonné, New York, Harry N. Abrams, 1994

2 For a more extensive discussion of this vision of the development of Modern Art see my article 'Art: New Perspectives to European (Western) Development' in Kees Paling and Vic Veldheer (eds.) The European Challenge. (Essays on culture, values and policy in a changing continent), Sociaal Cultureel Planbureau/ VUGA, The Hague, 1998, pp. 215-235.

3 See my article 'De taal van Cobra en haar bronnen', in the catalogue De taal van Cobra, accompanying the inaugural exhibition of the Cobra Museum for Modern Art in Amstelveen, 1995, pp. 15-44; (published in Spanish as: 50 anos del movimiento COBRA, Museo de Bellas Artes, Valencia, 1997). Here I discussed my view on primitivism, of which 'empathy with the material' forms a part (p. 40). See p. 15 of this article on the animistic relationship of Cobra artists with their material.

4 See ibid. in which I define the Cobra idiom afresh. I defined this earlier in my thesis: W. Stokvis: Cobra, geschiedenis, voorspel en betekenis van een beweging in de kunst van na de tweede Wereldoorlog, Utrecht 1973 (stencil), published in Amsterdam 1974, (reprints 1980, 1985, 1990), pp. 155-164. This therefore augments the definition. The definition is also found on p. 20 of the short book about the Cobra movement published since 1987 by the Spanish publishers Ediciones Poligrafa in six languages: W. Stokvis, Cobra, Movimento artístico internacional de la segunda posguerra, (Cobra: an postwar international artistic movement), Barcelona, 1987, (English ed. Barcelona 1987; American ed. New York, 1988; French ed. Paris, 1988, Dutch ed. (title: 'Cobra, de Internationale van Experimentele Kunstenaars'), Amsterdam 1988; German ed. Brunswick, 1989, Chinese ed. Taiwan, 1994. 1998 reprint Dutch ed.)

Group photo for the Höst exhibition of November-December 1948 in Copenhagen where Dutch guests participated.
Back row. Left to right: Sixten Wiklund, Ernest Mancoba, Carl-Henning Pedersen, Erik Ortvad, Ejler Bille, Knud Nielsen, Tage Mellerup, Aage Vogel-Jörgensen and Erik Thommesen.
Middle row: Karel Appel, Tony Appel, Christian Dotremont, Sonja Ferlov and Else Alfelt.
Front row: Asger Jorn, Corneille, Constant and Henry Heerup.

Ejler Bille
3 Figur med fangarme (Figure with Catching Arms), c. 1933, artificial stone, h. 28.5 cm. Private collection.

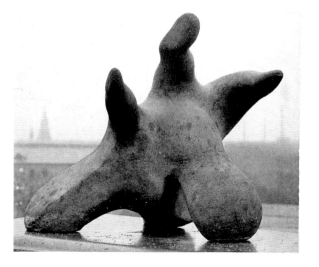

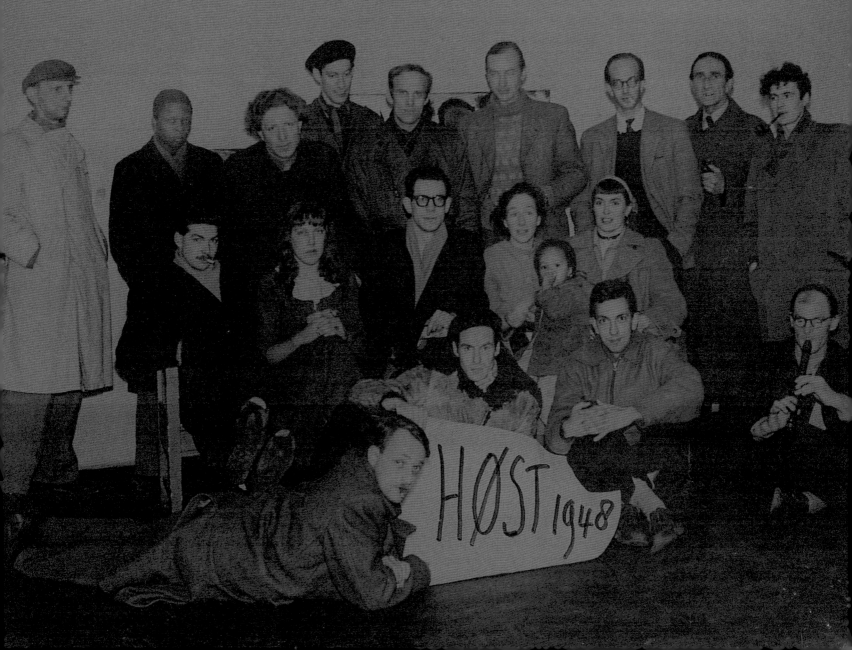

Historical background

Denmark played a leading role in the Cobra Movement both in painting and in sculpture. As early as 1934, the year of its foundation, the Danish 'Abstract Surrealist' group Linien expressed a desire to explore a more spontaneous expressive approach, where the imagination could be given free rein. From 1948 this approach was to take wing internationally in the Cobra Movement. The Danish group rejected the 'photographic' representation of dream visions and sexual fantasies, which the 'orthodox' Surrealists had adopted, and Cobra were later to follow their example. But finding a mode of expression which departed from all the rules, and creating images freely from the material, proved not quite so simple, and it was not until 1938 that a spontaneous expression began to break through in the painting of a few of the artists. In fact this appears to have manifested itself rather earlier in their sculpture, particularly in the work of the painter/sculptors Ejler Bille and Henry Heerup.

These artists rapidly found a freedom on the three-dimensional plane, possibly because they took as their model Picasso who, although primarily known for his groundbreaking work in painting, was also an influential pioneer in sculpture. Picasso's unprecedented experiments, working with whatever material was to hand, were known to them early on. In addition they were fascinated by the sculpture and reliefs of the Alsatian sculptor/poet Jean or Hans Arp. It would be true to say that sculpture was to a large extent the most vital source of inspiration for these Danish Experimentalists. After all, their knowledge of primitive and prehistoric art, and indeed of folk art, was founded on three-dimensional work.

In a short article entitled Fra naturalisme til symbolik (From Naturalism to Symbolism) published in September 1934 in the fifth issue of the periodical Linien, Ejler Bille outlined the different course he and his colleagues proposed to take vis-à-vis Surrealism. This course was to be 'a journey from the depiction of nature to that of the soul, from reportage to fantasy, from a descriptive art to a creative art'. In this Linien was the precursor of that spontaneous, primitive form of expression which blossomed among the group of artists associated with Asger Jorn and his magazine Helhesten (Hell Horse) during the Second World War. Both magazine and group were to find the international extension of their art and ideas in the Cobra Movement and its publication Cobra.

In the first issue of Cobra, published in Copenhagen in March 1949, Bille again voiced his conviction with the statement: 'It is vital that particularly the painter and the sculptor express themselves as directly as possible'.[1] It is significant that he specifically mentions the sculptor in this context.

Contact with international developments

In the early 1930s Bille and the group of artists around him were wide open to all the international developments that were to culminate in about 1945 in what I have dubbed the second major wave of Primitive Expressionism in twentieth-century art.[2] He and the painter Richard Mortensen, co-founder of Linien, had together visited Berlin in 1931 where they saw the work of the Cubists, Kandinsky and Klee. The painter Vilhelm Bjerke-Petersen, who was also one of the founders of Linien but who soon went on to develop more along the lines of orthodox Surrealism, was studying at the Bauhaus in Dessau between 1930 and 1931. His father – a prominent art historian with a deep-rooted interest in twentieth-century art, who also published on the subject – was able to provide him and his friends with considerable information, including access to past volumes of the German expressionist journal Der Sturm.[3]

Elsewhere they came into contact with the brilliant French publication Cahiers d'Art which had been founded in Paris in 1926 and circulated news internationally of all the latest developments in art through its (for that time) richly illustrated articles. Both this magazine and the equally sumptuously produced and surrealist-based French periodical Minotaure, founded in 1933, were eagerly scrutinized by the Danish artists.[4] The latter was advertised, discussed and quoted, both in terms of art and literature, right from the very first issue of their own magazine Linien in 1934. The third issue of Linien, for instance, carried a reproduction of several of Picasso's sketches for sculptural works that could be termed surreal.[5] This illustration was undoubtedly taken from the first issue of Minotaure in which an article by André Breton

was accompanied by illustrations of several of Picasso's sculptures, as well as a whole series of similar sketches by the artist.[6] The extent of the Danes' identification with these magazines, which were primarily a platform for artists working in the surrealist field, can be gauged by the fact that Vilhelm Bjerke-Petersen published a surrealist confession in Cahiers d'Art in 1935.[7] From its inception in 1926 this journal had closely followed Picasso's development, as well as showing work by Paul Klee, Max Ernst, Hans Arp and Joan Miró. The latter three in particular were featured in lavishly illustrated articles in later issues. Linien, Helhesten and later Cobra could be seen as modest reproductions of these distinguished French journals.

In 1935 the Danes mounted an exhibition showcasing the foreign artists they admired. Although organised by Bjerke-Petersen, from whom the group had distanced itself, the show received a wildly enthusiastic review by Bille in Linien. It included work by Arp, Tanguy, Ernst, Giacometti, Dali, Brauner, Miró, Klee and Oppenheim. Bille described some of these works as: 'bursting with such overwhelming vitality' that they 'made him forget everything else' so that he 'started to live for the first time'.[8] In 1937 Linien members mounted their own international exhibition in Copenhagen which included, alongside their own work, a further series of works by their favourite foreign artists. Only this time they had selected them themselves.[9] The edition of Linien specially published to accompany the exhibition carried illustrations of work by Linien members (interestingly, mainly sculpture), alongside that of foreign artists they championed, among them illustrations of reliefs by Sophie Taeuber Arp and Hans Arp, and sculpture by Bille, Ferlov and Heerup.

Interest in primitive art

Cahiers d'Art and Minotaure served another purpose beyond that of introducing them to these artists from abroad. From the outset these periodicals also published extensive photo reportage accompanying articles on many different forms of primitive or exotic art, including African, Oceanic and Pre-Columbian art, as well as Coptic, Persian, Chinese and prehistoric. These art forms – particularly African, Oceanic and prehistoric art – captured the imagination of the Linien members. Copenhagen itself had plenty to offer in that area with its National Museum which housed extensive collections of prehistoric and many other forms of primitive art. Furthermore they gained an in-depth knowledge of African art after Sonja Ferlov introduced them to an old friend of her parents, Carl Kjersmeier (1889-1961),[10] the internationally renowned African specialist and collector of primitive art. At the time Kjersmeier was just about to bring out his standard work Centre de style de la sculpture nègre africaine, and Sonja and her colleagues visited him regularly at his home where he zealously introduced them to his collection.[11] The sixth issue of Linien (October 1934) carried a short text announcing the forthcoming book, and this was followed in the February 1935 issue with reproductions of two works from his collection to mark the actual publication. During the war Kjersmeier also contributed an article on African art to Helhesten.[12]

Primitivism had formed an important element in Danish modern art from early on. A major impetus in this direction came from the special connection Denmark had with the French painter and 'father of Primitivism', Paul Gauguin, through his marriage to the Dane Mette Gad in 1873.[13] As early as 1893 a large exhibition of Van Gogh and Gauguin in Copenhagen had shown ten of Gauguin's works painted on Tahiti. At this time a group was formed in Copenhagen emulating the Nabis – the name given to a symbolist group of artists which Gauguin had gathered around himself in Pont-Aven (Normandy) in 1888.[14] Around the period of the First World War a form of Cubism emerged in Danish art. But it was the expressionist work that the painters Harald Giersing and Sigurd Swane, and the sculptor Adam Fischer (1888-1968), were producing in 1920 that first signalled the influence of primitive art. Fischer, who had settled in Paris in 1913, wrote articles on 'African negro sculpture' in the Danish art magazine Klingen (The Sword) which appeared between 1917 and 1918. The editors of this publication, which at that time attracted the Copenhagen avant-garde, also had links with the Africa specialist Kjersmeier.[15]

The Danish avant-garde artists of the 1930s were more intensively involved with both the newest developments in art and with their most important source of inspiration, primitive art, than the previous generation had been. From 1934 on several of them spent varying periods of time in Paris, where they not only

saw the work of the artists they admired, but also came into contact with many of them. When Bille was in Paris in 1937 to select works for the Linien international exhibition, he and some of his colleagues visited Giacometti, Arp, Ernst and Tanguy, among others.[16] In 1936 Sonja Ferlov settled in Paris where she met the South African painter/sculptor Ernest Mancoba whom she married in 1942. Ferlov's studio became the meeting-point for the Danes in Paris,[17] while Mancoba gave them in-depth guided tours of the recently refurbished Trocadero Museum – now renamed Musée de l'Homme – where artefacts from the collections that had previously come under the banner of 'ethnography' were now meticulously displayed as art. This museum had a huge impact on them. Jorn filled an entire sketchbook with studies of the things he saw there, and he and Bille wrote articles on the museum which appeared in a Danish publication.[18] In 1938 two spectacular events took place which were to have a far-reaching effect on later Danish Experimentalists. The first was the exhibition mounted by the Copenhagen National Museum of ethnographic artefacts brought back from the New Hebrides and New Guinea by the so-called Monsun expedition two years previously.[19] No less sensational was the arrival that same year in Copenhagen's State Museum of Picasso's Guernica, fresh from the 1937 World Exhibition in Paris and now on tour.[20]

Danish sculpture

These young Danish artists had passionately absorbed everything that was new in international modern art, while at the same time nurturing their profound interest in primitive art through exposure to the very best collections. With their combination of high-minded idealism and creative zeal, they developed an art which was to bring Denmark into the international arena. This had happened once before, in the realm of sculpture, but in a quite different way.

During his extensive stay in Rome the sculptor Bertel Thorwaldsen (1770-1844) attained international fame. He was perceived as the 'reincarnation of the classical spirit' and was revered as a hero in his own country, where he was accorded his own museum in the form of a temple in the centre of Copenhagen. Since Thorwaldsen Danish sculpture had been dominated by the 'tyranny of classicism', and it was not until the beginning of the twentieth century that artists managed with difficulty to throw off its shackles. The sculptor Kai Nielsen (1882-1924) was a major force in bringing this about. Nielsen derived his inspiration on the one hand from Rodin, and on the other from ancient Egyptian and Assyrian art. The more recent developments in French art, which included Maillol and Despiau, were a strong influence on the sculptors Adam Fischer and Astrid Noach (1888-1954). Fisher was also a Primitivist and his work that was inspired by African art marks him out as a forerunner of the later Danish Experimentalists. Astrid Noach had a huge impact on the following generation with her subtly understated sculpture, a reminder that she worked as a restorer of medieval religious art.[21] The contribution of this new generation, however, was of an entirely different order. Their luminaries were the Paris-based sculptors Laurens, Lipchitz, Brancusi, Arp and Giacometti, as Bille outlined in his article 'Abstrakt Dansk skulptur' published in Helhesten in 1944.[22] From 1930 onwards these young Danish artists were producing forms and visions in art which soon won Denmark a place within the international avant-garde.

Ejler Bille

Ejler Bille (b. 1910), who was the first to articulate the new direction in art, was initially active mainly as a sculptor, although he later devoted himself entirely to painting. From the outset he adopted an independent attitude to the various art academies that he attended from 1931 onwards. In his early sculptural work – a series of animal figures – Bille deliberately opted for a non-naturalistic approach, seeking instead to reflect the animal's essence by rendering it in a stylized and extremely restrained form (fig.4).[23] These highly-polished wooden images are reminiscent of the small amber sculptures, depicting birds and other animals in rudimentary form, that were discovered in Scandinavia and date from 8000-4000 BC.[24] At the same time one is reminded that Bille knew all about the developments in modern art. Indeed from as early as 1931 he started making entirely abstract forms. And around 1933 he increasingly applied this abstraction to his animal figures, which he sometimes painted in vivid colours – an attempt perhaps to reflect Kandinsky's forms and colours in

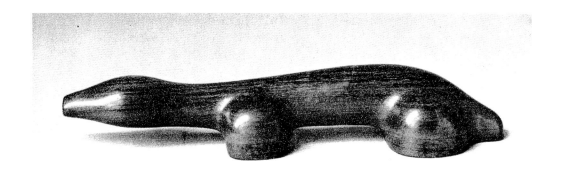

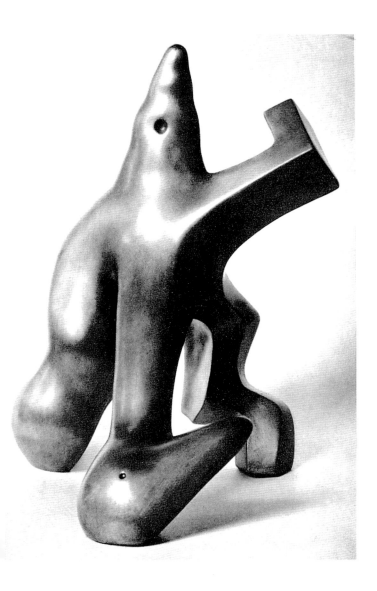

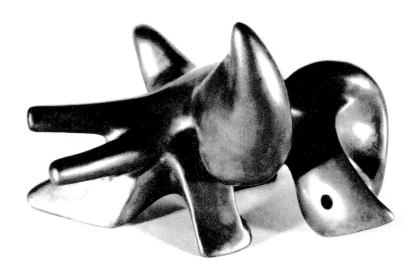

Ejler Bille

4 Maar (Marten), 1931, palisander wood.

5 Spadserende form (Walking Form),
1933-1936, bronze, Statensmuseum for
Kunst, Copenhagen.

6 Fugl, or Lurende fugl, (Bird, or
Luring Bird), 1933, bronze, h. 15.5 cm,
Statensmuseum for Kunst, Copenhagen.

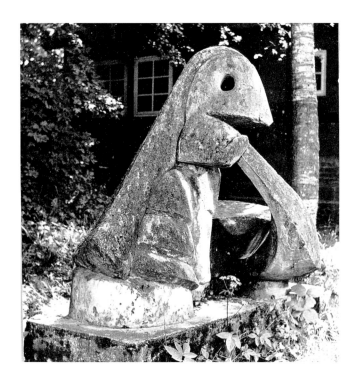

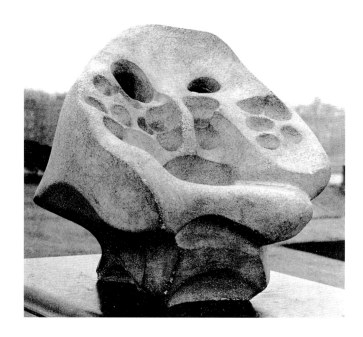

Ejler Bille

7 Ögle (Lizard/Snake), c. 1936, garden sculpture, cement, h. c. 138 cm, base 172 x 72 cm, Ebbe Neergaard collection, Jystrup, Denmark.

8 Maske (Mask), 1936, artificial stone. Private collection.

9 Ögle (Lizard/Snake), c. 1936, artificial stone, h. 16.5 cm. Statensmuseum for Kunst, Copenhagen.

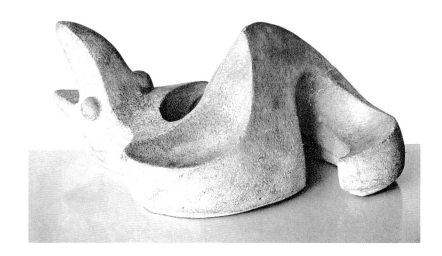

a three-dimensional plastic form.[25] Equally these humorous objects bring to mind folk art. But as his sculptures – by then predominantly in artificial stone and plaster – became more supple and organic in form, his major inspiration was undoubtedly Hans Arp (fig. 5, 6, 9 and 51). The animal or human associations give his creations a particularly idiosyncratic resonance, especially those with multiple arms, like Figur med fangarme (Figure with catching arms, c. 1933; fig. 3) and a piece like Spadsirende form, (Walking Form, 1933-1936; fig. 5), where the sculpture seems to want to move on.

In 1936 he achieved a very free expressive form with his artificial stone Maske (fig. 8), whereby he succeeded in giving the stone a certain plasticity, suggesting a secretive expression by means of deeper and shallower holes. That same year he made a creature out of large blocks of concrete which he called ögle or lizard (fig. 7).[26] He left it to the viewer's imagination to fit the body together: the concrete mass begins and ends in a rounded and pointed form which is clearly intended as the head, with a hole for the eye. This method of working with an unspecified form or raw material, subjected to a few intrusions that stimulate the viewer's imagination, looks forward to the painting style of the Helhesten Experimentalists and to Cobra. These two sculptures of 1936 stand somewhat apart from the rest of Bille's small sculptural œuvre created between 1931 and 1948.[27]

It was not until 1938 that Bille found a similar freedom in his painting, which for most of the 1930s had been characterized by a stiff abstraction.[28] That same year saw the painter Egill Jacobsen reach a spontaneous painterly outpouring in his dramatic painting Obhobning (Accumulation), which was seen as a Danish version of Guernica.[29] This picture was viewed as conclusive evidence that a number of Danish artists were quite decisively and consciously forging their own path. From this point onwards the work of these artists, who later formed the nucleus of the exhibition association Höst (Autumn),[30] is increasingly characterized by a spontaneous interplay of colour planes and lines in which – as Bille had already done in stone and concrete – fantasy creatures are conjured up by a few accents to suggest an eye, mouth or beak.

Bille was deeply involved with the Linien group and the Höst Experimentalists. His association with Cobra, however, was more aloof. Linien carried illustrations of his sculptural work throughout the magazine. But although he wrote articles in Helhesten on the new developments in Danish sculpture, the magazine mainly focused on his painting, which he was concentrating on at that time.[31] Within the Cobra Movement he was also primarily known as a painter.[32] In the 1930s Bille acted as a vehicle – through both his texts and his sculptural work – for a new form of expression which, from 1938 on, was to reverberate rapidly through painting and was also to leave its mark on sculpture.

Henry Heerup

Linien's first exhibition in 1934 also showcased the work of the sculptor, painter and graphic artist Henry Heerup (1907-1993), who participated as a guest. The highly intellectual artists that Linien had nurtured found in Heerup the exact counter pole. And yet his work slotted quite naturally into the latest artistic developments. What he made was usually the product of the special relationship he had with the material to hand. More than anyone else within the Danish avant-garde, this gave him the creative freedom of which Bille spoke; a freedom that had been developed by the 'spontaneous artists' around Helhesten and went on to have its international breakthrough in Cobra.

The Linien show was the first time that Heerup exhibited his skraldemodeller – assemblages of debris – alongside his familiar stone sculptures. This man, who came from a very humble background, obviously felt at ease and free among the group of avant-garde artists. Nonetheless he seemed to be working from a completely different premise. In the first issue of Linien he explained where his preoccupations lie: to make something out of all the things he 'finds lying about' on 'his bicycle rides between heaven and hell'. 'Children, your broken toys are resurrected by ideas/visions,' he exclaims. And speaking of his stone work: 'Often it's the stone that inspires what I make of it. There's always something within the stone itself. Granite is nature's hard-boiled egg.'[33]

Heerup can justly be called an outsider: an artist who, supremely unaware of what is happening in the art world around him, simply went his own way. But he was a rather curious outsider. From 1934 on he

worked quite happily on a piece of land outside Copenhagen – first in Vanlöse, then from the mid-1940s in Rödovre – which he used as his studio and where he assembled huge blocks of stone, pieces of wood and many other kinds of material. In his search for suitable stones he and a sculptor colleague Robert Jacobsen – with whom he collaborated for a while during the war – removed the old tombstones that were lying about a piece of land.[34] Hidden among the bushes in his garden were stones of different sizes that had taken on the form of a human head, a female figure, an animal, a mask or an imaginary creature. He kept his paintings stashed away in his shed.

An only child, Heerup was supported by the love of his utterly devoted mother. One might say that his entire œuvre is an ode to her, woman in general and the miracle of nature. His wife explained that everything he had experienced in childhood proved formative in later life. She also pointed to the exceptional relationship he had with nature. 'He felt he was in some way in nature's debt.' His daily life was bounded by rituals: 'He had to take a bath when the weather was right for it, sit in the sun when the sun was shining.'[35] In principle he always worked outside, painting in the summer but sculpting in all weathers.[36] These inexorable ideas represented the flip side to this life-loving man.

Heerup's school career was not a success, but early on he gained a wide experience of materials and manual skills through the many jobs he took on when leaving school at the age of fourteen. He worked as a graveyard assistant, was apprenticed to a stonemason, a lithographer, a signboard painter, and a bronze founder. And in between times he did nothing but draw. Rembrandt was his great hero among painters and Thorwaldsen among sculptors. When he was twenty he gained a place at the Copenhagen Academy where he attended both the painting and sculpting courses. But these courses were of very little use to him and he carried imperturbably on down his own chosen path. To the dismay of his teachers at the sculpture classes, rather than building up an image by adding more and more clay, he would take a large lump and start pulling pieces off until the shape that lay hidden in the clay emerged.[37]

Chiefly known for his sculpture, Heerup was a much-loved artist in his own country and his work was showcased in a well-nigh endless series of exhibitions both in Denmark and abroad. His paintings, which were originally in the Danish Expressionist style, show that he felt much less free in this genre. From the mid-1930s on symbols of love and death, in which the female sex and motherhood are pivotal, dominate his painterly and graphic work, while the stiff ornamental forms in which he places these symbols strongly recall folk art motifs.

In his sculptural work he was able – with no preconceived plan – to surrender himself entirely to the material, producing work touched by a sense of humour, cheerfulness and a large measure of human warmth. These elements were already apparent in his Monkey Mother and Child and his Mother and Child of 1930, which he sculpted from granite while he was studying at the academy. These pieces resonate with warmth and physicality precisely because he allowed the figures to emerge naturally from the form of the stone itself, leaving certain areas unworked. This also holds true, though in a different way, for the portrait he made in 1932 of Mille's Head. This image sculpted in the round reminds one of the rather stiff portrait busts by Kai Nielsen, a Danish sculptor of the previous generation whom Heerup admired.[38] As with a number of other busts by Heerup, the cheerfulness and the simplicity of form radiate something touchingly human, as though these were puppets hewn out of stone.

Family life, the child and the woman form the perennial themes of his work, as for example in Kone med barnevogn (Woman with Pram, 1933). His Female Torso of 1933, fashioned out of white marble and consisting of no more than the belly and breasts, conveys the female sex in such a rudimentary way that one might be looking at a prehistoric fertility figurine. This piece and some of Heerup's other work also show the possible influence of Inuit art from Greenland.[39] He also used the primordial female forms – breasts, belly and thighs – to make a variety of humorous sex symbols, as in his clay Female Temple of 1937, a sort of pink cake crowned by a single breast with moss growing out of the arm pits. His stone images in particular call up associations with prehistoric finds, like another Woman as Temple (1951), and sometimes with mythical creatures. His Happy Child of 1941 (fig. 11) with its mask-like face has something of a sun god about it,[40] while the gigantic heads carved out of granite (fig. 44), which immediately recall the mammoth images found

on Easter Island, seem like petrified giants. In the Cobra Movement he became particularly known for this type of sculpture and it was these works that were illustrated in the small monograph on him in the series Bibliothèque de Cobra.[41] Moreover it was solely his stone sculptures that were shown at the Cobra exhibitions of 1949 and 1951 in Amsterdam and Liège. At the latter the architect Aldo van Eyck, who designed the exhibition, set the works in a bed of coal.

Heerup began painting his sculptures as early as 1930, 'if the stone demanded it', sometimes in great detail, but often quite patchily as with his Blue Man, from 1942, his Gorilla (1943, his Prince Tonde (Prince Barrel, or the Carnival Prince; fig. 44) of the same year and his three Old Female Trolls fashioned out of a single millstone (1964-1965). In this he might have been inspired by the famous rune stones from the village of Jelling on Jutland, whose deeply incised decorative bands had originally been painted. In 1935 he had used a small bursary he had been granted to go and see these stones for himself. [42]

Heerup's skraldemodeller – his junk sculptures – are among his most amusing creations; his contention was that 'children have been making them for ever'.[43] He was by nature a scavenger and he carried everything he could back to his studio. As early as 1930, while at the academy, he discovered a 'middle path between painting and sculpture', as he called it: he had modelled a figurine of an animal at the zoo, but feeling something was missing, he was suddenly inspired to add a glass marble and a piece of wood. Delighted with the success of this discovery he nevertheless kept it to himself for a while. By 1934 when he showed various examples at a Linien exhibition, he had already created several works in this genre, and one can imagine the quiet enjoyment he must have had all those years while making these objects.

These pieces often provide a telling, but gently caricatured, image of man's plodding ineptitude in dealing with this world. This is reflected in his sculpture Marriage (c. 1940; fig. 13), where he took two gnarled stumps of wood, linked them together with a metal chain and screwed metal rings and the handle of a coffee grinder on top to serve as the head or headdress. By contrast an aura of tenderness surrounds his figure of Christ with Crown of Thorns (1941; fig. 12), consisting of a rudimentary wooden form wreathed by a mesh of metal wiring from which a few flowers protrude. Grammofonmanden (The Gramophone Man) of 1935 (fig. 10), a kind of totem pole which he painted and hung with a variety of objects, and Billeddrejer (Picture Mill, 1940; fig. 49), show close affinities with folk art. He also made many animals, some on a very large scale such as the 'horse' on which he was photographed. Unfortunately these large objects have been lost. The more abstract symbols that he put on the exterior of his hut on his piece of land outside Copenhagen seem like 'symbols to ward off evil spirits'. And during the war he used the same scant means to create his Nissemand (Goblin, 1943-1944, fig. 46) and his poetic Dödenhöster (The Grim Reaper, 1943; fig. 14). This turbulent figure with his scythe is made up of a few pieces of wood, an iron bed knob, a twisted chair leg, a cart wheel and the mudguard of a bicycle.

In the context of international developments in art, Heerup started experimenting with 'found objects' very early on. Although surrealist publications do make occasional mention of this genre, it was not until 1936 that the Surrealist Movement began to take any serious interest in this type of object made by their own artists. Cahiers d'Art devoted its first two issues in 1936 to the 'surrealist object' which at the time was also the subject of an exhibition organized at the home of the primitive art expert Charles Ratton.[44] Heerup's objects, however, have little in common with those of the Surrealists, although he was undoubtedly acquainted with their work. With some exceptions, his work is never touched by the alienating atmosphere that the Surrealists sought to engender in their work through the juxtaposition of totally unrelated objects.[45] And while the Surrealists did indeed refer to one aspect of folk art – namely the fetish of primitive tribes – the tone of their objects is predominantly oppressive, cynical and perverse. Heerup's work on the other hand springs from a totally different source. He was a great admirer of Picasso whom the Surrealists were eager to claim as one of their own.[46] But the collages, assemblages and objects that began to emerge in Picasso's œuvre around 1912 reflect a similar childlike inventiveness, humour and pleasure in the material's accidental characteristics that we recognize in Heerup, and that was to capture the imagination of a whole generation of artists during and directly after the Second World War.

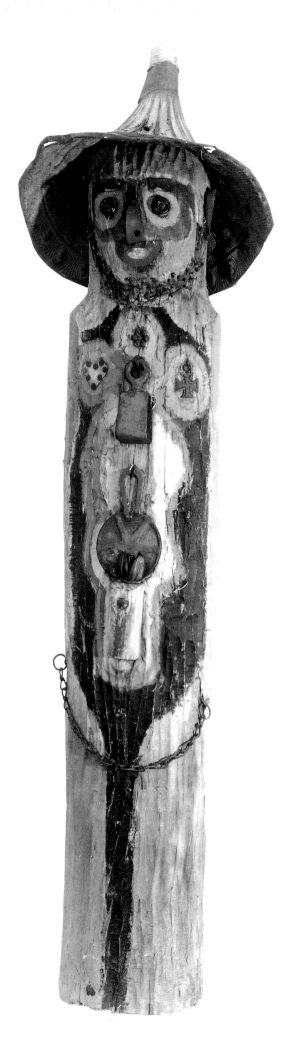

Henry Heerup

10 Grammofonmanden (The Gramophone
Man), 1935, painted wood and found metal
objects, h. 178 cm. Nordjyllands
Kunstmuseum, Aalborg, Denmark.
11 Glad barn (Happy Child), 1941,
soapstone, h. 40 cm.

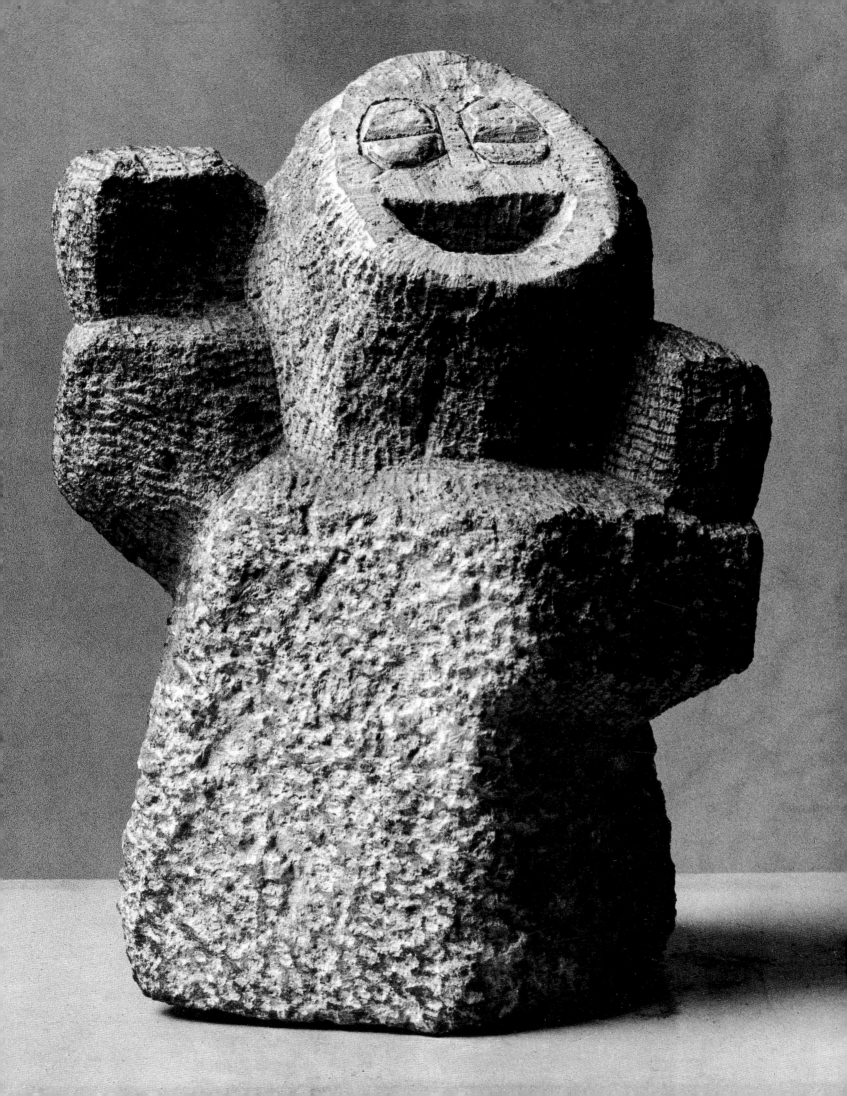

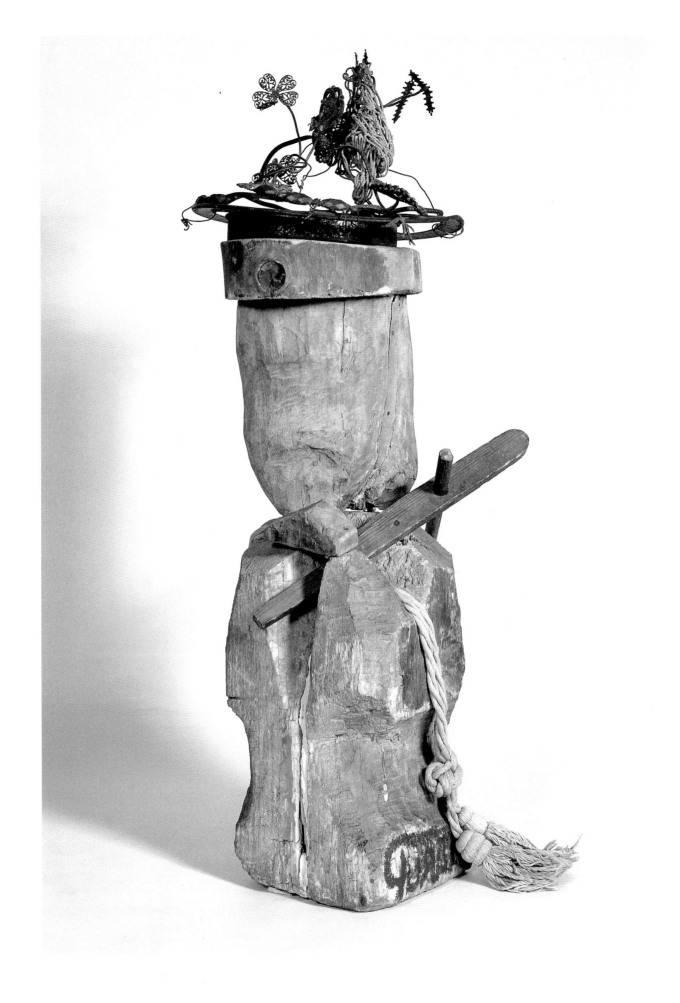

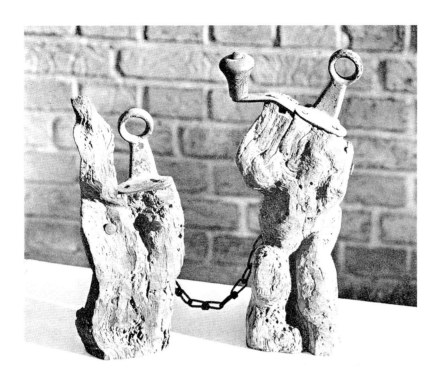

Henry Heerup

12 Christ with Crown of Thorns, 1944, lime and oak, cord and copper, 67 x 22 x 22.5 cm. Private collection, Antwerp.

13 Aegteskab (Marriage), c. 1940, wood and metal.

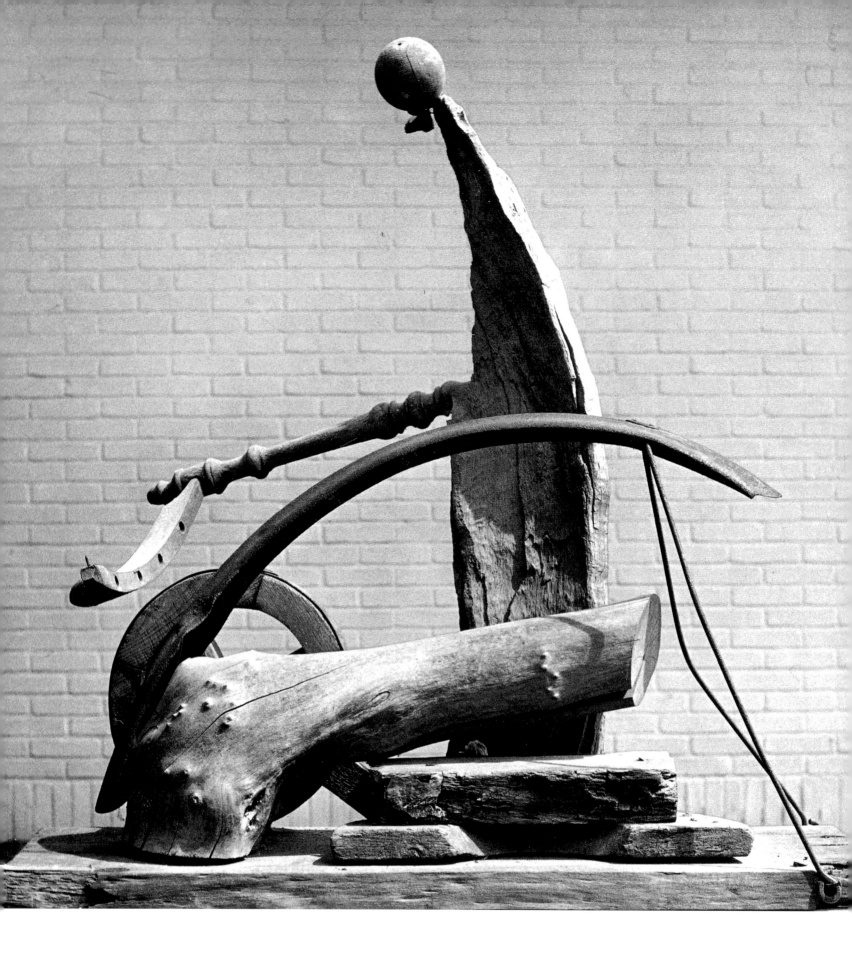

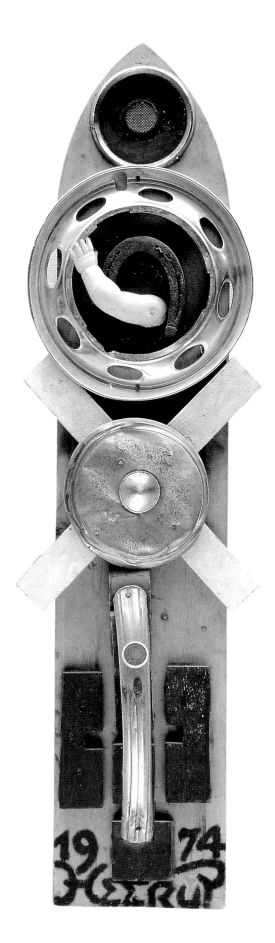

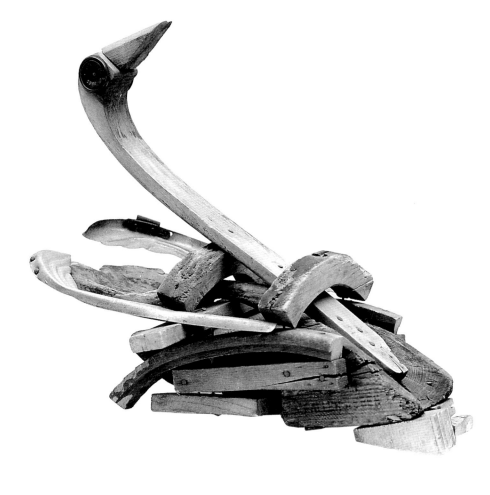

Henry Heerup

14 Dödenhöster (The Grim Reaper), 1943, assemblage, h. 75 cm. Louisiana Museum, Humlebaek, Denmark.

15 Strygebret (Ironing Board), 1974, assemblage, h. 145 cm. Cobra Museum for Modern Art, Amstelveen.

16 Svane (Swan), 1960, assemblage, 66 x 41 x 56 cm. Cobra Museum for Modern Art, Amstelveen.

With his fantasy figures in stone, but even more specifically with his skraldemodeller, Heerup seemed to anticipate the vital, richly imaginative expression of the postwar generation, who sought to expunge the Surrealists' alienating element. It is extraordinary, therefore, that, as far as I know, there is no mention of his skraldemodeller in any of the publications brought out by the Danish Experimentalists during the war, or those of the Cobra Movement.[47]

Sonja Ferlov

In the early 1930s Sonja Ferlov (1911-1985) also formed part of the artistic circle that founded the Linien group, although she did not start exhibiting with them until 1937. Her sculptural work is informed by a strong inner tension and at the same time a determination to keep that tension in check. The Danish writer Ole Sarvig wrote the following about the small figure Skulptur of 1949 that is illustrated on the last page of the book on Sonja in the Bibliothèque de Cobra series: 'This is a creature in conflict yet in balance with itself.'[48] In its bare essentials the work consists of nothing more than three legs joined together to form an abstract body, frozen in a rigid pose. Ferlov harnessed this three-dimensional plastic idiom to express a strong social commitment – shared by her fellow artists – that art can act as a liberating force in people's lives.[49]

Sonja began her career as a painter but it took a long time and extensive periods of isolation before she found her own artistic direction. In the early thirties while she was studying at the Arts and Crafts School and the Copenhagen Academy she met Richard Mortensen, Vilhelm Bjerke-Petersen and Ejler Bille. Although they were all more or less contemporaries, for a long time her relationship with them was more like that of pupil. From them she learnt a great deal about international artistic developments. Giacometti and Henri Laurens had a particular impact on her, while 'all Russian sculptors and Constructivists' were a revelation.[50] Moreover she grew up with Kjersmeier's collection of African art which undoubtedly acted as a formative influence on certain aspects of her later œuvre.

In 1935 she collaborated with Mortensen and Bille on a communal experiment, taking the surrealist object trouvé as their springboard. This experiment, which was possibly also influenced by Heerup's skraldemodeller, was to have a far-reaching impact on their later development. They collected pieces of wood of all shapes and sizes during their long walks along the beach and in the woods, and then created compositions from whatever they had found. This associative way of working with whatever forms that came to hand gave them a great feeling of liberation. In the autumn of that year Mortensen, writing in Linien about an exhibition that summer of Sonja's Levende grene (Living Branches; fig. 17), said: 'The land of inspiration opened up before us, and we found ourselves face to face with the full force and significance of this spontaneous method. We had accepted forms and vehicles of expression which had formerly been inconceivable in painting and sculpture and, without thinking, we reached for paint and canvas, clay and pen – the door was opened and light streamed in.'[51]

This experience gave Sonja an unexpected insight into the direction she herself should follow. Effectively this approach to material released her from nature as a motif which hitherto had been focal in her painting. She decided to become a sculptress. But nevertheless her Levende grene form the only spontaneous manifestation in her later sculptural œuvre, despite the fact that many of her later drawings and collages are works of great spontaneity.[52] Her first works in clay are clearly marked by the influence of Bille and Mortensen: her Bird with Young of 1935, for instance, shows a close affinity to Bille's stylized animal sculptures.

At the end of 1935 Sonja went to Paris to broaden her horizons. There she met Giacometti who, of all the artists she and her Danish colleagues visited, was to have the profoundest impact on her. However they were shocked to find that this artist whose surrealist work they so admired had now gone down an entirely new path and was 'working on models with small heads'. Fortunately the works familiar to them from reproductions were lying about all over the studio. Shortly afterwards Sonja herself was to acquire a studio in the same building.[53]

Apart from several extensive interruptions, Sonja spent the rest of her life in Paris where – with great

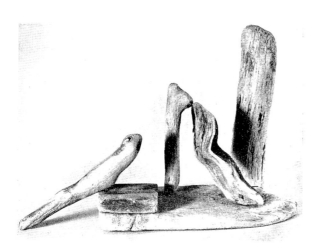

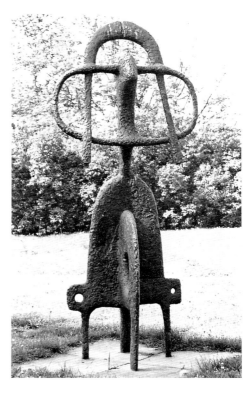

Sonja Ferlov

17 Levende grene (Living Branches),
1935, wood, h. 18 cm. Steingrim Laursen
collection.

18 Skulptur (Sculpture) 1940-1946,
plaster (later cast in bronze), h. 50 cm.
Silkeborg Kunstmuseum.

19 Confiance (Confidence), 1963,
bronze, h. 175 cm. Galerie Michael
Andersen collection, Copenhagen.

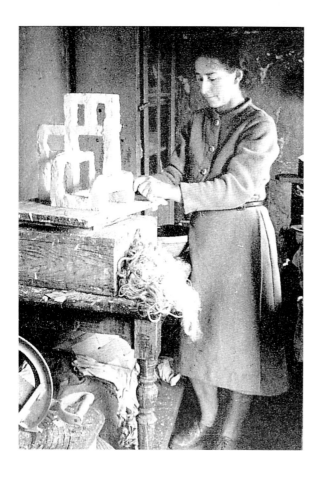

20 Sonja Ferlov at work in her studio
c. 1950. (Photo from: Christian Dotremont
Sonja Ferlov, Bibliothèque de Cobra
no 9, Copenhagen 1950, p. 2.).

21 Henry Heerup 'riding' his own junk
sculpture (unfortunately no longer
extant), c. 1962.
22 Shed at Henry Heerup's work terrain
in Rödovre near Copenhagen, 1962.

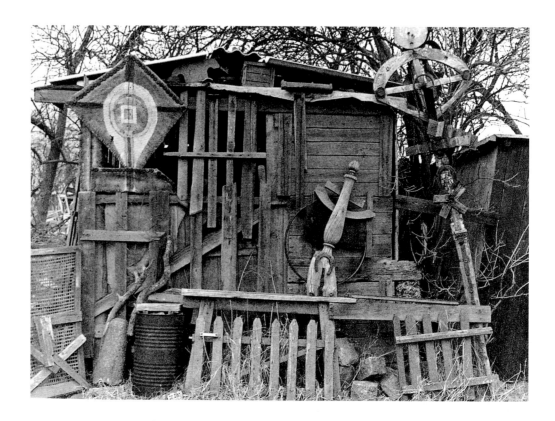

doggedness and self-criticism (she destroyed a substantial amount of her work) – she found her own direction in sculpture. Her sculptural work falls into two distinct categories. The one is hallmarked by concentrated abstraction or abstracted form, which can be seen as a continuation of pure, controlled abstraction and was taken up by the Linien group along with Surrealism. The other consists of the works which are clearly influenced by tribal art. These sculptures with their recurring mask forms are characterized by an equally austere, restrained design, as though she sought to imbue these works with the same power inherent in ritual tribal images.

During the long war years in Paris she worked on only one sculpture, Skulptur (1940-1946; fig. 18), which became her lifeline in that difficult time. Its sloping abstract form with a circular opening – 'an eye' – at the highest point has the air of a body sunken in on itself, poised in anticipation. This unnamed image, which was the fruit of long gestation (she was constantly adding a piece or taking something away), not only became the pivotal work of her entire œuvre, but also of Danish abstract sculpture in general. Abstraction continued to dominate in this aspect of her work until the early 1960s, as in Skulptur (1951; fig. 42) and Stille vaekst (Quiet growth, 1962; fig. 43).

Her later works in this style were highly abstract human figures, whose austere constructions in plaster with gently vibrating surfaces recall Giacometti's elongated, bronze human figures, as in Skulptur (Le Combattant, 1961) and Confiance (1963; fig. 19). But whereas Giacometti's sculptures radiate emotional fragility, the restrained forms of Sonja's constructions give off a sense of bottled-up power. This aspect is strongly present in the more socially committed images she was producing in the 1960s such as Effort commun (1963-1964) and L'Accord (1967), in which she portrayed groups of people.

Her association with Ernest Mancoba brought her and her colleagues into immediate contact with African art. It also opened their eyes to racial discrimination at close quarters; the latter was what prompted Sonja and her husband to return to live in Denmark between 1947 and 1952.[54] During those years she renewed contact with her Danish artist friends and exhibited alongside them at the artists' association Höst, through which she also became involved with the Cobra Movement.

It was when she started living with Mancoba that she created her first masks, such as Maske, (1939, fig. 41), with their frozen, terrifying forms. Ferlov herself says she was inspired by Mexican art[55] and indeed some of her early masks (many of which have been lost), as well as some she produced later, resemble the horrifying half-human-half-jaguar Olmec deity who demanded human sacrifices.[56] It is almost as if these masks were intended to articulate the aggression that an enemy society evoked in her. Or perhaps the stiffly symmetrical, hierarchical figures she created in her later, more African-inspired works, were intended to ward off the aggressive forces in society. In fact Sonja's way of working was far from 'spontaneous' and her sculptures seem closer to primitive art than the 'spontaneous artists' of Helhesten and Cobra. Indeed in primitive art, which formed such an important source of inspiration for them, spontaneity hardly plays a part.

Erik Thommesen

Like Sonja Ferlov, the sculptor Erik Thommesen (b. 1916) is the opposite of spontaneous in his expressive approach. A self-taught artist who worked mainly with wood, Thommesen built up an œuvre of highly austere forms which he invested with a monumental power. In contrast to Heerup, who took the material itself as his driving force, Thommesen bent it to his will. With enormous skill and craftsmanship he pared the wood away, or added to it, and the almost religious gravity of his work recalls the images and decorations in Scandinavian medieval village churches. It comes as no surprise that he deeply admired Astrid Noach, a sculptress from the previous generation who had drawn direct inspiration from these medieval religious carvings. [57]

Thommesen became involved with Höst, exhibiting with them for the first time in 1944, and his subsequent extensive participation in Cobra activities came about undoubtedly through Jorn. Photographs of his work were featured on three occasions in the Cobra magazine and the tenth issue published an article written by him. Moreover the major Cobra exhibition mounted in the Stedelijk Museum in Amsterdam in November 1949 showcased four of his works, and the final Cobra show presented in Liège in November 1951 included five.[58] Thommesen has always felt the need to withdraw and probably because of that he now prefers

not to be linked with Cobra. But his involvement with the movement is difficult to deny, the more so as his ideas on art and society are totally in line with those of the Helhesten and Cobra artists. In Levende Kunst-Formalisme (Living Formalist Art) published in the 1948 Höst exhibition catalogue he argues for 'a spontaneous human unfolding in art', calling this an 'expressionist development [...] signifying a transition to a more collective [...] approach to life'. Nonetheless his understanding of spontaneity must have been different from the other members of the group. His own working method, however, is well encapsulated by these words from the same article: 'The expressive form [...] must always be the natural result of the context.'

Thommesen's early clay sculptures dating from 1937 are clearly influenced by Matisse and Picasso's early revolutionary work in this mode. But from 1939 he started to develop his own, entirely personal style working in wood, which became his favourite material although he did produce one or two works in granite. The large, rough-hewn yet sensitive forms of his Man og kvinde (Man and Woman, 1939; fig. 24) evoke associations with both medieval wood carving and primitive images. On the other hand he was also clearly in touch with international developments in sculpture. From 1940 his work takes on an increasing formal simplicity. The human head becomes a major preoccupation, exemplified by his Self Portraits of 1940 and 1943 and the many works (Head 1945, 1951; fig. 50 and 53) and Figure (1948) in which this shape appears twice. Another recurring theme was the head of a girl or woman with plaits, Pige med fletninger, (Girl with Plaits, 1948; fig. 25). This sculpture shows an affinity with folk art, but also with the work of Brancusi, the Romanian artist who was himself inspired by the folk art of his own country. Thommesen's woodcarving is striking for the vibrancy of the skin of his figures and the 'inner force' of his forms. Alongside his heavy, compact sculptural forms, from 1949 he started creating long vertical pieces which were given names like Man (1949; fig. 52), Woman, Woman with Plaits, or Man and Woman. It was as though he had the underlying bone structure of the human frame in mind. He will certainly have been influenced in this by the work of Henry Moore, who was also fascinated by the human skeleton. Carved with love, Thommesen's sculptures speak to us in a warm human language, and his forms cherish and support each other, as in Mother and Child or in Family, or are completely submerged in one another, as in Man and Woman.

Robert Jacobsen

The way an artist is classified in terms of one group or another sometimes creates arbitrary and absurd artistic divides. According to one writer Robert Jacobsen (1912-1993) did not form part of the Cobra group. Yet the fantastical stone animals he produced during the war, and the comical dolls made from found objects which recur throughout his entire œuvre, show direct parallels with that movement. Although Robert Jacobsen enjoyed other contacts from 1947, he also belonged to the Höst 'myth creators' whose work produced during the war years came to be classed as 'typically Cobra'.

In the mid-1950s, some time before Cobra's ascendency, the Danish sculptor Robert Jacobsen and his compatriot the painter Richard Mortensen acquired an international reputation for the geometrical-abstract work they had been producing since 1947. At that time they were both exhibiting at the Denise René gallery in Paris which was entirely devoted to this genre, and their work also featured in many international shows. As a result the Cobra Experimentalists came to consider them as renegades: they had associated with the 'opposition', with the cool, aesthetic abstraction they so despised and that was all the rage in Paris in the Salon des Réalitées Nouvelles, and which was being propagated by the leading artistic circles as the newest trend in postwar art.

Nonetheless they had both exhibited with Höst, Mortensen in the years between 1938 and 1941 and Jacobsen in 1945 and 1946. Moreover they both signed the manifesto Den Ny realisme (New Realism), published in 1945 by the Höst 'spontaneous' group in the catalogue of their autumn exhibition and sent out into the world. This manifesto makes proud mention of the new spontaneous method of working the group had developed during the war. Jacobsen and Mortensen, like most of the other members of the group, had been working in an expressionist manner, surrendering themselves to their material and imagination. But unlike Mortensen, Jacobsen stuck to this way of working for much of his œuvre throughout the rest of his life.

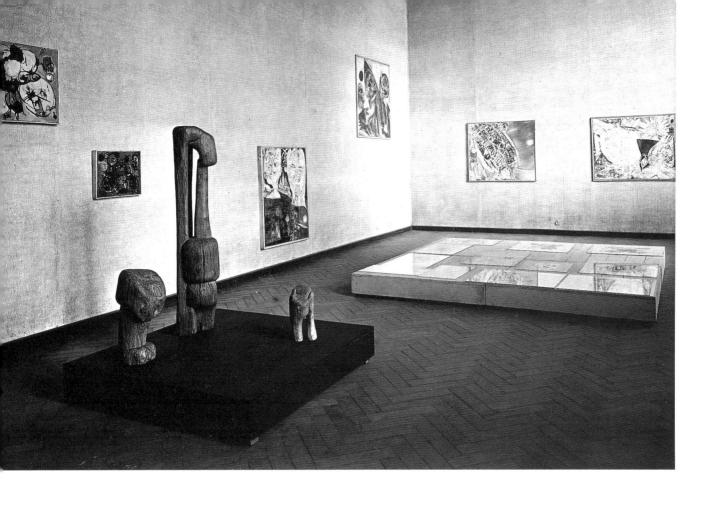

23 Room at the First International
Exhibition of Experimental Art - Cobra,
in Amsterdam's Stedelijk Museum, 3-28
November 1949, with three pieces by Erik
Thommesen on a low platform, and works
by Theo Wolvecamp and Carl-Henning
Pedersen (left to right) on the wall.

Erik Thommesen

24 Man og kvinde (Man and Woman),
1939, pear wood, h. 68 cm. Private
collection.
25 Pige med fletninger (Girl with
Plaits), 1948, oak, h. 142 cm.
Statensmuseum for Kunst, Copenhagen.

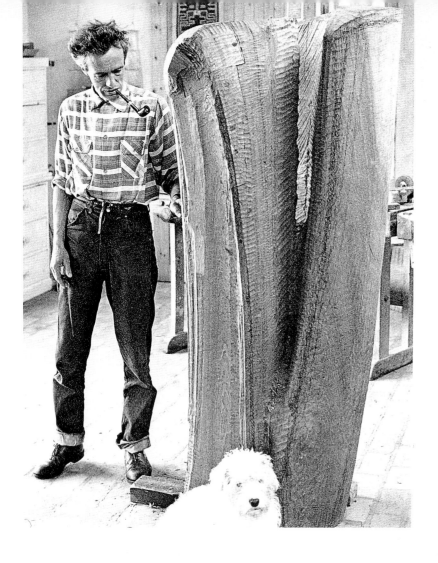

26 Erik Thommesen with one of his
sculptures, c. 1960.

27 Robert Jacobsen working in his studio
in Paris, c. 1953.

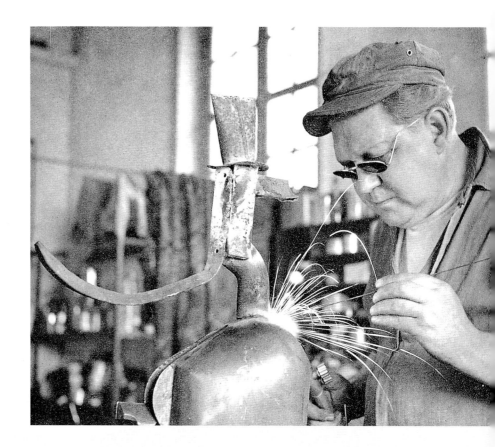

Robert Jacobsen, like Heerup, came from a humble background – his father had been a chimney sweep – and it was a long time before he decided to become an artist. For him, too, it was a foregone conclusion that when he left school at the age of fourteen he should get a job. He first worked in a sausage factory, then in a wine business, as an office clerk, with a corn merchants and on and off as a barman. He thought of becoming a jazz musician, but his mother's infectious collecting mania (she ran a second-hand shop) awakened in him an interest in the visual arts. The pictures he came up against prompted him to take a look in an art dealer's shop. This proved to be a turning point in his life because he came into contact with a group of artists who regularly gathered there to discuss art. Through books he rapidly acquired a knowledge of art history, ranging from Michelangelo to Picasso, and in this same period he also started carving a few wooden figurines. The large exhibition of German art mounted in the Free Exhibition Building in Copenhagen in 1932, where he saw the work of Kandinsky, Franz Marc, Emil Nolde, Kokoschka and Klee, among others, was to have a seminal influence on him.[59] Klee, in particular, with his extraordinarily unfettered imagination made a profound impact on him. At this time he was also introduced to the art journals Cahiers d'Art and Minotaure, which became his 'bible'. The experience of discovering the work of Arp and Brancusi in these magazines was overwhelming.[60]

It was the Linien exhibition of 1934 that finally brought Jacobsen into contact with a group of like-minded people. Heerup's work in particular must have been a revelation and his skraldemodeller haunted him as he worked among the jumble of his mother's shop; Jacobsen like Heerup was utterly devoted to his mother. In 1935 and 1936 he made his first 'dolls' from bits and pieces he had assembled, such as a table leg and a part of an iron. He also constructed a kind of totem pole from heavy wooden blocks which he painted Traeskulptur i sorte og röde farver (Wood Sculpture in Black and Red Colours, 1936-1937). But it was Asger Jorn with his remarkable spirit of adventure and recklessness who finally gave him the courage to decide to become an artist.[61]

Heerup initiated Jacobsen into the basic principle of stone carving, teaching him not only how to work the material with hammer and chisel, but also how to respect the essential life of the stone itself. Despite military service and working for the resistance, he continued to sculpt during the war, using 'old, rain-worn, grave stones which he and Heerup pinched'.[62] The years from 1939 to 1947 saw Jacobsen working mainly in granite and sandstone, although he occasionally used other materials including wood. He developed his own baroque idiom, one that reveals a strong affinity with nature. Out of his organic forms – which initially suggest the female figure, showing the influence of both Arp and Bille – he started in 1942 to build his mythic creatures, examples of which include Fabeldyr (Fabulous Creature, 1942-43) and Skulpture i granit (Sculpture in Granite, 1944-45); occasionally one finds clear plant motifs in his work as well. Jacobsen, more than Heerup, would work with a particular motif in mind which he would impose on the stone.

Primitive art had made a very strong impression on Jacobsen as a young boy of ten or twelve, when a friend of his father – a captain in the Congo army – brought back art objects with him and started a shop. Later in life Jacobsen himself collected not only African but also medieval and Asiatic figures, as well as Bavarian votive offerings.[63] In much of his work he appears to be seeking to recreate the primordial power of primitive and folk art. This is reflected in his stone mythic creatures which recall the animal configurations on the capitals of medieval churches. In addition primitive and prehistoric art must also have influenced him.[64]

In 1946 Jacobsen left the Höst group. He no longer felt he fitted in and was out of sympathy with the theoretician Bille 'who spent his whole life studying to become a primitive artist'.[65] By contrast he felt close ties with Mortensen, who had already distanced himself from the 'spontaneous' Helhesten artists by becoming a member of the editorial board of a rival art journal Aarstiderne (The Seasons). Aarstiderne published its inaugural issue in 1941, one month after the first appearance of Helhesten. Yet despite its reputation for taking a more moderate and traditional approach than Helhesten, both magazines covered much the same ground.[66]

In the spring of 1947 Jacobsen and Mortensen took off for Paris where they were the first to settle in a newly established Danish artists' residence in the suburb of Suresnes. During his nine years in Paris Jacobsen was to

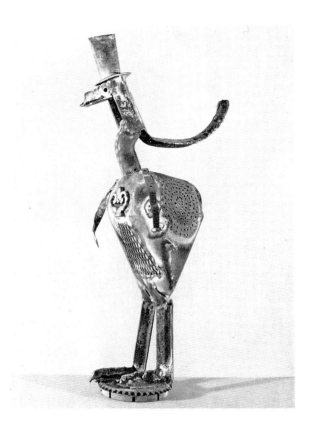

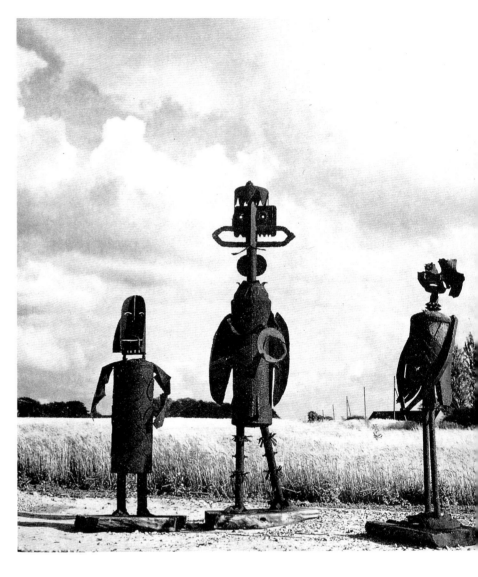

Robert Jacobsen

28 Le coq (The Cock), 1952. L.F. Foght
collection.

29 Loke og hans kumpane (Loke – a
Norse god – and his Companions), 1959,
as arranged in the sculpture garden at
Anglimuseum (of modern art) in Herning
(formerly Anglifabriek), Denmark. Iron.
Loke h. 350 cm.

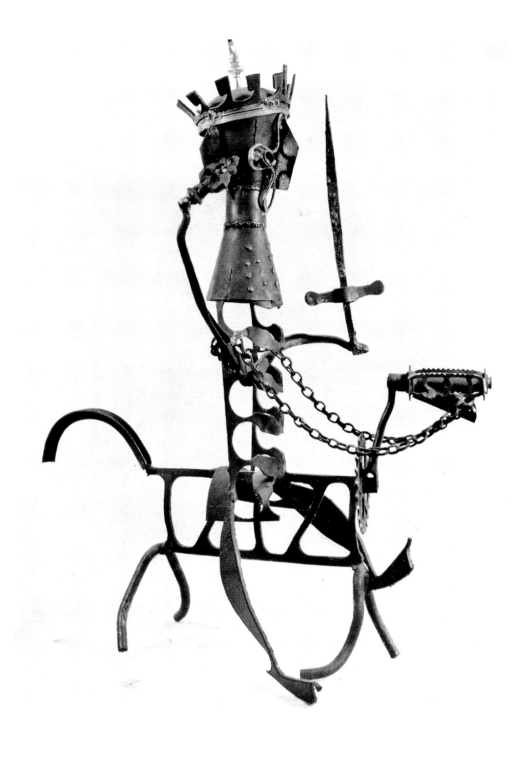

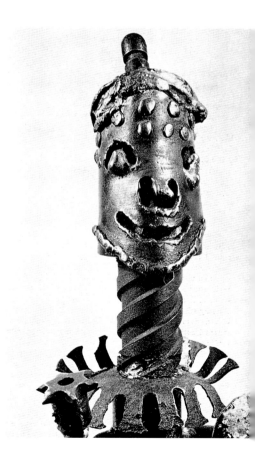

Robert Jacobsen

30 Le cavalier noir (The Black
Horseman), 1952- 1953, iron, h. 42 cm.
Galerie de France collection, Paris.
31 Afrikans Hövding (African Chieftain)
detail, 1951, iron. Private collection.

gain international recognition as a sculptor. In the first two years there his work in sandstone and marble underwent a transition to more geometric forms, and it was his geometrical-abstract work that first attracted attention in Paris. In 1947 Jacobsen and Mortensen established contact with Denise René, but at the same time they also became associated, on Jorn's instigation, with the French Surrealist Revolutionary Movement (the French strand of this Belgian/French movement in which the Belgian poet Christian Dotremont was a leading light). They took part in an exhibition by this group in the Breteau gallery which also featured the work of the painters Hartung, Atlan, Doucet, Soulages and Schneider. Also included were a few 'tachist' manifestations of an all-night party at the 'maison des artistes danois' where, led by the jazz-playing Robert Jacobsen, Mortensen and the French 'revolutionary Surrealists' Passeron and Halpern, produced several communally painted pictures.[67] Jacobsen was very indignant when Jorn and Dotremont founded the Cobra Movement independently of them immediately after the Belgian/French Revolutionary Surrealist Conference held in Paris at the beginning of November 1948. In an interview published in 1985 Jacobsen explained: 'I was also a close friend of Jorn, K.H. Pedersen, Egill Jacobsen. [...] Jorn was a superior being in every way but he ruthlessly betrayed us by joining up with Dotremont. He went off [...] leaving myself and Mortensen behind like a couple of imbeciles with Passeron and a few other revolutionary Surrealists. [...] They founded Cobra in Paris, in opposition to Paris, while still forging a career for themselves there! I can't forget that Cobra was a betrayal. In fact they never succeeded in really amalgamating the various movements in Copenhagen, Brussels and Amsterdam.'[68]

In the course of 1949 Jacobsen started working with iron, prompted by his great admiration for the welded-iron sculptures being made by the Spanish artists Gonzalez and Picasso. He was also familiar with the geometrical-abstract work of the Russians Pevsner and Gabo. Furthermore Giacometti's surrealist work also had a fundamental influence on him, as it had on Ferlov. One imagines that Giacometti's enigmatic Palace at 4 am of 1932 must have been in the back of his mind when he started making his open constructions in iron.[69] For better of for worse he set up a foundry in Suresnes where a local smith, who came to have a look, remarked that 'le gros Robert' – as the portly, barrel-chested Jacobsen was known – certainly knew his stuff. He soon found himself being asked to repair all kinds of things: bicycles, engines, stoves, etcetera. And he went on to build up an œuvre in welded iron which is informed by a rhythmical interplay of open geometrical forms, some of which were painted either by himself or a French painter friend, Deswasne. This work led him to be regarded as a leading member of the 'Ecole de Paris' and he exhibited throughout Europe and beyond. In 1950 Le Corbusier commissioned Jacobsen to make a large iron sculpture for Chandigarh, the city he had designed in India. With the help of Denise René, he managed through Le Corbusier to acquire the special tools for this work. In 1951 he mounted a one-man show in Copenhagen Tekeningen in ijzer (Sketches in Iron) where his new sculpture was ecstatically greeted: 'a ballet in black iron'. And that same year he also featured in a presentation of 'contemporary French art' (!) Klarform (Clear form) which was greeted with unanimous critical acclaim and his work was heralded as 'one of the most important events of that time in Denmark'.[70]

At the same time as he started working in iron, Jacobsen returned to making his 'dukke' (dolls), using any kind of found object that came to hand – often bits and pieces of metal that he picked up either in his studio or in and around the city. With his wonderful sense of humour and an abundant joi de vivre (a quality he shared with Heerup), he created a whole hjern folk (iron people). These 'people' not only provided enormous amusement for his young daughter Lykke, but also kept the wolf from the door, particularly in his early years in Paris.[71] These dolls also reflect his old love of primitive and folk art which he could now see in the Musée de l'Homme. At first he mainly used the found objects to fashion caricatures of the people in his immediate surroundings, but later his dolls came to symbolize stock characters. His iron people are somewhat akin to the figures in the Commedia dell'Arte, the ancient Italian popular theatre, and they include Salome (1949); African Chieftain (1951; fig. 31); A Dickens Figure (1951); The Black Knight (1952-1953; fig. 30) and The Lawyer (1954). Later in 1960 Jacobsen said: 'I made these to explore new possibilities and to show another side of myself. But not many people understood what I was doing, and I was accused of abandoning my ideals.'[72] His relationship with Denise René deteriorated and he exhibited with her for the last time in 1955. Two years later he had his first exhibition in the Galerie de France in Paris, a

solo-show entirely devoted to 'Les poupées'. It was widely acclaimed: 'This sculptor can make something from the simplest materials: cog wheels, bicycle chains, old exhausts, spoons and forks', said the Paris newspaper Lettres Françaises. Even the playwright Eugene Ionesco declared Jacobsen to be highly original. But opinions on his dolls were extremely divided. When, after a triumphant series of exhibitions in the major modern art museums of Europe and elsewhere, Jacobsen's work was finally exhibited in the principal museums of Denmark in 1958 and 1959, his dolls occasioned an unpleasant argument. The highest official in the Ministry of Justice demanded proof that his dolls were indeed art![73]

Like Heerup's skraldemodeller, Jacobsen objects trouvés dolls are immediately striking for their infectious humour and their warmth of appeal. Moreover they contrast starkly with the Surrealists' objects which aim instead to provoke a sense of alienation. In the summer of 1959, at Herning on Jutland, Jacobsen created three huge iron sculptures for the textile magnate Aage Damgaard, depicting three well-known characters from the Norse myths: the dubious hero Loke (three-and-a-half metres high) and his Companions (fig. 29), rather unsavoury characters from the Edda. One of Loke's companions shows a striking resemblance to a Fon sculpture from Dahomé that Jacobsen probably saw in the Musée de l'Homme.[74] To the best of my knowledge it was rare for the Danes, who preferred to give free rein to the imagination, to depict specific figures from the Norse myths.[75] This is rather surprising, for when one thinks of the spontaneous artists of Helhesten – whom the older expressionist landscape painter Niels Lergaard, who wrote for the magazine, dubbed 'myth creators' – one is automatically reminded of the stories in the Edda. But they chose not to depict existing myths, seeking instead to give full scope to their 'myth-creating fantasy', as Lergaard put it.[76]

Like a modern Thorwaldsen, Jacobsen returned to his home land in 1966 bathed in glory. That same year he and the French sculptor Etienne Martin were awarded the sculpture prize at the Venice Biennale. Back in Denmark he was able to fulfil his wish and create large-scale sculptures in the Geometrical Abstraction style, at the same time continuing to work on his 'iron people'.[77]

Asger Jorn

Asger Jörgensen (from 1945 Asger Jorn; 1914-1973), the driving force behind the Danish 'spontaneous' artists and founder of Helhesten, is chiefly known for the extraordinary line of development he achieved in his paintings. His passion for ceramics and working with clay, however, led him to produce many three-dimensional works in the course of his career. And in the last year of his life he made a group of thirty-one sculptures, using the traditional materials of bronze and marble.

Jorn had to struggle to achieve a spontaneous painting technique. The war years saw him gradually breaking free and during the 1950s he was able to surrender himself to the material he was working with. In the period after Cobra, Jorn – like the Dutch painter Karel Appel – expanded the 'Cobra idiom' and infused it with a seething dynamism. It was at the beginning of that new phase that he began working intensively with ceramics.

Although many of the artists associated with Cobra at some time or other worked with ceramics, Jorn was the undisputed master. And as in so many aspects, Picasso once again served as his model. Picasso had fearlessly embraced every type of material and technique, turning to ceramics in 1947. In 1953 Jorn zealously followed his example and his ceramic objects went on to form a major element in his œuvre.[78]

Jorn was particularly interested in the methods of the old pottery trade that he had witnessed in Sörring on Jutland.[79] Sörring had been a pottery centre from way back and Jorn wanted to breathe new life into this place in the same way as Picasso had done at Valauris on the French coast. Shortly before and after the end of the Cobra Movement in 1951, Jorn spent many months in the sanatorium in Silkeborg – the town of his youth – recovering from a severe attack of tuberculosis. In the years of enforced recuperation that followed, he applied himself to mastering the skills of the potter's trade – particularly colouring and glazing – with leading ceramicists. Working with Knud Jensen in Sörring and Niels Nielsen in Silkeborg, in 1953 he decorated hundreds of vases and dishes, some of which had been made to his designs. As he gained confidence in his

32 Asger Jorn working at the Mazotti
ceramics studio in Albisola, Italy, summer
1954. (Photo Henny Riemens).

33 Albisola, summer 1954, left to right:
Matta, his wife, Jorn and Corneille around
a ceramic animal on the ground.
(Photo Henny Riemens).

34 Carl-Henning Pedersen with his bronze
sculptures, Herning, 1966.

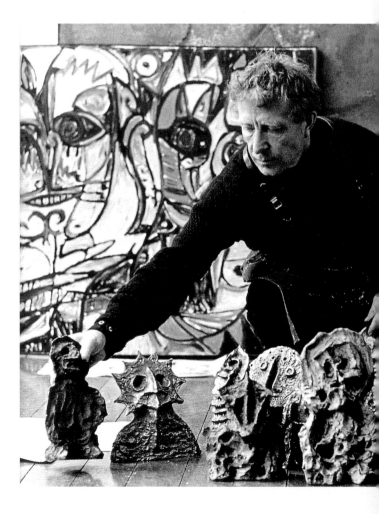

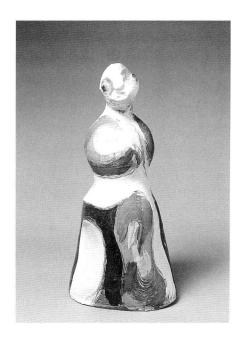

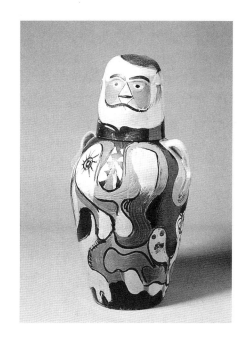

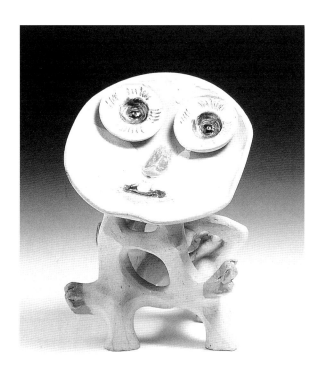

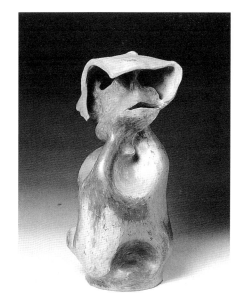

Asger Jorn

35 Kvindekrukke (Pitcher Woman), 1953,
ceramic, h. 77 cm, diam. max. 37 cm. Silkeborg
Kunstmuseum.

36 Vase med laag, formet som hoved
(Vase with Head-Shaped Lid), 1953, h. 77 cm,
diam. max. 37 cm. Silkeborg Kunstmuseum.

37 Maanehunden (Moon Dog), 1953, ceramic,
33 x 25 x 29 cm. Silkeborg Kunstmuseum.

38 Dödshunden (The Hound of Death), 1954,
ceramic, h. 45 cm, diam. max. 30 cm. Silkeborg
Kunstmuseum.

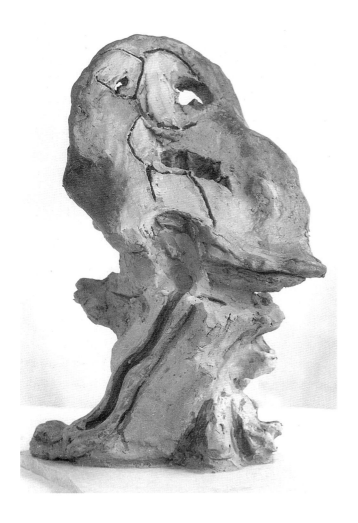

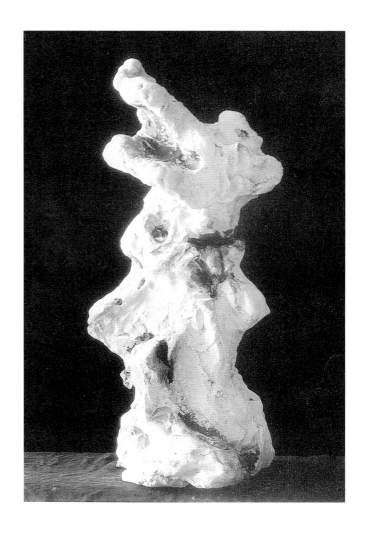

Asger Jorn

39 Seconda Horizonda, 1972, ceramic (model for bronze sculpture), 53 x 20 x 20 cm. Private collection, Milan.

40 Hurlunare (Barking at the Moon), 1972, ceramic, (model for bronze sculpture), 75 x 35 x 35 cm. Private collection, Milan.

skills he started working the surfaces of his objects by scouring, kneading and scratching them, as well as adding layers of clay at the glazing stage (engobe). Thus alongside the many painted pots and dishes whose original form remained unchanged, he also produced a series of works in which he modified the basic form. Examples of this process are Vase with a Head-Shaped Lid (fig. 36), Pot Woman (fig. 35), Animal Vase and the Portrait of Marino Marini on an upturned pot. He also produced a number of fantasy creatures like Moondog (1953; fig. 37) and Moongirl, where only the head retains the suggestion of a flat dish.

The desire to find a greater freedom of expression in this medium had already manifested itself as early as 1933, when, working with the potter Nielsen in Silkeborg, he fashioned a naked female figure in clay that was strongly reminiscent of Matisse's early sculpture. And during the war years he produced six clay or plaster fantasy figures that were shown in the 1944 Höst exhibition.[80] Among the figures from that exhibition still known to us is Untitled, which lies somewhere between Bille's organic forms and Robert Jacobsen's mythic creatures. There is something intangible and enigmatic about it, at once humorous and horrifying. The same could be said of his Varyl of 1952 – an invented word denoting something halfway between a werewolf and a snake – for which he used the kiln of his close friend the potter Erik Nyholm. The freedom with which Nyholm improvised with colour and glaze inspired Jorn in 1953 to start decorating clay objects in a serious way. And it was this painterly interest that gave him the taste for ceramics. The following year he was presented with a wonderful opportunity, from a completely unexpected quarter, to apply all the skills he had mastered in this sphere on a quite different scale.

In the autumn of 1953 Jorn travelled to Switzerland, partly to recuperate, but also because he wanted to be in a different environment.[81] He soon became involved in new activities and that same autumn he founded a movement which he called Movement International pour un Bauhaus Imaginiste (International Movement for a Bauhaus of the Imagination): MIBI. This initiative, set up in opposition to the so-called 'new Bauhaus', the Hochschule für Gestaltung established in Ulm in Germany which had eschewed the liberal arts, was enthusiastically greeted by the Italian artists Enrico Baj and Sergio Dangelo. The latter were both members of the partly Cobra-inspired, avant-garde movement Arte Nucleare, founded in Milan in 1952. Baj and Jorn carried on an intensive correspondence, and it was partly Baj who suggested that Jorn should settle in the small coastal town of Albisola, an ancient pottery centre near Genova. When Jorn moved to this Italian counterpart of Valauris in April 1954, he found not only a house with its own kiln, but he also came into contact with the pre-eminent ceramicist and poet Tullio Mazzotti (who called himself Tullio d'Albisola), who gave him free rein to carry out extensive experiments at his ceramics factory (fig. 32). Albisola had been a centre for experiments in ceramics since the late 1920s, attracting among others the Futurists, and producing work which inhabited the realm of sculpture.[82]

In this inspiring environment Jorn organized in the summer of 1954 a congress of his new international movement, the MIBI, as part of the Incontri Internazionale delle Ceramica (International Ceramics Congress) which was attended not only by Italian artists but also by many former Cobra members (fig. 33). Indeed the event was strongly reminiscent of earlier 'Cobra congresses'. In this atmosphere of communal experimentation the participants felt free to take a bold and innovative approach to working with clay and glazing. Karel Appel worked like a madman, creating animal and human figures from pieces of clay.[83] The congress was rounded off with an exhibition. The following summer Jorn instigated another experiment where children were invited to paint dishes, and Mazzotti again mounted an exhibition, this time of five artists who had created experimental work in his factory. In the surviving photographs of this closing exhibition of 1955 one can make out several dishes and reliefs made by Asger Jorn and Karel Appel, among others.[84]

In Albisola Jorn was soon working with much greater freedom with his material than he had in Silkeborg. In contrast to the pieces he had produced in Silkeborg the previous year, his clay Dödshunden, (The Hound of Death) of 1954 (fig. 38) seems virtually to have abandoned the vase form. This terrifying underworld creature probably encapsulates the sense of the proximity of death that he himself had recently experienced. In Italy Jorn also embarked on a series of reliefs which break down the boundaries between

painting and ceramics. In these pieces, which are often directly or indirectly modelled on one of his own paintings or graphics, he worked the material freely, giving them the name 'sprung' reliefs; possibly a reference to what can happen during the firing process. When creating these pieces he was inspired, among other things, by the ceramic details set into the brickwork of the houses in Albisola. His work of this period shows a strong interaction between his ceramics and his painting. At the time of the so-called Material Art Movement in Europe, Jorn started mixing sand with oil paint.[85] A milestone in his œuvre is the gigantic relief (c. three metres high and twenty-seven metres long) which he made in 1959 in the San Giorgio ceramic workshop in Albisola for the State High School at Aarhus on Jutland. He assembled this relief out of rough irregularly cut pieces of clay and worked on it with such ferocity – he even rode scooter over it (fig. 56) – that he created a deeply furrowed structure. Painting and sculpture (and/or ceramics) are here fused into an enigmatic, glowing kaleidoscope of colour from which emerge the vague interwoven forms of mythic creatures (fig. 55).[86]

During the various periods he spent in Albisola working with ceramics Jorn produced some fifty pieces using this technique, all of which inhabit the realm of sculpture. Some of these free-standing or bas-relief mythical creatures that he improvised out of clay have a certain childlike innocence, like the early Keramisk maske (Ceramic Mask, 1954), Maske fritform (Mask in Free Form, 1954) and Hund (Dog, 1953-1955; fig. 57). Others are distinctly comic, such as the dog-woman Giulietta (1970) with her white hat and bead necklace. Frequently, however, their jeering faces exude something oppressive and spectral, as in the Hound of Death (fig. 38). Egill Jacobsen had picked up on this aspect in an article he wrote in Helhesten in 1941 in which he drew a parallel between Jorn's work and the American writer Edgar Allan Poe's horror stories. A poem of Poe's that was published in this article alongside illustrations of Jorn's work begins with the words 'They are phantoms, disembodied things.'[87] Walking in and around his house in Albisola, which was turned into a museum in 1974, one comes across several of these ambiguous creatures or trolls, which constantly reveal different facets depending on the angle from which they are viewed as, for example, Keramisk Skulptur (Ceramic sculpture, 1954). They form the mysterious inhabitants of this house and grounds that he shaped entirely to his own vision by adding walls and terraces that he designed himself. This misty northern world in the midst of that Latin culture, with its preference for clear forms and colour, is again reflected in his large reliefs both inside and on the outside of the house.

In 1972, the last year of his life, he threw any residual caution to the wind and turned his back on ceramics and their sensuous colours, devoting himself instead entirely to sculpture in its most traditional form. Those light-hearted clay figures he had made earlier and which he self-deprecatingly regarded as a 'joke',[88] seem to have been the precursors of the series of bronze and marble sculptures which came out of the bout of furious activity of that year. He invested his bronze-cast clay models, such as the humorous and dramatic Hurlunare (Barking at the moon, 1972; fig. 40) and Seconda Horizonda (1972; fig. 39), with huge spontaneity and expressivity by keeping the surfaces rough and vigorous. And he was to indulge his passion for colour by applying patina so as to make each cast different. Jorn also made sketches of a few of these sculptures, not as a preliminary study but afterwards, from the clay models.

When searching for suitable marble at Carrara he would choose different coloured pieces that he found somewhere high up in the quarries, abandoned as unsuitable for artistic or industrial purposes. Like Heerup, Jorn had to establish a tangible contact with the material and 'feel the beginnings of a sculpture in his chosen block of stone'. He worked with marble in an unconventional way, drilling many holes in it.[89] Pieces like Last Tango and Burning Problem, which on all sides display fragments of animals and vegetable forms, suggest giant fossils. These final works also exhibit the theatrical figures which were present in his clay improvisations and the bronze work that followed, as in Seduction, for instance, and (his last work) Untitled, a three-headed horse; works which conjure up suggestions of both the Norse myths and the baroque gardens of Bomarzo near Orvieto.

Carl-Henning Pedersen

Carl-Henning Pedersen (b. 1913) who made such an impact on Dutch members of Cobra with his warm colours and the mythical world of his paintings and watercolours when his work was first shown, rarely made three-dimensional objects. Remarkably, perhaps, the same is also true of an artist with whom he was particularly close and with whom he kept in regular contact in the Cobra years: Corneille. While Jorn and Appel articulated a dramatic and turbulently passionate emotional life in their work, Pedersen and Corneille emanated a radiant, childlike happiness, an overwhelming joy expressed in colour and form.

Yet in 1966 Carl-Henning unexpectedly presented a series of forty-four miniature mythical figures relating to those featured in his paintings, formed in clay and cast in bronze (fig. 34), including **Solskive-figur** (Sundial figure) and **Hellig kvindefigur, med dragekrop** (Figure of a holy woman with a dragon's head; fig. 54). Without their bright colours, these diminutive secretive figures with their large round heads occasionally adorned with a wreath of points or rays, like the **Dobbelthoved solfigur med stjernekrans** (Double-headed sun-figure with star wreath), resemble prehistoric finds. Perhaps Pedersen, with his adoration of light, of the sun and from this his fascination with the ancient Persian cult of Mithras,[90] was trying to conjure up the memory of idols of a long-gone solar cult.

Since then Pedersen has regularly focused on painting large-scale ceramics. In these colossal tile panels, he recreartes by his use of colour, (which has matured since the mid-1950s, inviting comparison with Chagall), the infectious joy and warmth of his paintings. In 1966-68 he covered a huge wall five metres high and two hundred and twenty metres long with his gigantic dream birds for the Angli factory at Herning on Jutland which acquired official museum status in 1976. A similar ceramic panel made by Pedersen in 1976 covers the outside wall of the circular museum building near the Angli factory, which is exclusively dedicated to the artist's work and that of his wife Else Alfelt, who died in 1974. He has since made a number of other walls, at the ceramics studio Struktuur '68 in The Hague.

In 1993-94, Carl-Henning created forty ceramic sculptures at Copenhagen's famous Koninklijke Keramiekfabriek (the Royal Copenhagen), for whom he had painted a series of jugs and dishes in the early 1990s. These are small radiant mythical creatures, with supple forms, bright colours and a shiny glaze giving them a particularly vibrant quality.

1 This he did in a manifesto-like text: 'L'expérience est dans la vie' (Experience is part of life), in Cobra, no 1, Copenhagen, 1949, p. 11.

2 I have discussed the first and second waves of 'primitivist expressionism' that I have identified in twentieth-century art, in my article 'Der dynamische Bund mit der Materie', in Hans Mathäus Bachmayer- Otto van de Loo (ed.), Am Anfang war das Bild, (Eine Ausstellungscatalog der Galerie van de Loo) Villa Stuck, Munich, 1990, pp. 131-165.

3 See Peter John Shield, BA, AIL, Spontaneous Abstraction in Denmark and its aftermath in Cobra 1931-1951, A PhD thesis submitted to the Art department at the Open University, Dec. 1984, Nottingham, England, pp. 31-34. Unpublished. (Copies kept at University Library, Leiden and Cobra Museum for Modern Art, Amstelveen).

4 See op. cit., (note 3) p. 35, which notes that they also knew of the equally richly illustrated Le Surréalisme au Service de la Révolution, which started in Paris in July 1930. They probably also read the Surrealist magazine Documents, as mentioned in: Troels Andersen, 'Malerne omkring "Linien"', in Signum, vol. 1, no 2, 1961, p. 17.

5 See Linien, vol. 1, no 3, March 1934, p. 6. In the facsimile edition of this magazine (Esbjerg, 1984) this is on p. 42. Both page references are given below. On p. 15 of the same issue a piece about the importance attached to Minotaure, which, apart from being read by the readers circle of the Arts and Crafts Museum, was also available over the counter at Illum book shop.

6 See André Breton, 'Picasso dans son élément', in Minotaure, vol. 1, no 1, 1993, pp. 4-38. The illustration in question is on page 36. Linien, vol. 2, 1935, no 8-9, p. 7 (p. 111) quoted from Minotaure (no. 5) – a reproduction of Marcel Duchamp's Mona Lisa with Moustache! In the same issue of Linien, p. 16 (p. 120) the 1935 winter issue of Minotaure (no 6) was also discussed.

7 Vilh. Bjerke-Petersen, 'Pourqoi je suis Surréaliste', in Cahiers d'Art, vol. 10, no V-VI, 1935, p. 136.

8 See Eiler Bille, 'den internationale kunstudstilling i köbenhavn 1935 (kubisme=surrealisme) kritik', in Linien, vol. 2, Feb. 1935, no 10, pp. 3-6 (pp. 123-126). André Breton contributed an introduction to the exhibition catalogue which was written for the Surrealist exhibition of that year in Tenerife. This introduction was subsequently published under the title 'Préface aux expositions surréaliste de Copenhague et de Tenerife', in Cahiers d'Art, vol. 10, 1935, pp. 97 and 9.

9 Together with their own work, they showed work by Miró, Sophie Taeuber Arp, Hans Arp, Max Ernst, Tanguy, Mondrian, Klee and John Ferren.

10 See Mette Nörredam, 'Carl Kjersmeier', in Louisiana Revy, theme issue 'Den globale dialog, primitiv og moderne kunst' ('The global dialogue, primitive and modern art'), vol. 26, no 3, 1986, pp. 27. This issue served as a catalogue for an exhibition in which chiefly Danish modern art was shown beside examples of primitive art.

11 See Torben Lundbaek and Poul Mörk, 'Kjersmeiers samling' (Kjersmeier collection), and Knud Lundbaek , 'Kjersmeierne i trediverne' (Kerstmeiers in the 1930s) in op. cit., (note 10) resp. pp. 27-30 and pp. 31.

12 Carl Kjersmeier, 'Bambara, Sudan, Fransk Vestafrika', ('Bambara, Sudan, French West Africa'), in Helhesten, vol. 2, no. 2-3, (10-3-'43), pp. 35-40.

13 On his marriage to Mette Gad, with whom he had five children, see the catalogue of the Gauguin exhibition at Galeries Nationales du Grand Palais, Paris, Jan.-April, 1989, Isabelle Cahn 'Chronology': pp. 34-37, 70, 75 and 77. Mette Gad (1850-1920) was active in the Danish art world, as were her children and grandchildren. See op. cit., (note 3) p. 11 and p. 11 note 24.

14 The Nabists were grouped around the symbolist literary journal Taarnet, (Tower). See op. cit., (note 3) p. 11, and p. 11 note 26; also Mette Nörredam, 'Primitivism i dansk kunst', in op. cit., (note 10) p. 16.

15 See the articles cited under note 10, 11 and 14 and the publication cited under note 10; pp. 16, 17, 20, 27 and 30.

16 See op. cit., (note 3) 'Chapter V: Mask Pictures', pp. 77-109.

17 See op. cit., (note 3), p. 91.

18 See Nörredam: op. cit., (note 10) p. 21; and Shield: op. cit., (note 3) p. 92. In note 86 on p. 92 Shield remarks that Jorn's sketchbook is kept at the museum in Silkeborg. In the accompanying note (87) he cites the following publications by Danish artists about the Musée de l'Homme: Robert Dahlmann Olsen & Asger Jörgensen, 'Meneskets museum', Copenhagen, Nyt Tidsskrift for Kunstindustri, vol. XII, 1939, pp. 5-7; Ejler Bille, 'Kunstindtryk fra meneskets museum', Copenhagen Nyt Tidskrift for Kunstindustri, vol. XII, 1939, p. 8; and Ejler Bille, 'Nyaabnet afdeling af gammel amerikansk kunst i 'menneksetsmuseum', Trokadero, Paris', Copenhagen, Nyt Tidskrift for Kunstindustri, vol. XII, 1939, pp. 117-119.

19 See Mette Norredam op. cit., (note 14). In this article she discusses the influence this 1938 exhibition of Oceanic art had on the work of the Danish Experimentalists at length.

20 See Peter Shield, 'The War Horses. The Danish Reaction to Guernica', in Jong Holland, vol. 7, no 2, 1991, pp. 12-28. This article focuses extensively on the response of the Danish Experimentalists to the confrontation with Picasso's Guernica.

21 For more general information about Danish sculpture reference was made to Vagn Poulsen, Danish Painting and Sculpture, Det Danske Selskab, Copenhagen 1976, pp. 36-49, 150, 152, 158; and Henrik Bramsen and Knud Voss, Dansk Kunst Historie 5. Billedkunst og Skulptur. Vort eget aarhundrede. Efter 1900 (Danish Art History 5. Painting and Sculpture. Our own century. After 1900), Copenhagen 1975, pp. 26-38, 113-116, 126-129.

22 Ejler Bille 'Abstrakt Dansk Skulptur', Helhesten, vol. 2, no 5-6, 1944, pp. 157-165.

23 See op. cit., (note 3), p. 35.

24 See Asger Jorn og 10.000 aars Nordisk Folkekunst (Asger Jorn and 10,000 Years of Northern Folk Art), which accompanied a similarly named exhibition at the State Museum in Copenhagen and the Silkeborg Museum of Art in Silkeborg, April-May 1996. Here these statuettes from the so-called hunter-gatherer/stone age are illustrated on pp. 6 and 7.

25 See op. cit., (note 3), p. 37.

26 While this piece, which Bille began to make in the garden of Richard Mortensen's parents, was never completed, he nevertheless considered it important enough to allow its publication in this form, for example in 'Komentar til mine skulpturer', ('Commentary on my sculpture'), which he wrote and illustrated and which appeared in Signum, vol. 1, 1961, no 3, pp. 3-20.

27 Bille probably also experimented with three-dimensional work using paper, as a reproduction of one such work by him in his article in *Helhesten*, op. cit., (note 22) suggests. No other information about this has been found.

28 See for example, *Figur i rum*, (Figures in Space), Paris 1938, fig. 9, in Poul Vad, *Ejler Bille*, Copenhagen, 1961, (text in Danish and English).

29 See op. cit., (note 20), p. 15.

30 Carl-Henning Pedersen assured me in June 1996 during an interview, that Danes use the word Höst for autumn, even though the Danish dictionary gives the word 'harvest'. He was emphatic that it should not by any means be translated as harvest (as I have in the past).

31 In the article on Bille by Carl Henning Pedersen in *Helhesten* vol. 2, no 2-3, pp. 57-61, his sculpture is mentioned, although paintings and drawing feature in the illustrations.

32 A single sculpture, *Vogel*, from 1933, was reproduced in *Cobra*, no 2, March 1949, Brussels, p. 2, although erroneously attributed to Sonja Ferlov. In the fifth section of the *Bibliothèque de Cobra*, (Copenhagen 1950) Bille, with text by Michel Ragon, only the artist's paintings are presented. However, Dotremont did mention a plan to devote a future volume (never materialised) in the *Bibliothèque de Cobra*, (i.e. in the third series on the visual arts) to Bille as sculptor. (See W. Stokvis, 1974, op. cit.. in Inleiding (note 4), p. 103). Only three paintings by the artist were shown at the major Cobra exhibition of November 1949 in Amsterdam. No works by the artist were exhibited at any other Cobra shows.

33 Henry Heerup, 'Heerup', in *Linien*, vol. 1, no 1, 1934, p. 11 (p. 19 in facsimile dated 1984).

34 See Virtus Schade, *Henry Heerup*, Copenhagen, 1967, p. 106.

35 Idem, pp. 81 and 82.

36 See preben Wilmann, *Heerup*, Copenhagen, 1962, p. 45.

37 For the information cited here see op. cit., (note 34), pp. 31-41, and op. cit., (note 36), pp. 31 and 32.

38 See Henrik Bramsen and Knud Voss, op. cit., (note 21), pp. 30 and 31, and op. cit., (note 36), p. 38.

39 A similar undated *Female torso* (40 cm) carved by Heerup from soapstone (K.P. van Stuyvenberg collection) was placed beside a *Seated female figure* from the Thule culture, Angmassalik, Greenland, (wood, 7 cm, State Museum Copenhagen), by Ronald A.R. Kerkhoven in his book *Het Afrikaanse Gezicht van Corneille*, Abcoude, The Hague 1992, pp. 40 and 41, and in his thesis of the same title, Nijmegen 1995, p. 35, in which he also noted that much of Heerup's work is 'remarkably similar to the art of the Inuït of Greenland'.

40 Kerkhoven, op. cit., 1992 (note 39), pp. 40 and 41 placed this work by Heerup beside a *Seated male figure*, Mabila, Cameroon, wood, 27 cm, Pierre Harter collection, Paris.

41 Christian Dotremont, *Heerup*, Bibliothèque de Cobra, no 12, Copenhagen, 1950.

42 See op. cit., (note 36), p. 37.

43 See Henry Heerup, 'Skraldemand & "Skraldemodel" (Scavenger and "debris" art) in *Helhesten*, vol. II, no 4, 24-12-'43, p. 94.

44 See Marcel Jean, *The History of Surrealist Painting*, New York, 1967 (1st imp. 1967), (appeared originally in French, Paris, 1959), chapter VII 'Glory of the object'.

45 Idem, p. 230. On the background of the Surrealist object see the paragraph on 'Eugène Brands' in the chapter 'Nederland' of this publication.

46 See op. cit., (note 36), p. 37.

47 I have only recently realised that it was probably at the 1966 Cobra exhibition that I organised for Museum Boymans-van Beuningen in Rotterdam, which subsequently visited the Louisiana Museum, Humlebaek (Denmark), that they were first shown in a Cobra framework.

48 Ole Sarvig in 'Kunstrunde', *Information*, 30-1-1952, cited by Troels Andersen, *Sonja Ferlov Mancoba*, Borgen (Denmark), 1979, p. 36. Considerable use was made of this book. See also Christian Dotremont, *Sonja Ferlov*, in the *Bibliothèque de Cobra* series, no 9, Copenhagen, 1950.

49 See Troels Andersen, 'Sonja Ferlov-Mancoba', in *Signum*, vol. 2, no 3, 1962, p. 44. The Surrealists were the first to develop this idea, merging Marxist social idealism with their own artistic expression. The artists of *Helhesten* and *Cobra*, took up this idea. See op. cit., in Inleiding (note 4), pp. 85-88.

50 Ferlov published memoirs about this period in *Billedkunst*, no 2, 1966, p. 11, cited in Andersen, op. cit., (note 48) p. 27, note 13.

51 See Richard Mortensen, 'Sonja Ferlov. Om den spontane metode til irrationel erkendelse' (Sonja Ferlov. On the spontaneous way of recognising the irrational), *Julefluen*, (special issue of *Linien*, vol. 1935), text based on an exhibition of two sculptures and a collection of unusual 'living pieces of wood' by Sonja Ferlov, in Odense, August 1935.

52 See illustration in Andersen, op. cit., (note 48).

53 Idem, p. 27. Bille published an article during the war on the early work of Giacometti 'Alberto Giacometti', in *Helhesten* vol. I, pp. 79-81, containing two photo illustrations probably borrowed from *Minotaure*, vol. I, no 3-4, 1933, pp. 46 and 47. The photo of *Het paleis* from 1932 by Giacometti and his accompanying article were certainly adapted for *Linien* vol. I, no 2, Feb. 1934.

54 See also Marja Bloem, 'Sonja Ferlov Mancoba', in *Bulletin Stedelijk Museum Amsterdam*, Feb. March. 1995, pp. 16 and 17, accompanying an exhibition of c. thirty sculptures by Ferlov in the context of *Couplet 4*, a show at the Stedelijk Museum in Amsterdam at the same time.

55 See op. cit., (note 48), p. 30.

56 The Ferlof volume in *Bibliothèque de Cobra* series, op. cit., (note 48) features a titlepage photo with various sculptures by her that are now lost, many destroyed by the artist.

57 See Poul Vad, *Erik Thommesen*, Copenhagen, 1964, (text in Danish and English), p. 34. This publication was also used here, although the perspective on these artists is different.

58 In Asger Jorn's planned second series of the *Bibliothèque de Cobra*, which never materialised, one volume would have been devoted to Thommesen. See Stokvis, 1974, in Inleiding (note 4), p. 103, note 4.

59 See Ernst Mentze, *Robert Jacobsen*, Copenhagen, 1961, pp. 74 and 75.

60 See Xavier Girard, 'Là, Là et Là', in the catalogue *Robert Jacobsen Rétrospective*, June-Aug. 1991, Abbaye Saint-André, Meymac, France, subsequently shown in Aug. 1992 in Le-Cateau-Cambresis, Rodez, Saint-Priest and Evreux, p. 24.

61 See op. cit., (note 59) pp. 46, 47,49, 61, 62, 72, 74, 75, 77, 80, 81.

62 Idem (Mentze), pp. 84, 89 and 90.

63 See Robert Jacobsen, 'La sculpture dans tous états', (extraits de l'entretien avec Jean Clareboudt) in the catalogue Robert Jacobsen-Parcours, Musée Rodin, 1985, in op. cit., (note 57), p. 142; and Thorsten Rodiek, 'L'obscure contrainte devenant figure. Notes sur l'évolution de l'œuvre sculpturale de Robert Jacobsen', in the catalogue Robert Jacobsen, Städtische Kunsthalle Mannheim, 1987, in French translation in op. cit., (note 60), p. 159.

64 Mieke Sanders, who followed a project course – 'Cobra and Primitivism' – which I gave at Leiden University in spring 1997, discovered a remarkable similarity between the figure Björen, (Beer, 1944) by Jacobsen (Erik Andreasen collection, Copenhagen) and the Kaagtagtorjajik masker, (c. 1940) from Greenland (private collection). They both have the same long, crooked nose. See op. cit., (note 24), p. 14; also Ib Geertsen, Grönlanske Masker (Greenlandic Masks), Rhodos Intern Science Art Publishers, 1981, including the mask on p. 105. In Helhesten, vol. I, p. 76-78, an article appeared on 'Östgrönlandske aandemanermasker' (East-Greenlandic ancestor masks) by archeologist Gitz Johansen.

65 See op. cit., (note 59) p. 126.

66 Unlike Helhesten, which folded when funds ran out in 1944, it received a subsidy and continued to appear until 1950. See op. cit., (note 3) pp. 123, 124, 127, 130 and 137.

67 See W. Stokvis, 1974, op. cit., in Inleiding (note 4), p. 48.

68 See op. cit., (note 63), p. 141, op. cit., (note 59), p. 144 and 145. In retrospect, various French former Revolutionary Surrealists would join Cobra, especially Jacques Doucet, who met the group via Corneille and Appel, as well as Atlan, whose studio in Paris was a meeting place for Danish and Dutch artists. It remains questionable whether Jorn and the Dutch Experimentalists were aware of the essentially political infighting between Dotremont and the French (former) Revolutionary Surrealists, which led Dotremont to distance himself from this Parisian group. See W. Stokvis 1974, op. cit., in Inleiding (note 4), pp. 47-50 and 76-82. Another important reason for the separation was that in Denmark Jorn and Mortensen were the two leaders in the art world. They both had their own terrain and would have been out of place in a movement. Jacobsen was a friend of Mortensen and was therefore thought of as belonging to the other side. This was told to me by the bye.

69 See op. cit., (note 60), p. 36 and 115, and op. cit., (note 59) fig. p. 33 (on this photo, taken in 1949, Jacobsen is seen with a work by him featuring a cage construction containing a lunar shape on a socle).

70 See op. cit., (note 59), pp. 155-171, 196 and 200.

71 See interview with Jacobsen op. cit., (note 63), p. 141, and op. cit., (note 59), p. 208.

72 See op. cit., (note 59), p. 208.

73 See op. cit., (note 59) pp. 240-270.

74 This comparison was thought of by Mieke Sanders, see note 64; The piece reffered to is illustrated in W. Rubin (ed.) 'Primitivism' in 20th-Century Art, the Museum of Modern Art, New York 1984, vol. I, p. 232.

75 In that case, the patron would probably have asked Loke and his Companions to be cast in bronze by Jacobsen.

76 See Niels Lergaard, 'Myten', in Helhesten, vol. I, 1941, p. 65.

77 See op. cit., (note 59), p. 82, and the illustrations of his later 'iron people'.

78 See W. Stokvis, 'Cobra en de keramiek', ('Cobra and ceramics') in the catalogue Alles van waarde is weerloos. Cobrakeramiek uit de periode 1948-1959, Museum Het Kruithuis, 's Hertogenbosch, 1993, pp. 11-29. This article was included almost entirely in: Janet Koplos, Max Borka, Willemijn Stokvis and Jos Poodt, The unexpected. Artists'Ceramic of the 20th Century, The Kruithuis Museums collection, Het Kruithuis, 's-Hertogenbosch, Abrams, New York, 1998.

79 See Asger Jorn, 'Indtryk af Silkeborgegnens pottemageri', ('An impression of the potter's art in Silkeborg'), in Dansk Kunsthandvaerk, Copenhagen, XXVII, 1. Jan. 1954, pp. 11-15.

80 See the catalogue of the Höst exhibition of 1944. Here objects nos. 176-81 are called Sculptures in clay or plaster. Two of these are thought to have been recovered. See Ursula Lehmann-Brockhaus, 'Chapter 4: Sculpture', in Guy Atkins, Asger Jorn The final years 1965-1973, London, 1980, p. 79 and fig. 99. Considerable use was made of this entire chapter.

81 See Ursula Lehmann-Brockhaus, 'Incontro internazionale della ceramica, Alsbissola, Sommer 1954', in the catalogue Asger Jorn. keramik, Silkeborg Museum of Art/Badisches Landesmuseum Karlruhe, 1991, in Danish and German, p. 93.

82 Idem, pp. 94, 95.

83 See Simon Vinkenoog, Het verhaal van Karel Appel. Een proeve van waarneming, Utrecht 1963, p. 127.

84 A photo of this exhibition was reproduced in a series of pictures under the title 'Première expérience du Bauhaus Imaginiste', in: Asger Jorn, Pour la Forme, edité par l'Internationale Situationniste, Paris, 1958, p. 20. Much of this is work that was made in 1954 in Albisola. Matta, one of the other exhibitors, made the poster. Another photo of this 1955 exposition was reproduced (with an erroneous date: 1954) in op. cit., (note 78). I do not know where the photo originated. In W. Stokvis, Cobra. Il contributo olandese e i rapporti con l'Italia, Florence, 1987, Matta's poster is included on p. 52, clearly showing the date to be 1955.

85 See Troels Andersen, 'Das Bild aus Ton – Die Keramik Jorns 1953-1954', in op. cit., (note 81), pp. 74 and 75.

86 See Erik Nyholm, 'Chapter 7: Ceramics', in Guy Atkins, op. cit., (note 80), pp. 75-87, and Erik Nyholm, 'Das grosse Relief', in the catalogue Asger Jorn. Keramik op. cit., (note 81), pp. 33-37 (text in Danish and German).

87 See Egill Jacobsen, 'Asger Jörgensen', in Helhesten, vol. I, no 4, 18-11-1941, pp. 104-107.

88 See op. cit., (Lehmann-Brockhaus) (note 80), p. 102.

89 For information contained in this passage see Ursula Lehmann-Brockhaus op. cit., (note 80), pp. 112, 113; also the photo album with text by Mario De Micheli and photos by Mario Recrosio, Jorn Scultore, Milan 1973.

90 See my article 'Carl-Henning Pedersen een mythescheppend kunstenaar' ('Carl-Henning Pedersen a "myth-creating" artist'), in the catalogue Carl-Henning Pedersen, Cobra Museum for Modern Art, Amstelveen, 1996, pp. 11-21 and 63-73.

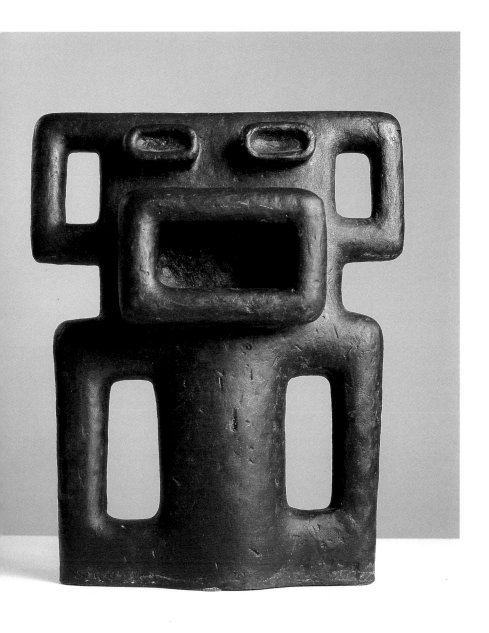

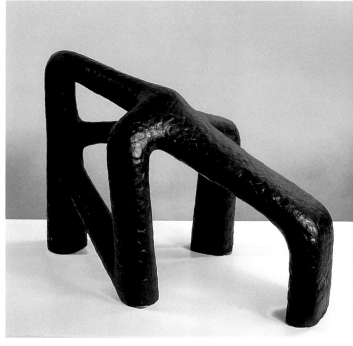

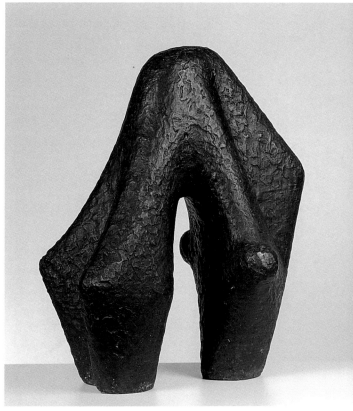

Sonja Ferlov

41 Maske (Mask), 1939, bronze (original plaster), 35.5 x 28.5 x 14.5 cm. Cobra Museum for Modern Art, Amstelveen.

42 Skulptur (Sculpture), 1951, bronze (original plaster), h. 32 cm. Cobra Museum for Modern Art, Amstelveen.

43 Stille vaekst (Quiet Growth), 1962, bronze (original plaster), 44.5 x 37 x 29 cm. Cobra Museum for Modern Art, Amstelveen.

Henry Heerup

44 Prins Tonde (Prince Ton [Barrel] or
the Carnival Prince), 1943, painted granite,
h. 77 cm. Professor Erik Andreasen
collection, Lyngby (Copenhagen).

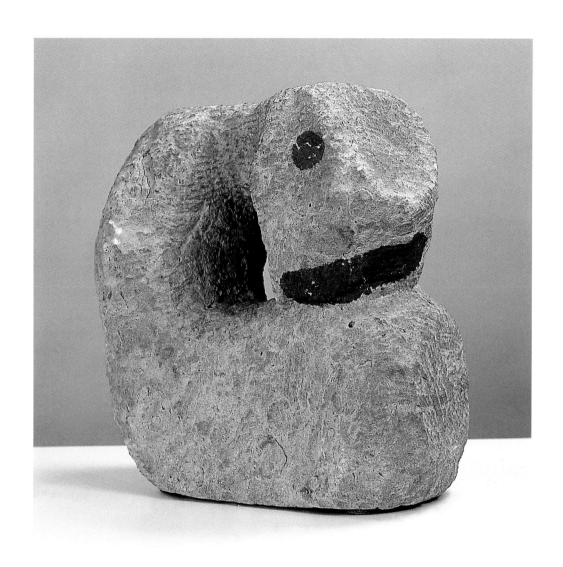

Henry Heerup

45 Cobraslange (Cobra Snake), 1950,
painted granite, 30 x 28 x 17 cm. Cobra
Museum for Modern Art, Amstelveen.

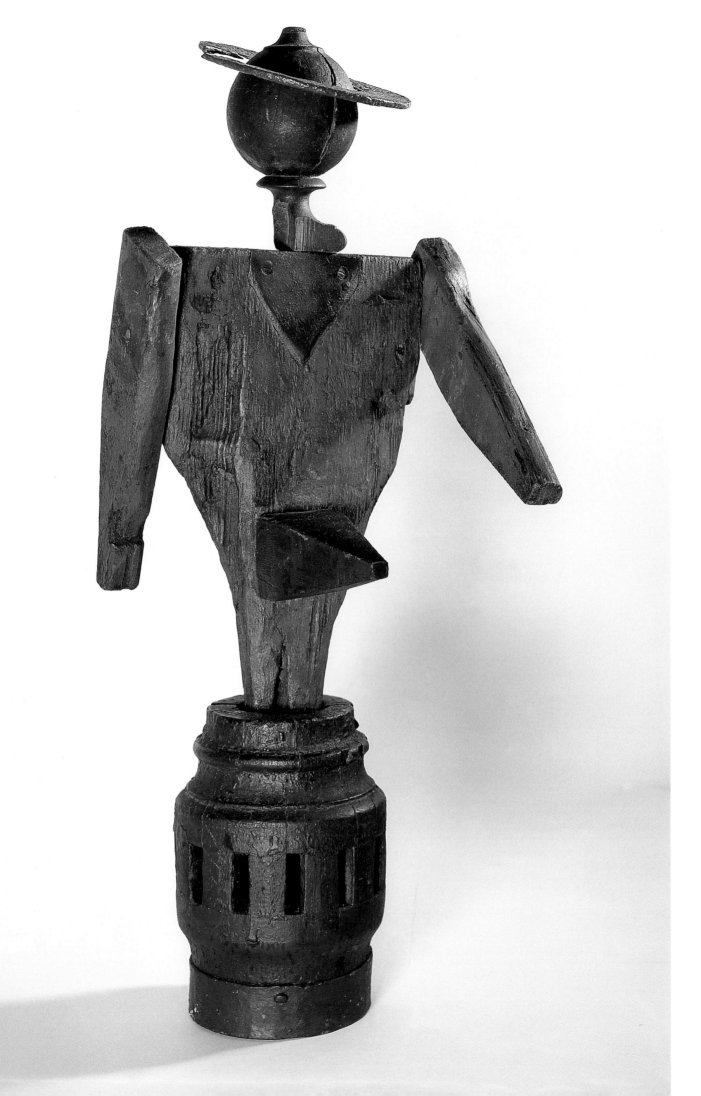

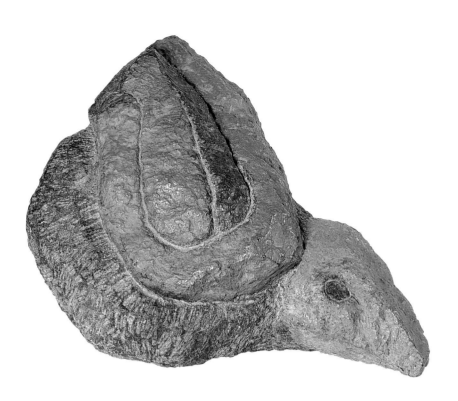

Henry Heerup

46 Nissemand (Goblin), 1943/1944, iron and painted pine and beech, 61 x 22 x 25 cm. Galerie Nova Spectra collection, The Hague.

47 Coloured Bird, c. 1955, painted diabase, 28 x 45 x 37 cm. Ellen and Jan Nieuwenhuizen Segaar collection, Antwerp.

48 Woman as Temple, 1951, granite, 46 x 26 x 11 cm. Ellen and Jan Nieuwenhuizen Segaar collection, Antwerp.

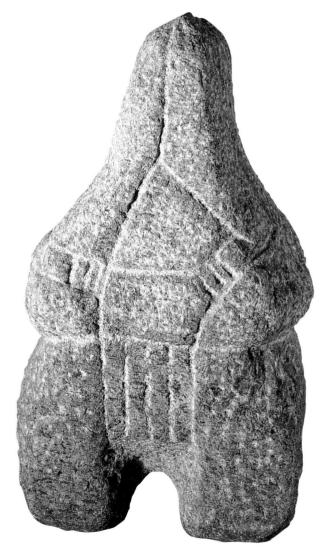

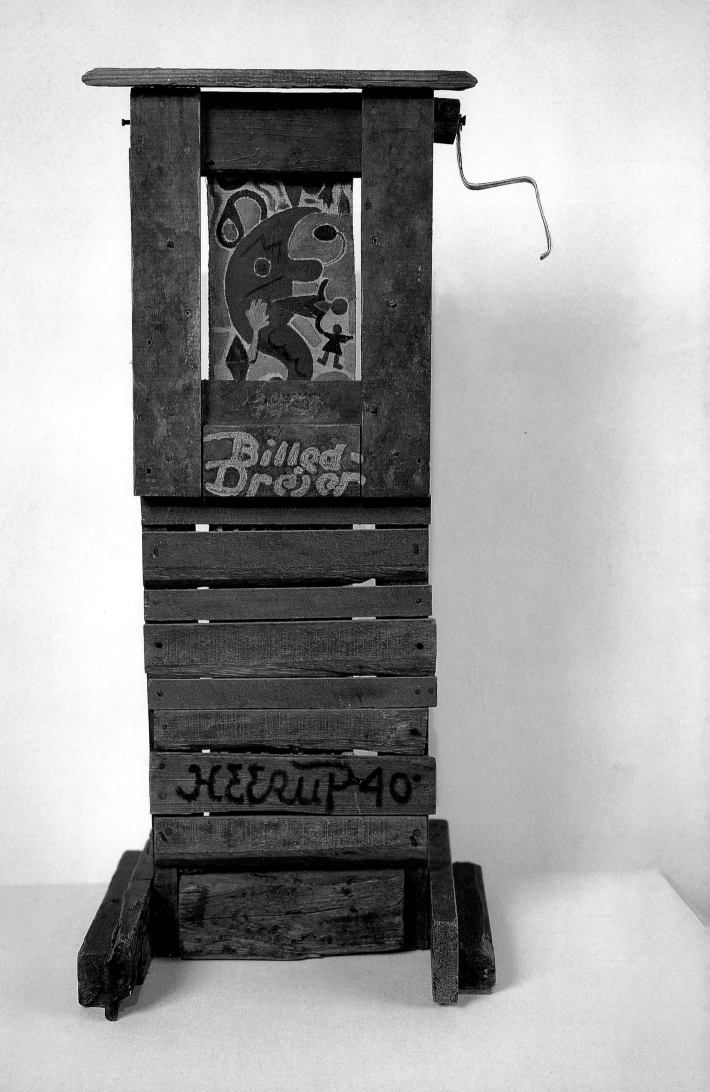

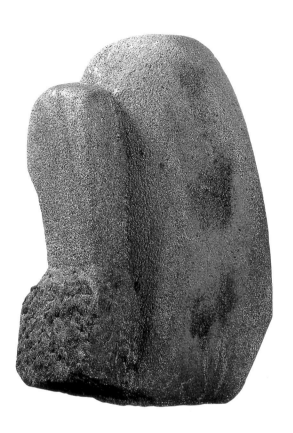

Henry Heerup

49 Billeddreijer (Picture Mill), 1940,
oil on canvas on wood support, 77 x 37 cm.
Albert-Jean and Philippe Niels collection,
Brussels.

Erik Thommesen

50 Head, 1945, granite, h. 95 cm. Cobra
Museum for Modern Art, Amstelveen.

Ejler Bille

51 Gående figur (Walking Figure), 1948,
bronze, 30 x 30 x 15 cm. Cobra Museum
for Modern Art, Amstelveen.

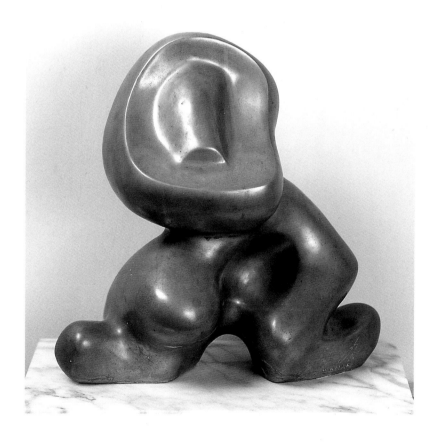

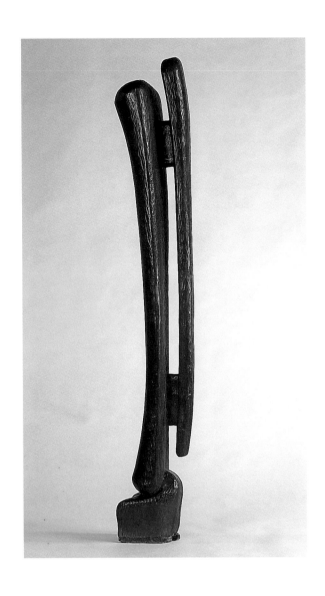

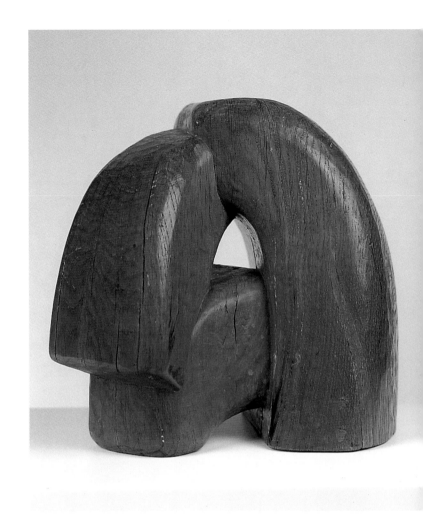

Erik Thommesen

52 Man, 1949, wood, h. 135 cm. Cobra
Museum for Modern Art, Amstelveen.
53 Head, 1951, wood, 27 x 30 x 20 cm.
Cobra Museum for Modern Art,
Amstelveen.

Carl-Henning Pedersen

54 Figure of a Holy Woman with a
Dragon's Body, 1966, bronze, h. 38 cm.
Carl-Henning Pedersen og Else Alfelts
Museum, Herning, Denmark.

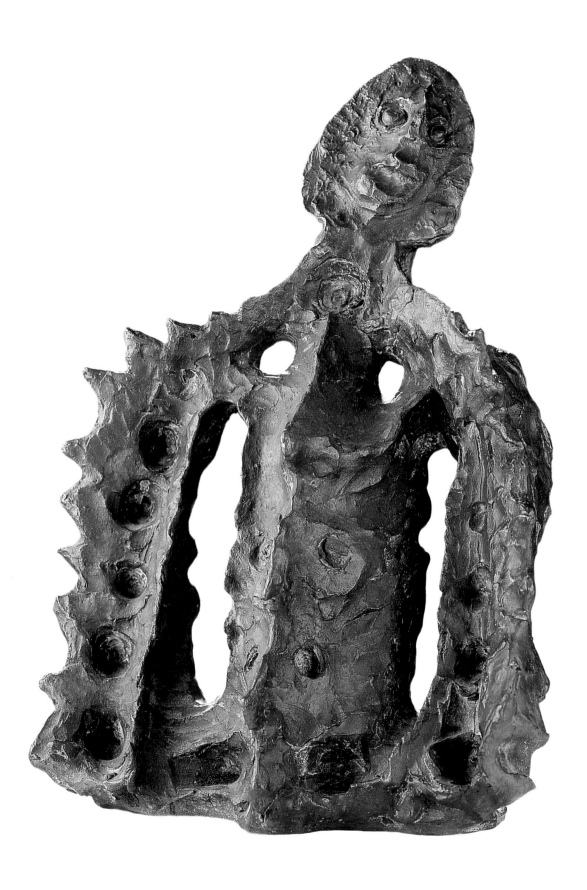

Asger Jorn

55 Det store relief (Great Relief; detail), 1959, ceramic, total size relief c. 3 metre high and c. 27 metre wide. Staatsgymnasium Aarhus, Denmark.

56 Asger Jorn working in clay on a scooter at San Giorgio ceramic studio in Albisola making a large ceramic mural relief, completed in 1959 for the Staatsgymnasium in Aarhus, Denmark.

57 Dog, 1953-1955, ceramic, 21 x 26.5 x 14 cm. Galerie Moderne collection, Silkeborg, Denmark.

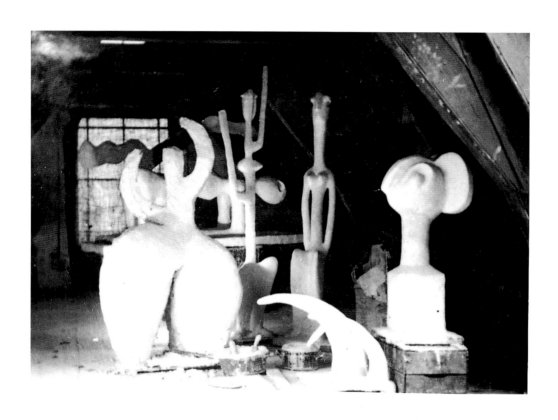

58 Karel Appel, Amsterdam 1947.
Oudezijds Voorburgwal studio with plaster
sculptures.

CoBrA The Netherlands

Historical background

During the postwar era the Cobra movement played a key role in making the cultural climate in the Netherlands more receptive towards new artistic developments. The line that director Willem Sandberg followed at Amsterdam's Stedelijk Museum also played a crucial role in this. Until the mid-1950s, the artistic climate in Holland was still extremely restrained. In retrospect, it is clear that Dutch members of the Cobra movement played a pioneering role in both painting and sculpture in the Netherlands. In the immediate postwar years, little attention was paid to experimental sculpture or assemblages. In such an uninspiring atmosphere, the artists themselves did not as yet view their attempts in this direction as objects to be preserved. As a result many of the early pieces were lost, and so the contribution of Dutch Cobra artists in the field of sculpture went unnoticed for a long time.

It is evident from the well-known art historian A.M. Hammacher's seminal and still relevant book on sculpture *Beeldhouwkunst van deze eeuw* (Sculpture this Century), which appeared in 1955, that for many years after the war sculptors were only noticed once they had fulfilled commissioned works. Only a few independent, pioneering outsiders are highlighted by this expert on Dutch sculpture in the form of an illustration. Representing the interwar years are the painters Herman Kruyder and Hendrik Chabot, who carved rough peasant figures in wood in the 1930s. Kruyder, from whom, apart from a few small modest sculptures, only one work is known – which he also painted – was clearly inspired by German Expressionism, particularly *Die Brücke,* while Chabot's work evokes that of the Flemish Expressionists.[1] For the postwar period, Carel Visser, who tended towards abstraction early on in his career, is represented by a bird sculpture he welded from iron. He was inspired in this technique when seeing the work of Gonzalez for the first time in the exhibition *13 Sculptors from Paris* held at the Stedelijk Museum in late 1948/early 1949.[2] In Hammacher's book one also comes across the name of Lotti van der Gaag, who worked entirely from imagination, mixed in Cobra circles and at first worked predominantly as a sculptress. The main line of development in sculpture, however, either completed or unrealised, is exemplified by artists who became known for their commissioned pieces, and who worked in the traditionally acceptable materials for sculpture: stone, bronze or occasionally wood. The same can be said about the postwar innovators the author singles out. As pioneers of modern sculpture, he mentions Willem Reijers and Wessel Couzijn, both of whom leaned towards abstraction in their designs for war memorials – the one sculptor working in a symbolical manner, the other in a more expressionist style.

Holland is not traditionally a nation of sculptors. The few prominent artists such as Claus Sluter, mainly active in Dijon during the fourteenth century, Hendrick de Keyser (also a leading architect) working from around 1600, and the Flemish Artus Quellinus and Rombout Verhulst, both active in the Netherlands in the seventeenth century, were unable to establish the same kind of tradition in sculpture as the country enjoyed worldwide for painting. In a matter-of-fact country such as the Netherlands, people rarely felt any need for monuments and even small commissions were rare. Around 1800 the opportunities for sculptors became even more scarce as less use was made of them to decorate ships and buildings.[3] It is precisely in this field, however, with the revival of Catholicism in mid-nineteenth century Holland, that demand was once again created for the sculptor. The growing ideal within architecture at the time was the idea of creating a synthesis of arts and crafts, one which would also be in the service of society. This ideal was given the catch-all term *Gemeenschapskunst* or Social Art and was meant to produce a much wider field of opportunity for sculptors than the fulfilling of commissions for Catholic churches. Under the influence of the English theorist and craftsman, William Morris, who championed the drawing together of Socialism and Art, this was a field that would embrace society as a whole.[4]

During the interwar years this particular social ideal was to have its own special development in the Netherlands with so-called 'building sculpture art' for the architecture of the Amsterdam School style. The sculptor Hildo Krop played a prominent role here with his many decorative carvings in this architectural style depicting humankind in all its manifestations of daily toil. These works were mainly produced in his capacity as town sculptor for Amsterdam from 1916 until his death in 1970.[5] It was partly through the efforts of

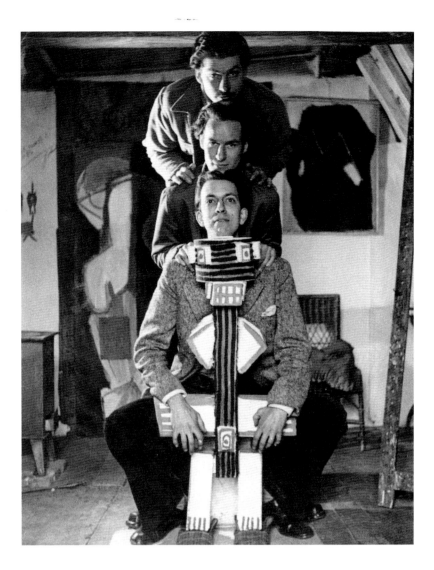

59 Top to bottom: Karel Appel, Corneille and Constant posing with a (lost) totem pole by Appel at his studio on Oudezijds Voorburgwal, Amsterdam 1948.

Eugène Brands

60 Self Portrait with Bird Cage, 1941, photo.

61 The 'Experimental Group in Holland' partying at Karel Appel's studio, autumn 1948. Left to right: Anton Rooskens, Jan Nieuwenhuijs, Eugène Brands, Karel Appel, Theo Wolvecamp; bottom: Corneille, poets Gerrit Kouwenaar and Jan Elburg, and Constant, (Lucebert missing). Unusual objects add to the fun: Constant is playing a guitar in which an axe keeps chopping. (Photo Ru Melchers).

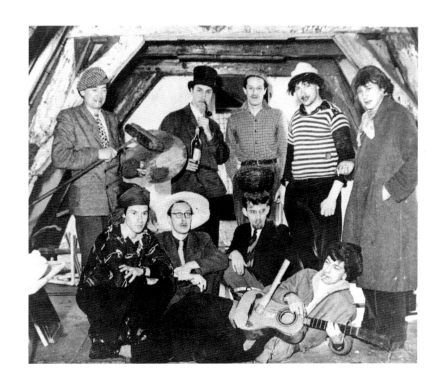

influential artists such as Richard Roland-Holst and Jan Bronner, who during the interwar years held sway at Amsterdam's State Academy of Fine Arts as professors of monumental art and sculpture respectively (Roland-Holst: 1918-34 and director from 1926; Bronner 1914-1947), that the Netherlands was held spellbound for decades by the nineteenth-century ideal of socialist thought.[6] An ideal both artists fervently championed, each in his own way.[7] This was also the driving force behind De Stijl (1917-1930), the movement with which the Netherlands made a fundamental contribution to the twentieth-century international avant-garde art. This movement, however, which was inspired by Constructivism and cool, geometric abstraction, did not have any Dutch sculptors in its ranks. In many other areas of art and society people were fired with a similar enthusiasm as that which drove these artistic movements towards an ideal based on educating people in a philosophical and aesthetic sense. At the same time a general yearning for tradition prevailed in our country, which was devoted to the fame of the nation's own seventeenth-century painting. This must undoubtedly explain the fact that, despite having produced a movement such as De Stijl, the Dutch were still not open to such innovative trends as abstraction. There was virtually no interest in, for instance, the 1938 exhibition Abstract Art held at the Stedelijk Museum which included works by the sculptors Arp, Bill, Brancusi, Calder, Hepworth, Moore and Vantongerloo (a Belgian member of De Stijl).[8] There appeared even less for the irrational experiments of Expressionism and Surrealism. Here for instance the general public was oblivious of young avant-garde artists in Denmark and in many other countries who were devouring magazines such as Cahiers d'Art, Documents and Minotaure. While these publications were dominated by Surrealism, they were also driven by a sense of social idealism. However, this idealism did not so much embrace 'educating' the general public in norms and values from above, as in stimulating individual creativity and discovering individual imagination – similar but different to the way the Cobra movement was to champion later.

With the wave of commissions for war memorials after 1945 – something historically new to the Netherlands – there developed in a sense the first awareness of a 'Dutch sculpture'. The sculptors were largely Bronner's former students who no longer made architecture-linked pieces but free-standing works, inspired by such great French sculptors as Rodin, Maillol and Despiau. The most striking aspect about these figurative works, of which those by Mari Andriessen stand out, is that they sympathetically depict war not in terms of fighters and victors, but in terms of victims, the suffering human being. During this same period of reconstruction many commissions were given to sculptors by virtue of the so-called government Percent Scheme, introduced in 1951, which set aside a percentage of the building costs for state buildings and schools for 'decorative' refinements.[9] The Dutch art world of the postwar years, in which a strong religious revival provided artists with many church-related commissions, was by no means ready for something like an assemblage made from household debris.

In the privacy of their own studios a few rebellious artists were kicking against the established order and producing, what were at that time in the Netherlands, extremely strange creations. For instance, Karel Appel is said to have made an assemblage from old-fashioned Dutch soap beaters, which a friend of his from that period claims hung in his studio.[10] While little could be traced concerning such material in national libraries and art institutes, these artists had apparently picked up on something that had already been happening abroad for decades. Eugène Brands, for instance, among the oldest of the artists to join the Cobra movement in 1948, was already impressed by Surrealist objects made before the Second World War. In his work the change from pessimistic Surrealism, which drew on the 1930s and the war, to vigorous Expressionism, which burst upon the international art scene after 1945 and from which the Cobra movement sprang, is clearly visible.

In the same way that the painters Picasso and Matisse broke new ground internationally with their three-dimensional experiments in sculpture in the early part of this century, a few Dutch Cobra artists were similarly engaged in the second half of the century, making objects which could have had a similar impact. Unfortunately their contribution to modern sculpture was only recognised as such after 1984.[11]

Eugène Brands

To the complete surprise of Eugène Brands (b. 1913), Willem Sandberg had devoted an entire room to his work at the exhibition Ten Young Painters held during the summer of 1946 at the Stedelijk Museum. 'Send everything in, and I'll make a choice', the museum director had said, having followed Brands's work since seeing the artist's first exhibition at Zandvoort townhall in 1939. Brands felt ill at ease with this attention as compared to that given to his fellow exhibitors, including Karel Appel, Corneille and Anton Rooskens. He had also submitted certain objets along with the paintings and these were placed in a display case in the middle of the room. The general public were surprised and horrified by all the strange bits and pieces it contained, including the work Keyring, which consisted of a doll with a crab's claw in place of an arm and a rusty key hanging from it. None of this has survived since neither the museum nor a private collector purchased any of it.[12] The only reminders of this early work are Brands's own written descriptions and a few photographs of some of the objects. The artist himself must have thrown everything away after a while, perhaps because they represented an extremely depressing period for him.[13]

In 1936 Brands had moved with his parents from Amsterdam to the coastal town of Zandvoort. This was when he made the decision to become an independent artist. For a short time, following his training at the Amsterdam School of Arts and Crafts (1931 to 1934), he worked as a commercial designer but it was not something he enjoyed. The year 1938 must have been crucial in so far as his finding his own way in the visual arts was concerned. In April of that year Brands saw the exhibition Abstract Art at the Stedelijk Museum and in June he obtained a copy of the catalogue for the Exposition Internationale du Surréalisme at Amsterdam's Robert Gallery. Having first drawn in a naturalistic style, he now experimented with abstraction and surreal fantasy. In some of his preserved drawings,[14] especially those dating from the war years, the influences of Kandinsky, Klee, Mondrian and Calder, whose work he no doubt saw at the Stedelijk exhibition, are clearly evident (later Brands acknowledged the huge impact Klee's work in particular had had on him).[15] In other drawings, in which he conjures up phantom-like visions, he clearly incorporates the influence of the works depicted in the catalogue by, among other artists, Max Ernst, Joan Miró, Salvador Dali, André Masson, Kurt Seligmann and Victor Brauner.[16]

Both abstraction and Surrealism were fundamentally significant for Brands's further artistic development. His 'finger exercises' made during the war, followed by his postwar works on paper and then his canvases all emanate a personal lyrical abstraction. Following a period in which he was engaged and inspired by the magical world of children's art, he was to explore abstraction in great depth in his later painterly style. As well as this main theme, there was an evident surreal strand in his work whereby, along with the few stories and poems he wrote, he also made collages and assemblages, the latter of which partly rank as sculpture. He followed this route in virtual isolation – only a few other artists intrigued by what they saw at the exhibition at the Robert Gallery were motivated to experiment in a similar, solitary fashion. For example this influence can be detected in the poems and collages of the poet and artist Jan Elburg, who like Brands joined the Experimental Group Holland and the Cobra movement[17] and in certain objects made by the poet Chris van Geel. It was only in the 1980s that there was any interest shown in these scarce instances of Dutch Surrealism.[18]

Brands's body of work is permeated with his feeling for the strange, supernatural forces that control the universe and determine human behaviour without our always realising it. Initially the artist must have been drawn to the dark, oppressive side of this. In the Surrealist work he saw he must have recognised the powerful attraction of alien elements. These artists made visible the language of objects which, when placed in an incongruous context, conjured up an atmosphere in which the human form was either excluded or in fact is a powerless object. The French poet Comte de Lautréamont had already noticed this special characteristic of objects in his Chants de Maldoror (1869) – a poem in prose dealing with the delights of evil – in which he states: 'Beautiful as the chance encounter of an umbrella and a sewing machine on an operating table.' No doubt Brands noticed this now famous statement, which had a major impact on the Surrealists' vision, contained in Georges Hugnet's text which he wrote for the exhibition catalogue for the Robert Gallery.

Eugène Brands

62 Seahorse, c. 1940, pencil on paper, 38.7 x 32.4 cm, no signature or date under the title. Prentenkabinet collection, Leiden University.

63 La vis mortelle (The Deadly Screw), 1941, photo of a lost assemblage.

64 L'Illusion du Phare (The Illusion of the Lighthouse), 1941, photo of a lost assemblage.

A drawing Brands made in September 1940 Design for a Construction certainly recalls a sewing machine.[19] Moreover, the hanging buttons of his assemblage Le Rêve du Petit Jean (by now he was using French titles for his work) from the same year, made up of items from his mother's sewing box, directly evoke the Surrealist Augustin Espinoza's work Fissures Défigurées, which was illustrated alongside Lautréamont's text in the catalogue. In the same publication there is also an illustration of the work of the Italian painter Giorgio de Chirico who, along with Lautréamont, was hailed as a precursor by the Surrealists. From 1910 on this artist conveyed a mystifying atmosphere in which inanimate objects emanate uneasy activity, while in between human beings are depicted in the form of tailors' dummies.

Out of an interest in primitive peoples, Brands admired and collected not only their art, as the Surrealists did, but also their music and probably understood how these people ascribed power over humankind to inanimate objects such as fetishes, masks and similar imagery.[20] Shortly before and during the early part of the war, Brands also collected various flotsam and jetsam that he found at low tide on the beach at Zandvoort. At home he would then make precise pencil drawings of these, such as Zeepaardje (Seahorse, c. 1940; fig. 62) followed by 'objects'. Around 1944 when he was living in Amsterdam again, he wrote an essay – which he has been unable to locate – entitled Taal der dingen (Language of Things), which he illustrated with a sketch of such commonplace objects as cutlery, tableware, a violin, a portable gramophone, a birdcage, braces, all scattered across a wooden floor, with a small table and squat cupboards. The human beings are depicted in the form of a tailor's dummy, two portraits, a wooden puppet and a doll's head, the latter resembling a severed human head.[21]

Little of the work Brands made in which he abandons himself to the alienating power of the inanimate object has survived. One of the earliest examples is the photomontage Illusion from 1938 in which he uses the picture of a girl, no doubt intended as a memory of a passionate youthful love.[22] However, in subsequent drawings of objects and in the handful of early assemblages he made – of which only photographs now·exist – it is noticeable that he is mainly preoccupied with the inanimate objects themselves. Two portraits of the artist are encountered in conjunction with a cage, which also contains a poem 'Minstrel Man' by the American black poet Langston Hughes and a clockface without hands. He clearly intends to show us with these photographs that he is engaged in the world behind visible reality, where time has no meaning. In covert terms it is a confession. The artist is obviously the poet locked up in the cage. The rope (?) behind his back, that runs off the picture, appears to indicate he would like to leave this world for another (fig. 60).[23] Brands once said to me: 'Surrealism is actually the conviction that behind this reality is another reality, but then this is not the reality, this is then a dream.'[24] This other reality emerged in his work during the war years in the form of gloom-filled imagery of mortality, conveying an atmosphere of the inevitability of fate, and especially in the uneasy immobility and complete silence of objects, between which human beings glide as strangers. It was also expressed not only in his incongruous objects such as La Vis Mortelle (fig. 63) and L'Illusion du Phare (fig. 64), both from 1941, of which only photographs survive, but also in the poems and prose he wrote at the time.[25]

It was inevitable that at some point after the war Brands would make a conscious decision to break away from the bleakness in his work. Instead he chose pure optimism. As he later claimed: 'I'm a born optimist.'[26] Perhaps it was discovering a large blue enamelled pan lid one night on the streets of Amsterdam, in which he instantly recognised 'space and the universe', that marked the beginning of this change. The next day he gave this Heavenly Lid, shown later in a display case at the 1946 Stedelijk exhibition, a complete Milky Way system with Orion brand white bike paint. The artist's amazing childhood discovery of an infinite universe in which human beings are mere cells – a knowledge which must have weighed heavily on him in later years – was also a source of wonderment and gave him a sense of well-being. When he found the lid he may have recalled the moment of this first discovery. It is since that period that Brands felt increasingly less absorbed by the immobility of objects and started to enjoy the panta rei, the 'everything flows' of the Ancient Greeks.[27] Around the end of 1947, a free lyrical use of colour emerged in his paintings and assemblages. From then on

all his work was imbued with a gentle, shimmering and joyous sense of poetry. The assemblages he made, such as **Relief IX** (fig. 105) and **Small Black Moon**, both from 1948, and **Sign in Orion** (fig. 104) and **The Summer** (fig. 106), both from 1949, and which he now preserved, still have that fetish-like element in the way he incorporated unusual elements such as horse hair. However, due to their poetic and vibrant colours, these reliefs no longer recall the displaced objects of Surrealism. Rather the artist is more in tune with that great poet of the assemblage, the Dadaist Kurt Schwitters, whose work he must have seen at the 1938 exhibition of abstract art in the Stedelijk in Amsterdam. At the same time Brands's pieces recall primitive art, although it is now its vital energy that one finds in his work.

'First and foremost we are optimists', Brands wrote in a short piece on the back cover of the first issue of **Reflex**, the mouthpiece for the Experimental Group Holland. In retrospect, his membership of this group, which he was persuaded with great difficulty to join by its founders, must have been ample confirmation to him of the lonely path he had travelled with his art until then. The many poetic assemblages, reliefs and collages Brands subsequently made such as **Orion Haze** in 1965, **The Lovely Bike Ride** in 1966/67 (fig. 107), **Ericeira, Portugal** in 1986 and **Kalimantan** in 1996 (fig. 108) are testimony to his belief that a mysterious force lies hidden behind every small object or smudge of colour and that this is part and parcel of the awesome wonder of the universe. This is a belief in keeping with the way primitive tribes perceive their relationship with the cosmos.

Karel Appel

The exhibitions of abstract and Surrealist art which Brands saw before the Second World War were missed by **Karel Appel** (b. 1921), Constant (b. 1920) and Corneille (b. 1922) as they were several years younger than Brands. During the war, the Netherlands, which in the 1930s was highly traditional in outlook and (aside from a few exceptions completely uninterested in what was taking place in innovative art at home never mind elsewhere) was entirely sealed off from outside information.[28] The Culture Chamber, established by the Nazis based on the German **Kultur Kammer**, forced artistic life into an inescapable straightjacket of restrictions. It was only after the war that it became evident to many young Dutch artists what interesting developments had been taking place in art during the first forty years of the century. It was by immediately travelling abroad as well as visiting the exhibitions mounted by Sandberg at the Stedelijk Museum that they actually got to see for the first time the work of such twentieth-century masters as Braque, Picasso, Matisse, Laurens and Lipchitz.[29]

In 1946 Appel went with his friend Corneille, with whom he attended classes at the Amsterdam State Academy of Art for a few years during the war, to Brussels and in late 1947 to Paris. The overwhelming impressions he gained from this time are evident in the way in which his work erupted into wholesale experiments on canvas and paper as well as in three-dimensional form.[30] Whereas he had admired the work of Van Gogh and the French Impressionists during the 1930s and the work of the Amsterdam Impressionist painter George Hendrik Breitner during the war years, it is evident after 1945 that he quickly found many other sources of inspiration.[31]

In surviving photographs of his studio on Amsterdam's Oude Zijds Voorburgwal, one can see Appel standing in front of his easel on one side of his attic surrounded by various canvases painted in the **jeune peinture Francaise** manner. The fact that he greatly admired the School of Paris is evident in the heavy plaster sculptures on the other side of the attic.[32] These immediately bring to mind the work of Matisse and Picasso, particularly in the voluminous forms of the female figure in the left-hand foreground. Appel had already interpreted the female form in a similar vein much earlier, as the only known small sculpture from his youth **Naked Torso** (1936), made in chamotte, illustrates. With this piece, however, an amazing work for a 15-year old, one is reminded more of the prehistoric forms of fertility goddesses such as the so-called **Venus of Willendorf.** With the head, on the right in the studio picture, later titled **Bird's Head** (fig. 97), Appel was directly following in the footsteps of his great precursors. This sculpture may be seen as an even more simplified form and a variation of a series of heads by Matisse (**Jeanettes**, 1910-12), Raymond Duchamp-

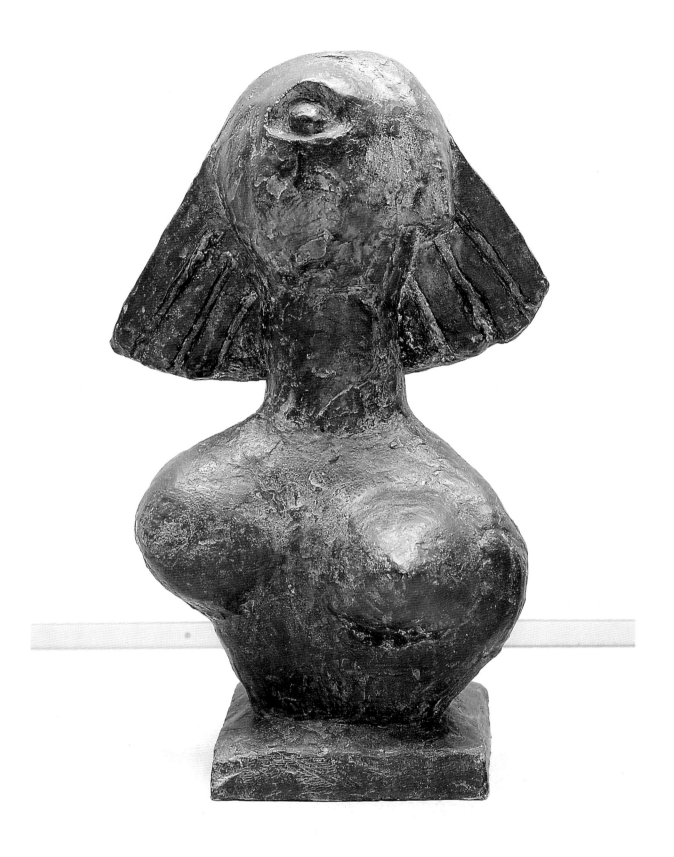

Karel Appel

65 Woman's Bust, 1947, bronze (original
plaster), Cobra Museum for Modern Art,
Amstelveen.

66 Karel Appel with axe posing in front of his relief titled Asking Children of 1949. Photo taken in autumn 1949 for the large Cobra exhibition at Amsterdam's Stedelijk Museum. (Photo Mrs Kokkorris Syriër).

Karel Appel

67 Totem Pole, 1948, gouache on wood, 84 x 24 x 10 cm.

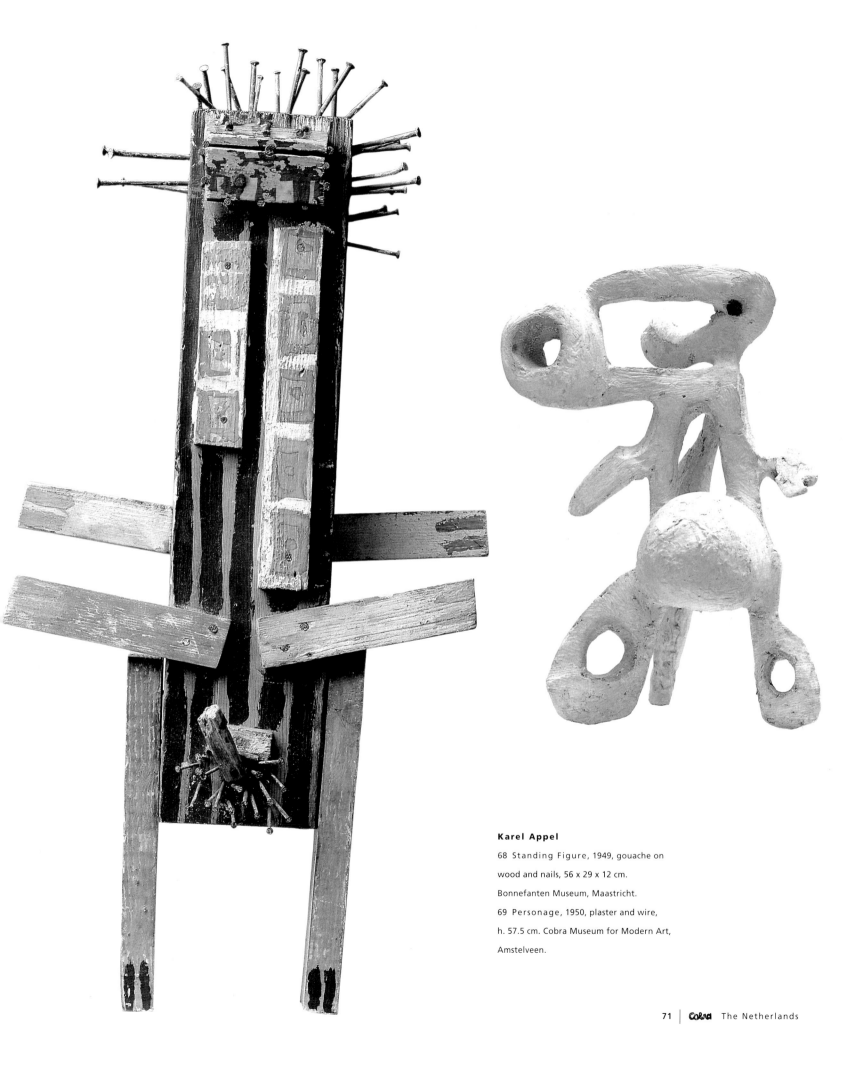

Karel Appel

68 Standing Figure, 1949, gouache on
wood and nails, 56 x 29 x 12 cm.
Bonnefanten Museum, Maastricht.
69 Personage, 1950, plaster and wire,
h. 57.5 cm. Cobra Museum for Modern Art,
Amstelveen.

Villon (**Maggy,** 1912) and Picasso (**Female Heads,** 1931-32), which the historians of modern sculpture always link together.[33] It seems as if Appel's sculpture elaborates on Picasso's last piece in his series which the Spanish artist appears to have based not only on the features of his girlfriend Marie Thérèse but also, by the highly pronounced nose, on the inspiration of a Nimba mask in his collection from Baga, Guinea.[34] In the two other sculptures, in the middle background of the studio photograph, including **Bird Woman,** Appel has clearly been inspired by African tribal art, as his outstanding predecessor Picasso was on many occasions, although the pieces also recall the work of Max Ernst.

In the Amsterdam department store De Bijenkorf, one of the few places in the Netherlands that was open to contemporary art at the time, several of these plaster sculptures were draped in fabric and displayed in the store's large atrium during the summer of 1949. Appel subsequently destroyed most of them, having turned away from this style.[35] The artist wanted to invent something fresh and different from the School of Paris. As a result little remains of what could be seen in his attic in 1947. A few plaster works, including **Bird's Head** and **Woman's bust** (1947, fig. 65), survived and in the mid-1960s were cast in bronze in limited editions.[36]

Around the time Appel was making these plaster sculptures he began producing an entirely different kind of three-dimensional work. He must have been considerably struck by Eugène Brands's found objects displayed at the 1946 exhibition at the Stedelijk. However, the surrealist alienation from which Brands was about to free himself at the time had no appeal whatsoever for Appel. Rather it was more the poetry imbued in his painted panels that interested the younger artist. It was during 1947 that Appel also began collecting objects on Zandvoort beach, along the Amstel river and on the streets of Amsterdam in order to arrange them into new compositions. Unlike his plaster sculptures, Appel's assemblages were from the start highly expressive and rough. 'Then I suddenly began using wood, messing about with the materials. I began banging together heads one night when I'd run out of paint using cork I'd found on Zandvoort beach as well as tin, nails, scrapwood and cable wire', he told the poet Simon Vinkenoog.[37] He also recalled spending time in Cassis, in the South of France, during that same year. He exhibited the assemblages he made there in a small gallery in Paris and afterwards never saw them again.[38] In Amsterdam in 1947 he also made his humorous **Passion in the Attic** (fig. 98), consisting of an old wooden panel which he had dismantled with great difficulty from his house on a canal. Onto this he made a barbaric-looking creature from rudimentary materials, including pieces of round cork for the eyes and breasts and leather scraps (from a local cobbler), a strip of wood and another large piece of cork to depict eye sockets, backbone and rib cage, while the body with two delighted, raised hands was vaguely outlined with pale blue paint. A large, blatantly red painted mouth into which a sizeable number of nails had been hammered represented the apparent state of ecstasy of the person. The reason for this is clearly conveyed in the lower half of the body with its chaotic erogenous zone, depicted using huge, curly-red iron hooks (the pubic hair?) and strips of leather, surrounded by a penis made from a large piece of vacuum-cleaner hose.[39] It obviously represents sexual union between the male and female. A few other panels made and painted in a similar way still survive.

The artist made several improvised free-standing pieces from found objects such as **The Wild Fireman** and **Windmill**, both from 1947. After losing his studio in early 1948, Appel, as he had done so many times before, roamed the streets, sometimes sleeping and working at the homes of friends. 'The street was actually my studio', he once said about this period. Poking about in dustbins he put together his objects. 'I began down one side of the street and by the time I'd got to the other, I'd got a sculpture together.'[40] The first time he saw the work of Kurt Schwitters in a 1956 exhibition at the Stedelijk Museum, took him completely aback. 'That was a blow', Appel told me, 'I'd been making these assemblages quite spontaneously and then I saw Schwitters and thought, it's already been done.'[41] I then stopped, otherwise I would have been doing something that had already been done.' The humour and vitality of Appel's assemblages, however, recall less of Schwitters's poetic style than of the objects Picasso had been composing in this vein very early on. 'But before that (before Schwitters) I'd seen Picasso at Sandberg's exhibition [Stedelijk, April 1946, W.S.] and that was a much bigger blow. I had to get used to it. I went in and then walked immediately out again.' – as he recounted this Appel had his arms in front of his eyes. – 'It was such a blow. It had such a force.'[42] Picasso's wealth of ideas was also

the key source of inspiration for Henry Heerup's Skraldemodeller, the man whom Appel termed 'the most important Danish artist' after seeing his work again in 1983, adding 'I really appreciate his sculpture very much.'[43]

At the end of 1948 Appel had an exhibition of his objects at the Madrid Bar, next to the Van Lier gallery, on Amsterdam's Rokin. It received a blistering reaction from both the press and the general public. A stone was even thrown through the window of the premises.[44] The Dutch public could still make no sense of this kind of art. 'What could I do with it?' Appel asked Vinkenoog resignedly, 'I've had to throw a lot away or give a lot away, including dismantled bikes, an object made from a few hundred found soap makers, a smashed typewriter …'[45] Curiously, at the various Cobra exhibitions hardly any assemblages were shown, not even from Heerup, Appel or Brands, despite the fact that Sandberg had shown such an interest in the genre in 1946. Only one object by Corneille was exhibited at the Cobra exhibition in the Stedelijk in November 1949 (fig. 72). The first issue of Reflex, the mouthpiece of the Experimental Group Holland, which appeared in September/October 1948, published Appel's Passion in the Attic, Brands's assemblage Wing at Rest, and Red Bull by Jan Nieuwenhuys, brother of the painter Constant.

Brief attention was paid, however, to a third style of sculptural work that Appel produced. These were small wood sculptures and reliefs painted in bright colours, in which the typical Appel signature in three-dimensional work is possibly depicted most clearly. Moreover, where in the history of modern art can one find such expressive and blithe sculptures and reliefs made from ordinary firewood? In a photograph taken at the Santee Landweer gallery in Amsterdam, where Appel, Constant and Corneille exhibited their work in early 1948, Appel is proudly standing next to one such sculpture (Standing Figure, 1947; fig. 74) into which an inordinate number of nails have been hammered. A work of the same genre, but bigger in size, which unfortunately has not survived, can be seen in one of the photographs taken in Appel's studio. It can almost be interpreted as a silent statement: Constant is squatting on the floor in the foreground, while the heads of the three artists (Constant, Appel and Corneille) appear above the sculpture as if the trio are riding their mascot like a horse (fig. 59).

In these kinds of sculptures, like the 1947 work Green Person and the 1949 Standing Figure (fig. 68), the human form is depicted rudimentarily and in obvious symbolical terms: exaggerated breasts; a spiral or round form for the female genitalia; a stick for a man's penis and nails used to represent pubic hair for both. In one respect primitive totem sculpture springs directly to mind, but these works much more recall the way in which children depict human figures: frontal, with large faces and teeth, wide outstretched arms and rake-like hands and feet. The bright gouache colours Appel uses particularly reflects children's artwork.[46] The 1947 work An Individual, which is nothing more than a plank with two long slats of wood for legs, can even be seen as a children's naive version of the human form, pure and simple.

Various drawings, gouaches and paintings made in 1947 appear to signal the arrival of these three-dimensional figures, for instance, the gouaches Woman with a Blue Fish, Untitled and Figure as well as the canvas Moon Men.[47] Appel even titles a sheet of nine drawings of these figure types Sketches for Wooden Sculpture (1947; fig. 2). None of these, however, represent precisely the delightful wooden sculptures the artist made between 1947 and 1949, or at least those that have survived. Only his thin, elongated Large Totem Pole (1947) made from one narrow plank of wood on top of which he attached a few more blocks of wood and painted white, blue and black is quite similar to a totem pole in his sheet of sketches. It is likely that the wood he used for these pieces was partly ripped from his studio floor.[48]

Among the group of gaily painted wood sculptures of this period are a series of four reliefs entitled Asking Children made from bits of firewood attached to old wooden panels or parts of floors, one dated 1948, the others 1949 (fig. 99).One of these was illustrated in the second issue of Reflex. Among the many beings brought to life on these panels are a large number of childishly drawn figures staring from the planks of wood with huge, surprised eyes and the occasional cocked ear. While they bear a slight resemblance to African masks, they again appear to have walked straight off the page of a child's drawing.[49] Their humour and bright colours also evoke the painted objects and assemblages Miró began making in the 1930s. Appel was

deeply moved seeing children begging for food in the autumn of 1948 while travelling through Germany en route for Copenhagen, hence the title of these works. However, one comes across similar 'children' in several of his works on paper dating from 1947, including Prisoners.[50]

On occasion Appel was inspired by the shape of a piece of wood itself, for instance in his endearing 1947 work Cat; also Owls and a Totem Pole (fig. 66), both from 1948. The cat with a bright-red painted head and yellow body with red dots appeared in the fourth issue of Cobra magazine. Appel probably originally intended to exhibit this totem pole at the 1949 Stedelijk Cobra exhibition. There is a photograph of this piece on a low dais in one of the museum's rooms in front of a wall with a work by Jacques Doucet. Appel made the totem from a piece of a tree trunk onto which he painted three bird masks, one above the other. The upper one had a wing formed by a point of protruding wood, while the lower has two bird's claws.

Several crudely executed assemblages from this time such as The Bridge dated 1948 (fig. 101), are undoubtedly the direct result of Appel poking around garbage cans. For more polished, abstract works as Construction II (1949) and his humorous Spin (1950) he probably obtained wood offcuts from a furniture maker. It was precisely by using these kinds of sharply sawn-off forms that he was able to produce highly evocative symbols in space. In the summer of 1950 Appel executed an immense version of them for the large manifestation in the Ahoy building in Rotterdam to celebrate the city's resurrected docks after their destruction during the war. As the architect Aldo van Eijck recalls, it was the well-known architect Bakema, one of the few at the time who was struck by the vitality of how 'those lads' of the Cobra movement presented themselves during their 1949 exhibition in Amsterdam, who commissioned Appel to make the sculpture, which was given the title The Tree of Life.[51]

After completing the work, Appel had by no means exhausted his three-dimensional experiments with various materials. Seeking refuge in Paris, after fleeing what Appel and Corneille perceived to be an uncomprehending and hostile Dutch art scene, the two artists stayed firstly in the cold and damp garden house of the Maison des Danois in Suresne belonging to the sculptor Robert Jacobsen. In Jacobsen's studio Appel made a grinning head called The Smile (1950) from scrap iron left over from the sculptor's pieces.[52] Although he intended to make more of these iron sculptures, it remains his only one. However, he was shortly to use its free and open construction, which he employed here for the first time and which was no doubt inspired by Jacobsen's work, in a different way for other experiments. These new works were executed in accommodation Appel and Corneille quickly found in a warehouse for storing hides on rue Santeuil, where they lived for a few years in extremely reduced circumstances. Bursting with energy and inventiveness, Appel here, with no forging and welding equipment, made open, fragile three-dimensional constructions from sawn pieces of wood, plaster and wire, which he painted in bright, dense daubs of colour. Built from the few and shabby materials he could muster, these works in their unexpectedly tender and poetic forms sing the praises of his newly acquired artistic freedom. His works Sculpture with Bird (fig. 102) and Untitled (unfortunately), both from 1950, are reminiscent of the jubilant poem April in Paris by Appel's friend, the Flemish poet Hugo Claus, who had also just arrived in Paris. In this poem, written in the spring of 1951 and for which Corneille made some gouaches, Claus describes feeling like their beloved jazz saxophonist Charlie 'Bird' Parker whenever he walks along the Champs-Elysées: 'Hello Charlie, bleeding hawk, [...] who walks along the street of a summer evening with an animal's gaze', he exclaims. In the spiral springs that Appel incorporates into these small sculptures, which probably came from the beds found at the flea market and which the artists used to mark out the boundaries of their studios in the empty warehouse space, I can see saxophones. In the one small sculpture Bird appears to be playing (a hockey-stick form within it could also represent a saxophone), while in the other sculpture one has the sense of music bursting out of the framework in which his figures are mounted. In these quick 'sketches' of wire and plaster, an entire band seems to be suspended with 'loud' open mouths apparently blowing and singing, with trumpets and a saxophone as well as a sheet of music (upper left).[53]

During this period when he created play in his paintings and gouaches by working with large, open outlined shapes over and between daubs of colour – a play similar to that found in Miró's work, which had a huge

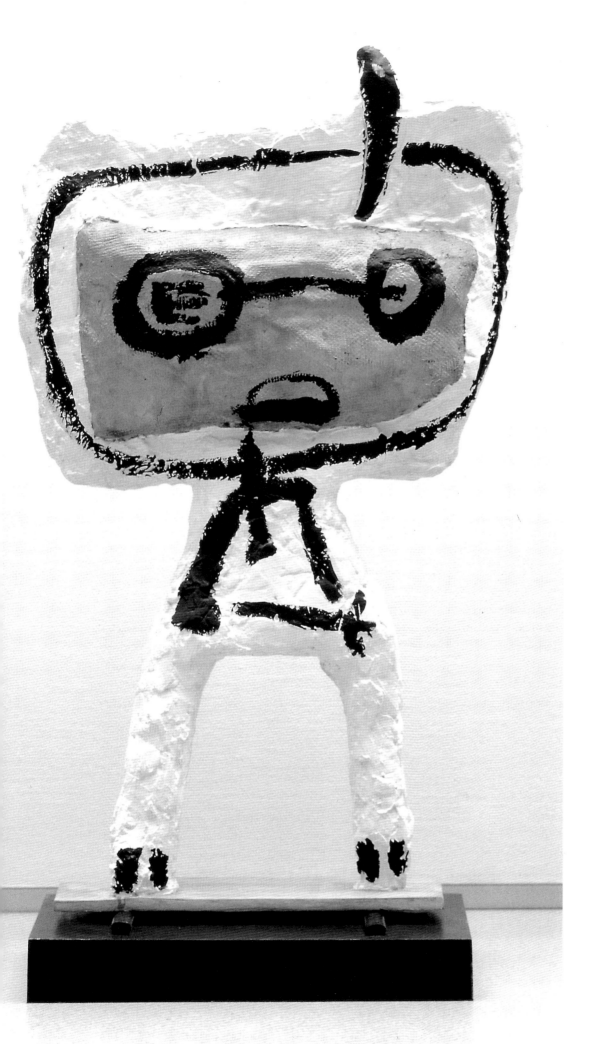

Karel Appel

70 Cavaleriekind (Cavalry Child), 1950, painted (original gouache and jute on plaster), 132 x 84 x 12 cm. Cobra Museum for Modern Art, Amstelveen.

impact on the Cobra movement – Appel also made more plaster sculptures. The material was cheap and suitable for many purposes. For instance, although the landlord forbade them to use the material out of fear that it might block the drainpipe of the one sink they all shared, they used the plaster to seal their improvised studio walls.[54] To Appel it must have seemed an obvious time to incorporate this medium into his art again. In 1950 he produced a bucket half filled with plaster to represent milk, chained to a panel he painted himself which he called Farmer with Donkey and Bucket. This curious combination, which evokes an assemblage with a chain by Miró in 1931,[55] was a precursor of the so-called combine paintings devised by the American Robert Rauschenberg in the second half of the 1950s.[56] As well as certain relief-type works, comprising sawn-out forms smeared with plaster, Appel also began in the autumn of 1950 making several free-standing plaster sculptures onto which he painted daubs of colour.[57] These include Cobra Bird (fig. 103), Elephant and two Individuals (fig. 69). The last two works have a highly organic feel to them in that Appel made the same kind of play with open forms as in his reliefs, by using an iron armature which he then covered in plaster.[58]

These diverse three-dimensional experiments using cheap material and even waste products form the prototype for what Appel was to devise later in this genre on a much bigger scale, sometimes using professional assistance. Among these early experiments are his first attempts in ceramics. Appel, along with Constant, Corneille and Rooskens, had worked in the ceramic department of a brick factory at Tegelen in Limburg (the Netherlands), between 1948 and 1949, although this was mainly limited to decorating vases, plates and other tableware.[59] However, during the joint experimental ceramic period organised by the Danish artist Jorn in Albisola, Italy, during 1954, Appel's approach to clay was entirely different. Hauling chunks of clay from the mud of the small Italian coastal resort, which had recently experienced flooding, he set to work on it with an iron bar. 'I punched animal shapes into the clay and once hammered into shape I painted them before they went into the kiln.' Among the results are Dog made in 1954 and a few crudely made, grey painted heads or masks such as Head, also from 1954. The spontaneous manner in which Appel indulged while working with clay – again during the following year in Albisola – must also have inspired Jorn to adopt a freer style in the medium.[60]

In the second half of the 1950s, however, Appel was mainly engaged in painting. The consciously childlike fantasy of his Cobra years now evolved into enormous dramatic rhetoric in paint. The making of objects, as he himself now confirms 'was not my first love, that was always the easel, painting [...] with this I get closer to my imagination.'[61] It is undoubtedly due to his passion for paint and colour that whenever he did make a sculpture it had to have colour as well as form. Appel's Danish contemporary Henry Heerup was similarly inclined. In this sense both resumed a centuries-old tradition or natural tendency which reached its apogee in medieval art and which lives on in primitive, folk, naive and 'outsiders' art. In fact the ancient Greeks originally painted their sculptures in bright colours, yet when these were later excavated in their blank white state they became the Western ideal for sculpture.

In the spring of 1961 Appel was given the opportunity to indulge his creativity on tree trunks from the burnt olive grove of his Parisian dealer, Jean Larcade, director of the Rive Droite gallery. For two long summers at the dealer's large estate of L'Abbaye de Roselande, near Nice, Appel worked on the trunks, which were pulled out of the ground, roots and all, by local workers and then washed clean. As with his earlier owls and cat images, he was guided by the shape of the wood itself. In a sense these ancient trees spoke his language. Their characteristic twisted forms matched the agitated way Appel hurled paint across his canvases. He worked the trunks with a chisel and hatchet and then painted them with varnish mixed with brightly coloured pigment. In this way he allowed the forms of animals, people or even abstract shapes that he discovered in the natural wood to come to the fore in a highly expressive way. At the same time these sculptures, of which he made eighteen, come across as three-dimensional, solidified versions of his paintings.[62]

Clearly inspired in the 1960s by Pop Art, which was taking hold all around him, Appel once again collected odds and ends which he used in his canvases, especially in 1963, a year he spent chiefly in Italy. This time instead of looking for refuse around dustbins he bought large quantities of cheap plastic toys from an affluent consumer society. Although by adding numerous plastic dolls, musical instruments, flowers, swords, buckets, watering cans, etc, these canvases now seemed to spring out from their background surface, they do not feel like reliefs. Essentially they are garishly coloured paintings accentuated by equally gaudy plastic objects.[63]

It was only after 1965 when Appel immersed himself in making large, free-standing figures and reliefs in wood that sculpture as such was taken up again. In the outbuildings of the Chateau de Molesmes, the castle-like manor house he bought in 1965 in Auxerre, south of Paris, the artist had the space to erect and produce gigantic works. As in certain experiments he had made during his Cobra period, he once again used sawn pieces of wood. Now, however, they were not random offcuts, but shapes cut out of plywood according to plan, which he combined to form not abstract compositions but animals, human figures, portraits and flowers. The clear, childlike figuration of his Cobra period gained a new and large-scale lease of life. The vitality and colour of these forms as well as the more tragic or demonic features given to the human figures, however, clearly belong to his later development. A few years later, Appel decided that these monumental works, made between 1965 and 1972 and culminating in 1976 with a huge sculpture in the same style Anti-Robot with Flower placed outside the University of Dijon in France, be executed in various other techniques.[64] His Flower and Bird from 1966, painted on both sides, was made from flat pieces of plywood placed on top of each other. In a subsequent phase the flat, basic wood form disappeared under a thick layer of polystyrene, as in his Motherhood of 1968. During 1971 in Connecticut, America, he executed these kind of sculptures in stainless steel or enamel-painted aluminium, to which he also attached moving parts. 'I travel in my mind to a childlike feeling or a toy feeling. My work is a toy for adults,' said Appel in an interview around this time.[65] The artist was to return to the original concept in plywood when he made several exuberant circus figures between 1976 and 1978.

By the early 1960s Appel was already extensively involved again with ceramics. Using professional ceramists he designed not only large wall decorations, but during the 1970s produced a series of free-standing sculptures. Brightly painted animal, human and plant shapes in this medium were made in such a way that, like his large sculptures in wood, they appeared to consist of many separate pieces joined together by placing one on top of the other to form the whole. In 1987 Appel made a few gigantic windmills in clay with his own hands – a nostalgic reference to the motif of his mother country that is often encountered in his œuvre. These windmills were made from large, crudely formed lumps of clay which he bound together with heavy rope.[66]

As if seized by the fear that life and memory might suddenly disintegrate, Appel, in the late 1980s, also devised works comprising parts of the human body, sawn out in wood or cut out of huge blown-up photographs, tied together with heavy cable and then painted. 'Everyone has at some time been operated on and afterwards feels better than they've ever felt before. In this sense the whole of civilisation is being continually repaired', as Appel described these pieces.[67] Here he was inspired by his collaboration with ballet dancers in his large-scale theatre production Peut-on Danser le Paysage (Can You Dance a Landscape) for which he was commissioned by the director of the French Opera in 1987. For the decor and sets of this production – which was entirely conceived by him – and for which he collaborated with the Japanese ballet dancer Min Tanaka, – he used numerous ropes.[68]

Appel undoubtedly acquired his keen interest in the theatre from his mother. 'My mother was a born actress', he wrote on the first page of an autobiographical text published in 1971.[69] In 1962 he, and the poet Bert Schierbeek, put together the theatre production A Large Dead Animal, while during the 1950s in Paris he must have worked on various other theatre productions.[70] The decors and sets he made, especially those for the opera productions Noach in 1994 and Die Zauberflöte in 1995 for which he did all the visual presentation, can partly be considered as straightforward sculpture. That they were also received as such is evident from the fact that after use they were exhibited in the Stadsschouwburg and the Muziektheater in Amsterdam.[71]

It was not only in Amsterdam but New York in particular, that Appel felt completely at home, and was inspired and motivated to rummage through the streets. Collecting materials from garbage cans or secondhand shops or indeed shops of any kind became like a compulsion. During the 1970s and '80s, between producing his other work, he assembled objects from these gleanings, including a series of painted cardboard boxes, some of which were filled with rubbish, and his humorous dolls made from plastic bottles and household brushes. 'The style of an artist is dictated by the evolution of society itself', says Appel. 'In the 1940s I found worm-eaten wood, rusty wire, perhaps an old door hinge or a bicycle – not a trace of plastic or electronic waste.'[72]

By 1990 Appel's involvement with making objects virtually dominated his work and since then he has occupied himself with producing large-scale assemblages. Although his expressions in three-dimensional form always had the purpose of liberating him for his paintings,[73] in recent years the assembling of objects from pieces of junk has become as important as his two-dimensional work.[74] Now he is no longer just interested in the waste of the consumer society; on his travels to different countries he collects objects rooted deep in the human psyche, such as weather-beaten artifacts and painted images associated with folklore or religious rituals from around the world. He has found, for instance, old wine barrels, parts of farm-carts, peasant furniture and papier-mâché carnival heads. These come from the Tuscan countryside where he now has a house and a studio. Appel also frequently visits Indonesia where especially on Bali, with its ancient Hindu polytheism, many wooden statues and masks of gods in human and animal forms are still carved. Yet it is primarily in New York, where virtually any culture can be found, often with its own centre or neighbourhood, that Appel finds no shortage of the most amazing objects.

For Appel, the sculpture he assembles and calls Hybrid Art is a way forward towards a new form of three-dimensional expression for the coming era. Yet, with all the artifacts collected from these cultures Appel, in his latest works, appears to be saying a final farewell, paying tribute to that which he and the entire Cobra movement felt inextricably bound – traditional primal symbols handed down from one generation to the next via religion and folk art in forms lovingly made by hand. This may be why in many places he has incorporated hands into the sculptures. With the onslaught of commercialisation, technology and Westernisation in general, these traditional forms, in which the mythical element predominates, appear destined to disappear as the new millennium approaches. This seems to be the message of his giant, life-sized and sometimes wall-to-wall installations, which recall the many family altars or small temples stuffed with offerings of every kind which are found across Bali. More to the point, some of these – particularly the structures Appel calls Pyre – evoke the large imaginative towers of wood, paper and bamboo decorated with ornaments, masks and big wooden animal figures used for cremation ceremonies. During such a ritual several corpses are placed inside the towers and cremated in a huge festive funeral celebration together with the structure.

Appel himself says he had no idea what he intended with these structures; he was more or less instinctively motivated to make them. With great physical effort, he seems to draw the material together for a burial ritual for himself and for everything in the cultures of the world that he, and not only he, has loved so much. In fact many others, including both artists and people from every walk of life, have been consciously or unconsciously seized by a yearning for the well-spring, for the genuine, true primitive form of life. The artist's newer structures are not painted in his characteristically bright, cheerful colours but more in the strident colours and the black of German Expressionist Max Beckmann's paintings with their crude brushstrokes and disturbing portentous imagery, to which Appel's assemblages bear a strong resemblance. Like Rauschenberg, whom he greatly admired, Appel has also attached the occasional stuffed animal to these works. Nature also appears to perish in certain unpainted pyres for a horse or bird, for instance, which he moulded by hand in plaster. The large bodies of the animals in whiter-than-white plaster lie lifeless between old decaying commonplace objects such as car tyres, ladders and tables. On the fence next to Pyre for a Bird made in 1993 Appel, who always wanted to be a bird, hung a paint-smeared artist's apron as if to say: the work is finished.[75]

In the photograph taken in early 1948 at the Santee Landweer gallery, Constant and Corneille (b. 1922) stand proudly holding a three-dimensional object (fig. 74). In fact, it is barely visible as it melts into the background of Corneille's dark jumper. 'It was an object made from iron and painted plaster and I carried that plaster on my shoulder', Corneille explained to me.[76] 'I must have made at least fifteen objects at the time, most of these were made of pieces of wood. I used to go with Karel [Appel] along the Amstel, close to Amsterdam. It was a mess at the time. The grass was a metre tall, but we found a lot of wood. We knew the objects wouldn't make any money. We never sold any.' A totem pole by Appel was used as a lectern by the poet Louis Tiessen (Corneille's friend) when he opened the exhibition at the Santee Landweer gallery, although in his address he only spoke about painting.[77] 'This exhibition was specially devoted to these kinds of objects', recalled Corneille. 'The gallery owner was a terribly formal man, a bourgeois art dealer. It is remarkable that he organised such an exhibition.' Unfortunately little has survived from the show.

Although Corneille has rarely deviated from the flat surface in his artistic career, he did in fact create many three-dimensional works in the early days. In 1947 he began making occasional collages with newspaper and in 1948 he was also attaching artifacts to canvas. In his work Toi from 1948 (fig. 71) he attached a twisted piece of metal wire and three pieces of cork. Onto another work he stuck various small blocks of wood which he painted in bright colours. Of the many three-dimensional objects he made only a few are known from photographs. It was probably in 1948 that he assembled a craggy sculpture from pieces of wood, a wheel, barbed wire and other metal waste which he then painted in stripes and added two eyes. A short while ago a photograph surfaced in which Corneille poses with this piece on the roof of Karel Geirlandt's house in Ghent (Geirlandt was later director of the Palais des Beaux Arts, Brussels) (fig. 73). Another lost assemblage from his hand was erected between the slats of the cage designed for the poets at the large Cobra exhibition in November 1949 in Amsterdam. From pictures of the cage it is clear that the object was made of planks of wood, sawn-off tree branches and nails and then painted with eyes (fig. 72).

In the same period Corneille sometimes turned to working with plaster. In 1948 he made Couple, using simplified forms in this material. 'At the time I very much admired Brancusi', he explained. A second plaster sculpture, also from the same year, comprising a head with a large hand pressed against it recalls the relief Die Klage (1940) by the German Käthe Kollwitz.[78] Again using the same medium in 1951 the artist made a figure called Le Pêcheur (The fisherman, fig. 109). This small piece, consisting of various planes which together suggest a large-headed being holding a fish, bears a close affinity to his two-dimensional work of the same time. The three figures were cast in bronze in a limited edition of six in 1987.[79]

It is remarkable that Corneille felt hardly any wish to express himself in three-dimensional terms during the whole of his artistic development. Sculptures were only made in the 1990s and then to a limited degree. What actually did continue to be an immense source of inspiration was primitive sculpture, especially African. Shortly after the war, Corneille along with Constant and Appel, possibly inspired by Eugène Brands, came into direct contact with this type of art at art dealers Aalderink, Lemaire and especially Van Lier on Amsterdam's Rokin, where they exhibited in 1948.[80] From 1958 on Corneille was to assemble a fine collection of African art comprising over 600 objects.[81] The masks, birds and especially the exaggerated human forms, in particular the female, which he so admired in primitive art are all clearly evident in his work on canvas and paper. Only once, around 1977, did he make a large, African-inspired sculpture which received the mysterious name Oiseau Kiv. He made the work in reinforced concrete and then had it cast in bronze. 'It was with a huge enlarged version of this Kivu bird that I made my contribution to the entrance of the Kivi village [in Congo, formerly Zaire], which was to be in the form of a totem', Corneille explains. 'It was my Western contribution: a white man making a totem. It is both male and female. The design was never executed. Everything fell apart because of events there', he continues. 'This village situated on Kivu river was considered the little Switzerland of the Congo before war broke out. All the villages are now destroyed and all the large villas completely plundered.' This monumental Kivu sculpture, which still exists in its original smaller version, has an enormous presence and leaves one wondering why Corneille did not venture more often into the three-dimensional.

It is only in recent years that he has regularly started to liberate his joyful and colourful world of birds,

women, suns, snakes and poetry from the flat plane in a kind of free-standing relief, by placing sawn-out flat forms on top of each other, allowing them to project into space. His manner of working is similar to that used by Appel for the wooden sculptures he began making in 1965 in Molesmes. Between 1993 and 1994 Corneille made around thirty-five such pieces, some of which were very large.[82] His designs for glass appliqués were shortly afterwards produced by the Van Tetterode glass studio, Amsterdam, and have a similar construction.[83] Truly three-dimensional are his colourful, very domestic-looking **Cat** and **Bird** made in polyester in 1996. The same can be said about a flying bird made in 1997 in an edition of nine and cast in bronze.[84]

Corneille also had intervals when he was engaged in decorating ceramics. This he did not only with Appel, Constant and Rooskens in 1948 and 1949 in a pottery factory at Tegelen (Limburg), but also in Albisola, Italy, during the ceramic event organised by Jorn. He worked there during the summers of 1954 and 1955 for three months at a time. As well as decorating factory produced plates he occasionally made his own vases. Later in the 1970s some of his decorative designs for plates were painted by Struktuur 68 in The Hague. In this studio his series of reliefs from 1993, 1994 and 1996 were produced as well as his designs for three-dimensional ceramic objects. In St Amand ceramic studio at Treigny in Bourgogne where he has recently immersed himself again in decorating plates and bowls, he also made a relief consisting of seventy tiles (1998) for a synagogue in Paris.[85]

Constant

Constant (b. 1920), for whom in his later artistic development the three-dimensional was to become a highly serious business in the form of the many models made for his Utopian city New Babylon, already nurtured a certain interest in sculpture from early on. When he was sixteen he attempted to make two mask-like male heads, one in teak the other in cement.[86] In 1938 he attended the Amsterdam School of Arts and Crafts where his lessons included modelling and learning how to cast plaster. During his training at the State Academy of Fine Arts in the same city the following year, Jan Bronner was one of his teachers. Constant found his work far too stylised, however, and his primary interest was still drawing and painting. More so than Appel and Corneille, Constant kept abreast of new developments in art through reading books.[87] During the war he was also confronted with the avant-garde in art when he visited the home of his future father-in-law, the composer Jacob van Domselaer, in Bergen, North Holland. Domselaer had been in close contact with Mondrian and was trying to adapt the theories of De Stijl into his own music.[88]

Towards the end of the war, Constant threw himself into experimental work. This was not only limited to paper and canvas, for in the postwar period he made three-dimensional objects, some in metal and others from wood offcuts. From the first kind, wire sculptures, only two are known to have survived, namely **Small Man**, made in 1947, (fig. 80) and **Snared Bird** from 1948. At the same period he must have made several other sculptures in this style, including one entitled **Chicken** in which he used a scouring pad and a fencing mask (he was already extremely fond of fencing at the time). Only a photograph remains of this particular piece (fig. 79).[89] In the lines of these wire objects which he manipulated in space, he recalled the nervous, feverish handwriting that so typifies his drawings of the Cobra years. This would surface again in his paintings and water colours which he made to be used as guidelines for his New Babylon project in the early 1960s.

It was due to Constant's initiative that in February 1948 sculptures and paintings by Appel, Corneille and himself were exhibited in the Santee Landweer art gallery, named after an old Berlin gallery. He knew the owner, Baron von der Feltz, as he had already exhibited work with him in 1947. Constant recalls that at their joint show the plaster sculptures Appel was making at the time were also exhibited. The object Constant holds in the picture taken at the gallery (fig. 74) includes the hilt of a fencing foil. He gathered the material for his objects at home in his studio.[90]

Constant also procured pieces of wood and made the occasional free-standing objects, such as the extremely wild looking assemblage – of which only a photograph exists – to which he added hemp of the kind used for sealing thread (fig. 76). More often he attempted to use wood in conjunction with other materials, producing relief-like works which he then painted. On these reliefs one sees the same roughly rendered forms

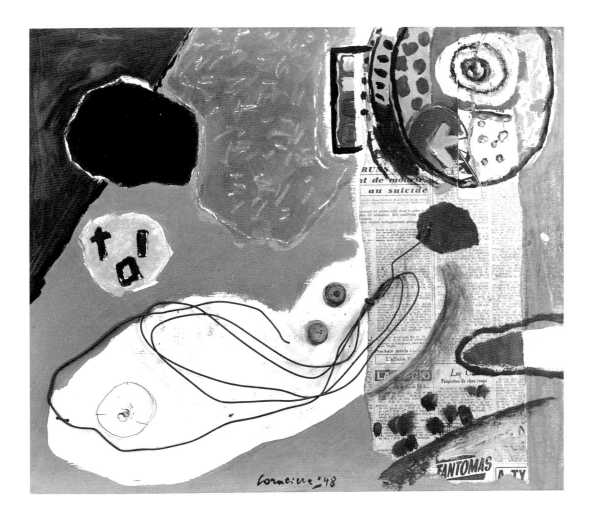

Corneille

71 Toi (You), 1948, collage on wood,
38 x 46 cm. Private collection, Os,
Netherlands.

72 L'arbre de vie (Tree of Life),
1948/1949, assemblage, painted wood and
metal objects. Lost. Presented in the poets'
cage at the Cobra exhibition of November
1949 in Amsterdam's Stedelijk Museum.
(Photo Mrs Kokkorris Syriër).

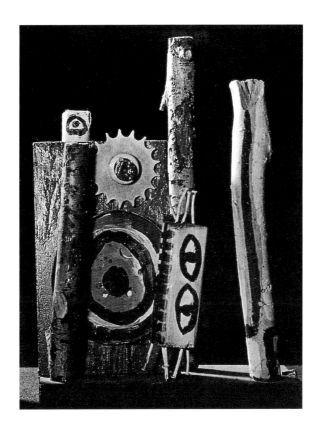

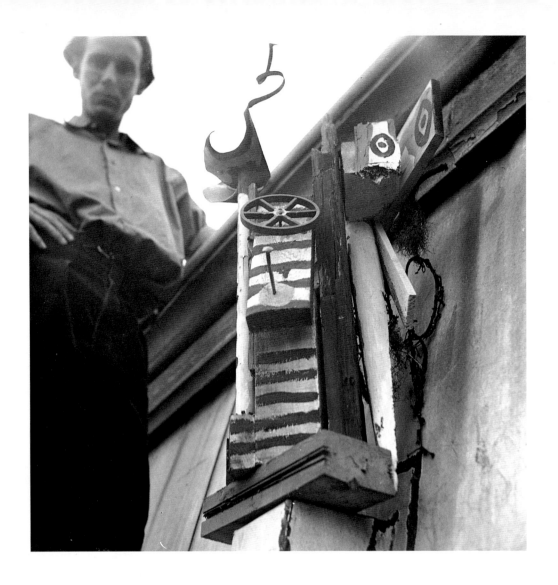

73 Corneille with a (lost) wooden assemblage of c. 1947-1948 in a contemporary photo taken in Ghent on the roof of the house of Karel van Geirlandt, later director of the Paleis van Schone Kunsten in Brussels.

74 February 1948: Constant, Appel and Corneille (L. to r.) posing at their show in the Santee Landweer gallery in Amsterdam, each holding an object. They mainly exhibited three-dimensional objects.

of fantasy animals that were typical of his paintings of the period. The only remaining example of this genre is Cat from 1948 (fig. 111). The reliefs were shown in the exhibition Les Fins et les Moyens, held by the Belgian section of the Cobra group in Brussels in the spring of 1949. The relief Whale, which Constant says was also exhibited, can be seen to the right of the well-known picture of the poet Dotremont, the 'secretary general' of the Cobra movement, sitting behind his typewriter at rue de la Paille in Brussels (fig. 126). Two other reliefs from the same exhibition, of which only photographs remain, included one assembled from the trimmings of rubber shoe heels and the other with plug sockets (fig. 77) (the whale, in fact, also had a plug socket). Later on Constant saw these two works hanging in a bar somewhere in Brussels.[91] One work inspired by Miró, Untitled from 1947 (fig. 110), was preserved. This piece, painted on bark, can best be described as a relief.

Constant depicted the characteristic fantastic animals of his paintings and wood reliefs in the well-preserved and even restored relief in cement that he made in the summer of 1949 in the garden of the Danish poet Jörgen Nash (brother of Jorn) at Tirbirkelunde, Denmark. In this relief, applied to a free-standing, man-sized wall with a lower side piece, one can see the Constant animals tumbling around in colour, sometimes with a head, tail or paws sticking above the edge of the wall (fig. 78). [92]

A few years after the Cobra group disbanded Constant began making three-dimensional objects again, this time not with materials found accidentally but with wire, aluminium and Plexiglas consciously chosen – a new phenomenon in art at the time. During this same period the artist also deepened his friendship with the British painter and later sculptor, Stephen Gilbert, who joined the Cobra movement at the end of 1948.[93] Like Gilbert, Constant evolved towards abstraction in his paintings of 1952. At the same time both artists became interested in the architectonic environment and were open to the ideas of De Stijl, a movement which Constant had previously detested.[94]

Constant, who lived in Paris (rue Pigalle 57) from 1950 to 1952, a period in which he also travelled through a devastated Germany and produced his dramatic war paintings, was given the opportunity in 1952 to stay in London for a time through a grant from the British Council. As one of the conditions of the grant was to visit other artists' studios and colleges of art, Constant was able to meet well-known artists Roger Hilton and Alan Davie, sculptors Henry Moore and Barbara Hepworth as well as painters/sculptors Victor Pasmore and Ben Nicholson. There he must have experienced the artistic climate as being extremely positive, as London made him aware of just how important the social environment was for a person.[95]

On his return to Amsterdam, Constant's thoughts on the city as backdrop for human existence and on the structure of cities prompted him from 1953 to create spatial constructions which can be read as architectural drawings. Gilbert, who had also studied architecture for a year before becoming an artist was similarly engaged at the time.[96] With their austere, geometric forms, Constant's first studies – which he presented as sculptures, such as his Monument for Post-War Reconstruction made in 1955 for the large exhibition E'55 in Rotterdam – are still highly suggestive of De Stijl, an influence he markedly defers to in his paintings and reliefs of the time. He quickly arrived at more playful forms in which he connected bent sheets of Plexiglas with metal rods into lighthearted compositions. After that Constant made ingenious constructions in which he interwove metal circles or wheels into a dynamic tangle of crisscrossing 'spokes'.

It is these kind of sculptures, combining technique and fantasy, that appear to be a natural continuation of the wire sculptures Constant made in 1947 and 1948. With pieces such as Planetarium (1955), Space Circus (1956-61, fig. 81), Sun Ship (1957) and his circle or 'bike wheel' constructions such as Construction with Semicircles and Départ pour l'Espace from 1958 and Fleur Mécanique (1959), Constant took an entirely different historical strand from the Expressionism of Cobra.[97] In the first place they are a continuation of the work of Russian Constructivists such as Tatlin, Naum Gabo and Antoine Pevsner or the Hungarian Moholy-Nagy, who saw the future of art linked to the development of technology, as did Mondrian and De Stijl in their own way. At the time Constant was able to apply something of this new development to his art, which he also saw in the light of improving the human environment in a practical way when he was commissioned to make sculptures for children's playgrounds. [98]

Around 1954 Constant and Gilbert came into contact with the French-Hungarian sculptor Nicholas Schöffer. Since 1948 he had been engaged in creating kinetic sculptures, which also produced sound, and which he wanted to use to give urban environments an imaginative appearance.[99] There was a plan for the three of them to exhibit in the Stedelijk Museum under the title Neovision but this never took place.[100]

Undoubtedly encouraged by these contacts it was Constant who ultimately explored ideas on human environments most rigorously. In 1958 he explained his belief that 'It is the artist's task to discover new techniques and to use light, sound, movement – in short any kind of discovery which can influence these environments', a belief which was in fact similar to the message of the White Manifesto which the Italian artist Lucio Fontana had issued twelve years earlier.[101] In similar vein in letters in French to the Situationistische Internationale in September of that same year, he wrote: 'Ten years separates us from Cobra and the history of so-called experimental art shows us the mistakes of this.'[102] With his views on future environments and the role of art, Constant found a kindred spirit in his old Cobra colleague Asger Jorn, who had founded the International Movement for a Bauhaus of the Imagination in Albisola, Italy, in 1953.[103] Although Constant, like Appel and Corneille during the Cobra years in the Netherlands, had occasionally painted ceramics and had even thrown the odd vase in the shape of the head of a bull, the communal ceramic experiments Jorn had stimulated as part of his new movement in Albisola during the summer of 1954 and 1955 had completely passed the Dutch artist by. This movement, with its lofty ideals that immediately appealed to Constant, was to evolve in 1957 into an international group of artists exploring future social environments, known as the Situationist International.[104]

Especially in the earlier stages of the movement, Jorn voiced all the antipathy he had harboured since 1937 towards the Functionalism propagated by the Bauhaus, on which he had also devoted various articles during the war.[105] Anti-Functionalism was also a feature of the Cobra movement. The first issue of the magazine Cobra that appeared in Copenhagen in the spring of 1949 contained an article by a certain Michel Colle in which he wrote that instead of an architectural landscape 'of cubes and prisms from Le Corbusier' he was searching for 'an architecture of the dream'. Colle illustrated the piece with drawings of his sculptural, curvilinear architectural designs.[106]

From the time of his renewed contact with Jorn in 1956 until 1974, Constant built on his city of the future, the New Babylon, which in its many varied raised structures was to manifest itself all over the world.[107] Here as a result of the achievements of technology human beings could once more choose how they spent their time as they had in the earliest forms of communal life. He shared this ideal with Marx and Engels who had already proposed it in their Deutsche Ideologie published in 1848.[108] According to Constant, everyone in this future environment could finally give free reign once more to their creativity. He later realised that this was a continuation of the old Cobra view given a new form. This new vision linked him to Mondrian, who also saw technology as an indispensable means of achieving his ideal of a harmonious society in the future.

Constant's transparent constructions, 'fatamorgana's' for a future environment (fig. 82) in which people would enjoy freedom of movement, can also be seen as sculptures. They were made by an artist who originally tried to find the source that bound him to the primitive and to the child in himself, only subsequently allowing technology to enter his fantasy world. At the same time, the different stages of his development feature wheels and ladders, firstly as symbols of despair and escape, and later as components of irrational structures, proposals for a Utopian, although sometimes stifling and prison-like, new world. In 1956 Constant summed up his ideas for a future social environment – which he expressed in almost mythical terms in his fantasy buildings – in a sentence every bit as appropriate to the aspirations of the Cobra movement: 'C'est dans la poëzie que sera logée la vie' (Life will be lived in poetry).[109]

Kunsthandel
Santee Landweer
Keizers gr. 463 Amsterdam

constant

K. Appel·
Corneille·

14 Februari – 4 Maart 1948
werkdagen 10–12.30 en 2–5 u

Constant
'48

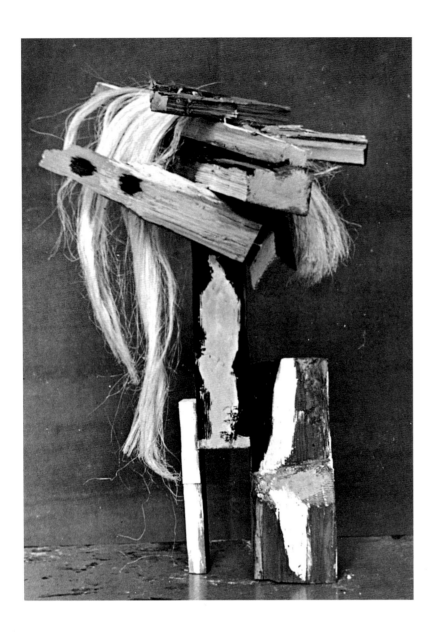

Constant (p. 85)

75 Poster for an exhibition of mainly three-dimensional objects: Constant, Appel en Corneille bij Kunsthandel Santee Landweer, voorjaar 1948 in Amsterdam, litho.

Constant

76 Lost assemblage of painted wood and flax, 1948.

77 Lost relief of wood and sockets, c. 1948.

78 Constant working on a cement relief executed in the summer of 1949 on a wall in the garden of the poet Jörgen Nash (brother of Asger Jorn) at Tibirkelunde in Denmark.

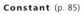

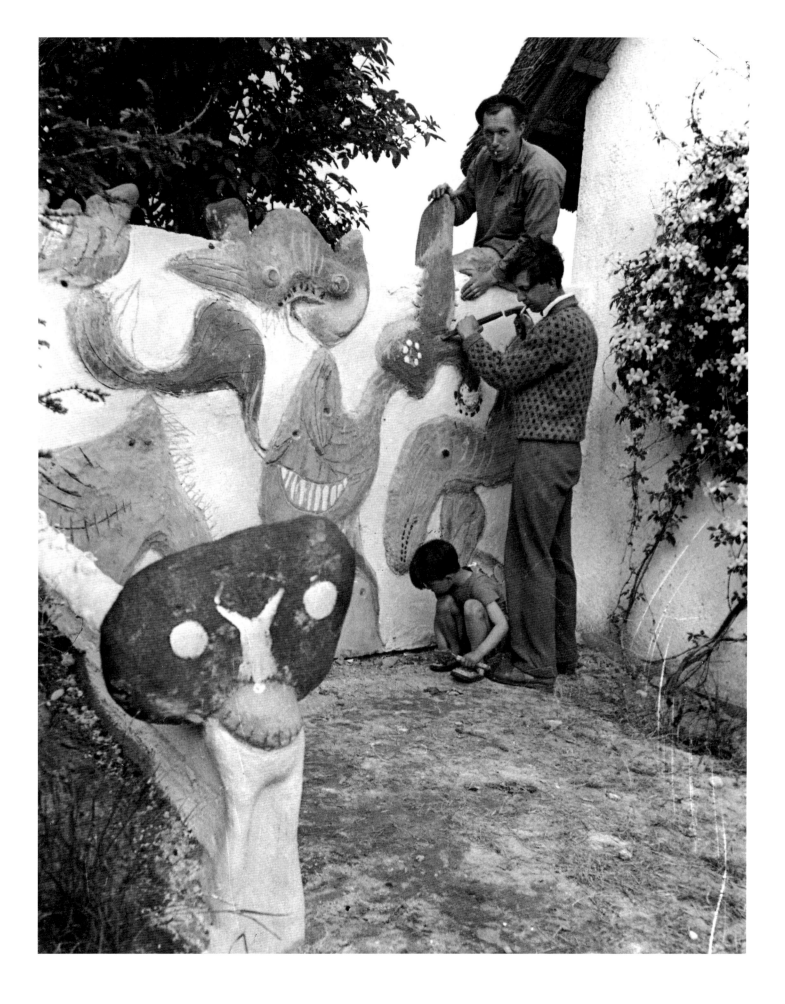

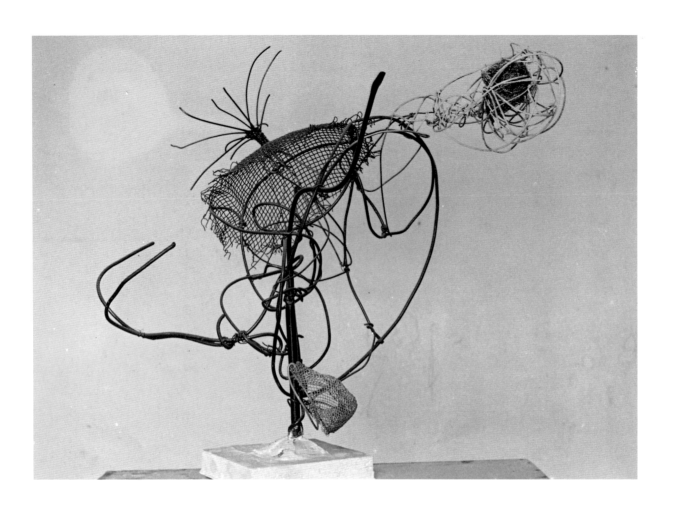

Constant

79 Chicken, 1948, lost assemblage of
wire, fencing mask and scouring pad.
(Photo Bram Wisman).
80 Small Man, 1947, wire, h. 50 cm.
Gemeentemuseum, The Hague.
81 Space Circus, 1956-1961, metal,
90 x 105 x 110 cm. Property of the artist.

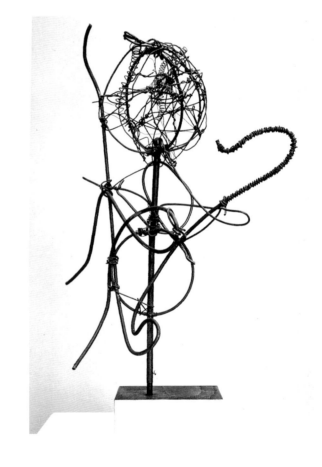

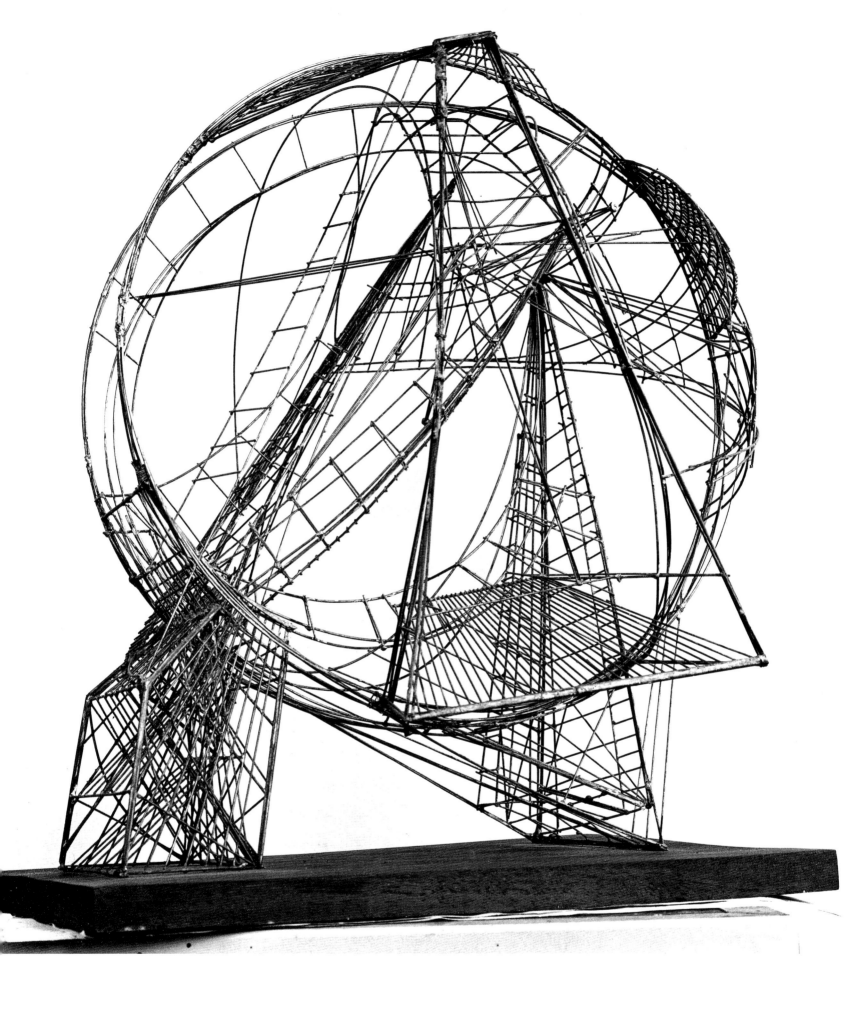

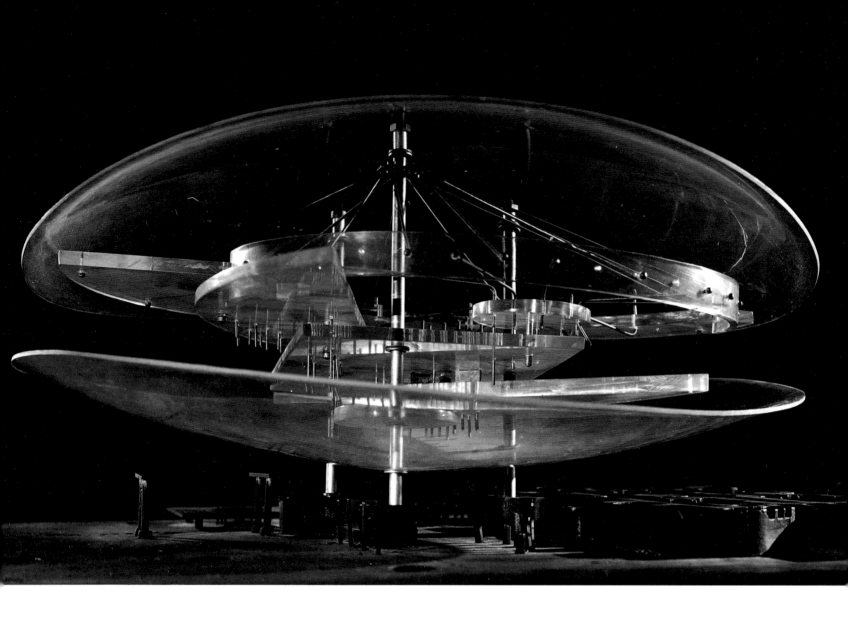

Constant

82 Spatiovore, 1960, plexiglass, iron
rods, inox, 119 x 64 x 56 cm; base 4 x 155 x
105 cm. Gemeentemuseum, The Hague.
83 Constant at work, 1957. (Photo Bram
Wisman).

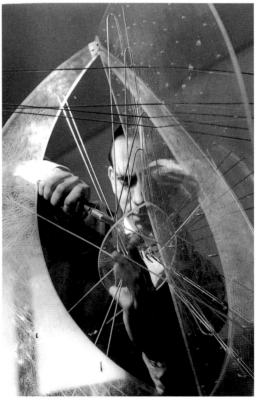

In the spring of 1949 Corneille was looking for like-minded artists to take part in an international exhibition of experimental art (Cobra) to be held in Amsterdam in November of that year, when he discovered the work of the sculptor **Shinkichi Tajiri**. This artist, born in 1923 in the USA of Japanese parents, took part in several leading Cobra manifestations. His contact with the Dutch members of the group especially and later with the Dutch art world in general was to evolve to such an extent that within a few years, especially after he settled in the Netherlands in 1956, he became entirely incorporated into the Dutch art scene. Dutch art itself was to be enriched by this exceptional artist who during the 1950s and '60s had already gained an international recognition as a precursor of new experimental sculpture. This was in the form of what had already taken place in painting – an international trend, now also apparent in sculpture, to abandon oneself to the characteristics and irregularities of the available material. Within this international context, dubbed **Art Informel**, Tajiri's work can be seen entirely seperately from Cobra. Apart from the fact that Cobra was a precursor and also part of **Art Informel**, Tajiri's sculptures, especially in his development during the mid-1960s, show certain similar trends that place him close to the special nature of the Cobra movement.[110]

In Tajiri the Cobra members met an artist who, due to the world conflict which had only just come to an end, no longer felt at home anywhere. The Cobra artists saw themselves in a similar light, although their estrangement was more of a Romantic longing. With their art and their ideals for a new society, they distanced themselves from what they saw as a decaying Western world, as indeed many other artists had before them. The roots of the real – the natural – existence they preferred to seek elsewhere.[111]

Tajiri, throughout his entire life, was to focus increasingly on the search for his own roots, driven as he was by a desire to find out more about his uncommunicative father, who had died young. This search resulted in a tale of almost mythical proportions but which was actually based on truth. Later, when visiting the now completely Westernised Japan, he felt a stranger there as well, although his work was considered more Japanese than that of modern, Japanese artists.[112]

From 1962 on, Tajiri, a descendant of an old aristocratic family, many of whose forefathers were either Samurai warriors or Zen Buddhist priests, withdrew to the Dutch province of Limburg in the eighteenth-century castle of Scheres with its fortress-like interior. Here he worked quietly on his 'warriors', symbols of aggression and defence, but also of fertility and contemplation. In recent years he recorded his own history there. The book that resulted is an extraordinary event in the history of world culture. As well as an account of his fate as a pawn in the war machine, he also printed the scroll showing the genealogy of his family. It dates back to a Chinese prince, a grandson of the twenty-sixth emperor of the Han dynasty. Around the year 270 AD this prince emigrated to Japan.[113] Tajiri's mother had entrusted the scroll with him in 1963 in Tokyo when he held his first exhibition in Japan.

Until he was thirteen Tajiri lived on the borders of Watts, the black ghetto of Los Angeles. Here his father, who had emigrated to America in 1910, began a bicycle repair business. As a child, all of Tajiri's friends were black Americans. His creativity was very much stimulated at an early age not only because he made his own toys, but also because the youth gangs, of which he became a member, constantly needed new 'weapons', such as various kinds of catapults. Despite the tough existence – he was already working at the age of four – he began drawing at the age of eight.[114] In San Diego, a city close to the Mexican border, where he had moved with his family in 1936, his drawing talent was discovered by a woman artist in 1941. She brought him into contact with the sculptor Donald Hord. This marked a special period in Tajiri's life when he was taught by an artist whom he much admired and who, in his robust sculptures carved from hard diorite, portrayed various themes related to the Central American Indians. During the same period Tajiri immersed himself in aviation technology with a view to studying aircraft construction and began making model aircraft.

Tajiri was to experience just how suddenly life can change when the Japanese airforce made a surprise attack on the US naval base at Pearl Harbour on 7 December 1941. The Japanese living in America, who already suffered discrimination, were now seen as part of the Yellow Peril. In early 1942 legislation was introduced which led to their internment. Tajiri was able to extricate himself from this extremely distressing situation when he and his family were interned by joining the newly established Japanese-American regiment of

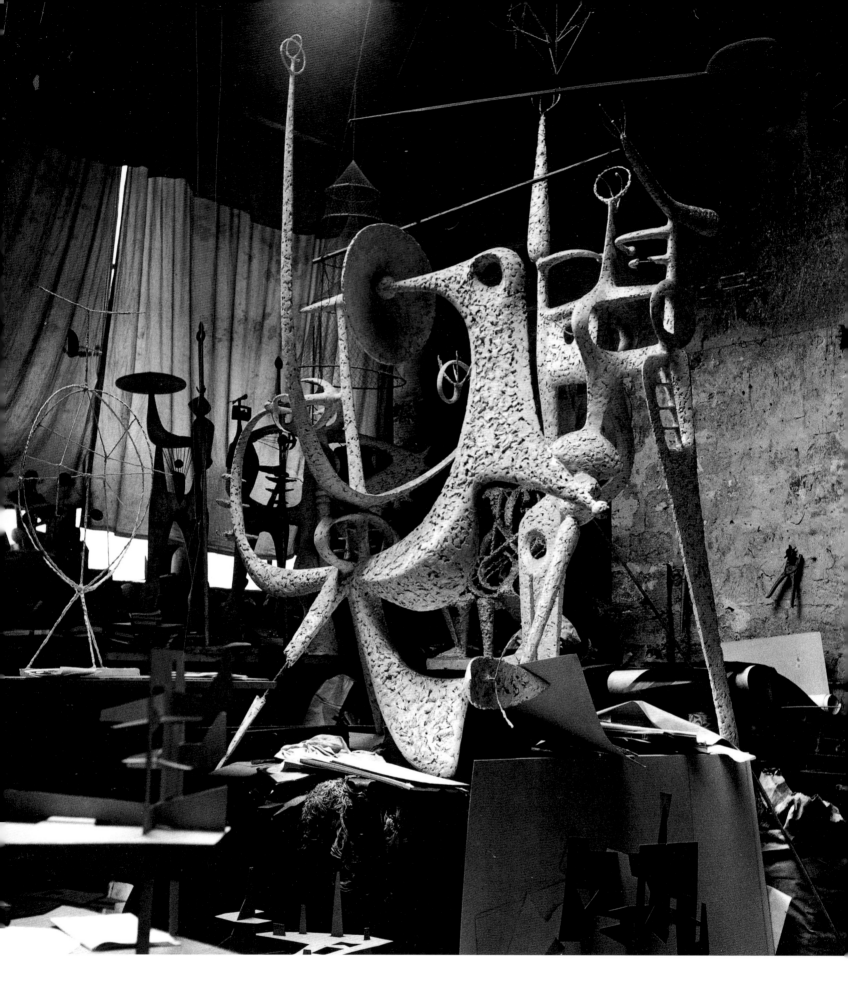

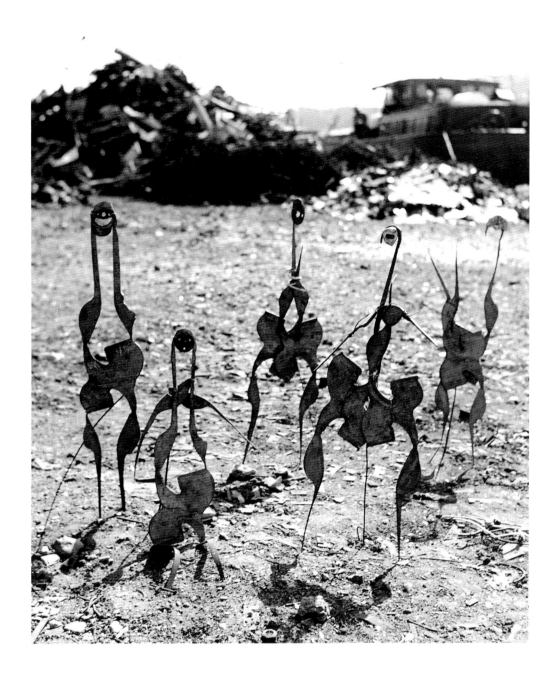

Shinkichi Tajiri

84 Tajiri's studio at Montparnasse, Paris

1949. (Photo taken towards the window).

85 One-Day Sculptures, 1952, made of

junk from the Seine, Paris. (Photo Sabine

Weiss).

volunteers. After an intensive period of training this commando team was deployed in the toughest situations in Europe. In Tajiri's case this was northern Italy. Many of these young soldiers were killed. They were regarded by the Germans as traitors and summarily executed whenever captured.[115] 'When I thought about this after the war, it seemed a clever way of wiping out the cream of one ethnic generation.'[116] Tajiri was rescued after an injury to his left leg and following an operation at a hospital in Rome he was declared fit for limited duties.

In early 1946, having returned to the United States, Tajiri was awarded a grant via the government scholarship system for war veterans and at the end of that same year entered the Art Institute of Chicago. Here for the first time confronted on all sides with twentieth-century art he threw himself into experimental works, making mobiles and 'three-dimensional Mondrians'.[117] He also worked for a while producing the works of the Japanese-American sculptor Isamu Noguchi, whom he had met at the internment camp in Arizona in 1943.[118] Noguchi's poetic language of form in marble must have made a huge impression on Tajiri. With discrimination against the Japanese in America continuing unabated, Tajiri decided in 1948 to try his luck in Europe. On the same scholarship, Tajiri was allowed to study at a school in Paris begun by the sculptor Zadkine for precisely this type of American student.

Tajiri arrived in Paris at the end of September 1948 and it was the start of a new life. Despite all that he had experienced, his determination to enjoy the possibilities now presented to him is obvious from a short poem he wrote at the time:

> Hush!!!
> Do not call us,
> Disturb not our sleep,
>
> Leave us
> In suspension.
>
> (the long sleep
> between hard times
> and death),
>
> to those minds
> to whom a seed
> contains
>
> an idea of beauty.[119]

Through the Dutch poet Simon Vinkenoog, who modelled for Zadkine – he was a 'wonderfully elongated Lehmbruck in white marble', Tajiri recalls – he came into contact with the circle of Dutch experimental artists, several of whom had settled in Paris in the late 1950s. 'I have a pocket full of stars/its source is replenished/I know not how', he wrote in another short poem that year.[120] At the same time Tajiri began keeping a note book which he filled with humorous experimental drawings and writings similar to those he saw from the hands of collaborating Dutch artists and poets (fig. 118). These appear to contain covert references to his own personal history. During this period, in which he was chiefly engaged in painting, taking lessons with Léger for a while and then – in order to make his grant stretch – enrolling at the Acade-mié de la Grand Chaumière, interest in his work came from the extremely rich American painter/dealer William Copley. He invited Tajiri to parties at his home some 30 kilometres outside Paris.[121] 'Copley liked my work. I was adopted.' There he met people like Max Ernst, Man Ray and Samuel Beckett.

In 1949, while he was taking classes with Zadkine, Tajiri was highly influenced by this inspiring teacher. One of the two plaster warriors he made, for instance, for an important Cobra exhibition in Amsterdam directly recalls Zadkine's Orpheus, executed a short time before, in that both featured a human figure with an open chest filled with wires.[122] At the same time, both warriors, one of which is now lost, reveal the

beginnings of his long-legged creatures which shortly afterwards became typical of his own fantasy world in metal. The surviving warrior with wires, later cast in bronze (fig. 116), appears to represent Tajiri's own situation. In this piece two warriors seem to be united in one figure. On the right is the Western warrior with his visor-like head inspired by the medieval suits of armour Tajiri had studied with great interest at the Musée de l'Homme.[123] To the left, there appears to be another head wearing an Eastern rice hat. The neck wearing this hat however can also be interpreted as the arm with the shield of the person wearing the armour on the right. Inside the strings, which represent the inner nature of this split Westerner, who is at the same time Oriental – or an Oriental who is being used as a shield – the heart appears as a ball being thrown back and forth between both possibilities. The fact that Tajiri wanted to say something similar either consciously or subconsciously is evident from a small shield on the left knee that recurs in many of his warriors and which alludes to his life being saved by a wound to his left leg.[124]

Tajiri's subsequent attempts to break free of Zadkine's influence can be seen in works that can be similarly interpreted such as David and Mrs Goliath, also from 1949 (fig. 115), in which he is clearly inspired by Max Ernst.[125] As in Ernst's work The King Playing with the Queen (1944) in which the king places the queen wherever he pleases, here a female Goliath, with crescent-shaped (demonic?) horns, manipulates a David. Perhaps this is a manifestation of another (subtly disguised) theme that I have discovered in his work – the struggle against the power of women. David, with his tall Japanese hair style and a bad left leg, presses his shield against a claw that his gigantic opponent lunges at him. It is not a comb in David's hair but a catapult which is aimed at Mrs Goliath's breast and which has already wounded her. Other works dating from this period have since been lost, like those shown in the photos of Tajiri's studio in Montparnasse. These were playful structures on thin legs very much in tune with the simplified forms often used by the Paris School artists around this time.

In 1951 Tajiri's grant ran out and he had to find a way to earn money. In this period he gave free reign to his inventiveness by working with junk found along the Seine. His quirky 'one-day sculptures' that he assembled on the spot from this material recall similar work by the Dane Henry Heerup, although he did not know him. These pieces were photographed by the photographer Sabine Weiss (fig. 85).

It was during this period that Tajiri became friendly with the Danish sculptor Robert Jacobsen and they actually became sworn blood brothers. He spent entire days watching Jacobsen working on his metal sculptures at his forge in the Maison des Danois, in the Paris suburb of Suresnes. Here Tajiri learnt how to weld.[126] His first sculptures using this technique were exhibited at the large final exhibition of Cobra work in November 1951 in Liège. Here he had an entire room at his disposal which he filled with four plaster and four metal sculptures (fig. 86). The metal works in particular were highly reminiscent of the language of form of Calder and Miró.

An entirely Tajiri language of form was first evident in the sculptures Figure, made between 1952 and 1953, and Wounded Knee from 1953 (fig.87), which were made from a network of iron rods welded together. Their structure is reminiscent of the so-called Watts Towers, the completely bizarre structures that the American outsider-artist Simon Rodia made between 1921 and 1954 on a piece of ground that he bought in the Watts area of Los Angeles. In his youth Tajiri had made a point of seeing these towers. Tajiri intended his Wounded Knee, the most spectacular of the two sculptures, which he painted black and red, as a political statement against the United States and its oppression of the Indians. This was also incorporated in an engraving he made in 1974.[127] However, the flimsy warrior, a transparent sketch of metal in space, again wearing a shield on his knee, valiantly sticking out a third knee with a catapult and wearing a kind of visor on his head from which all manner of defensive weapons project, is without any doubt Tajiri himself. He also belongs to a race that the Americans would have liked to have ejected from their country. In this work he has expressed his own history with a new mythical creature of universal interest.

Tajiri expressed his own wartime experiences in a more literal way in a series of reliefs entitled Scorched Earth that he began making in 1953 (fig. 120). 'For a soldier at war, the earth is his best friend', Tajiri once said in an interview. Just how ravaged this same earth he feels so attached to can become is

86 Room at the Second International
Exhibition of Experimental Art – Cobra,
held in October-November 1951 in Liège
with work by Tajiri now lost. In the
foreground, his first welded iron objects.

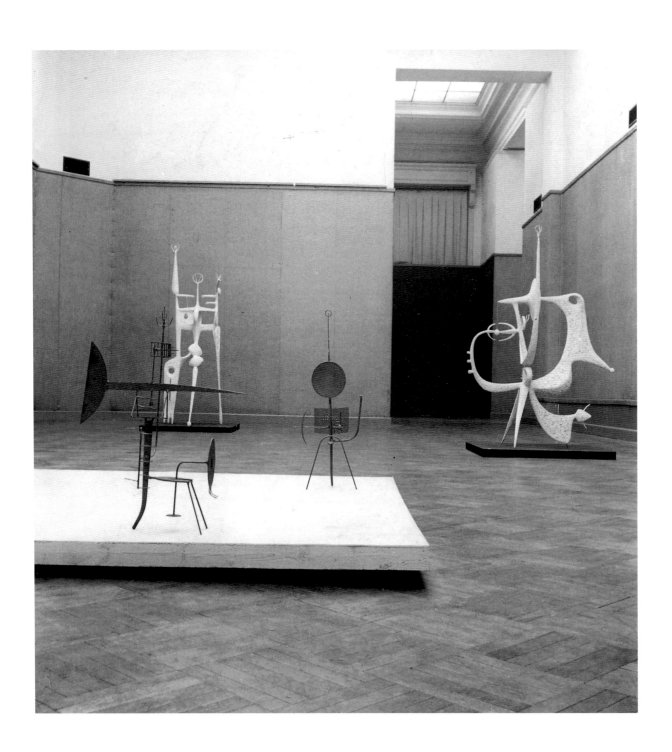

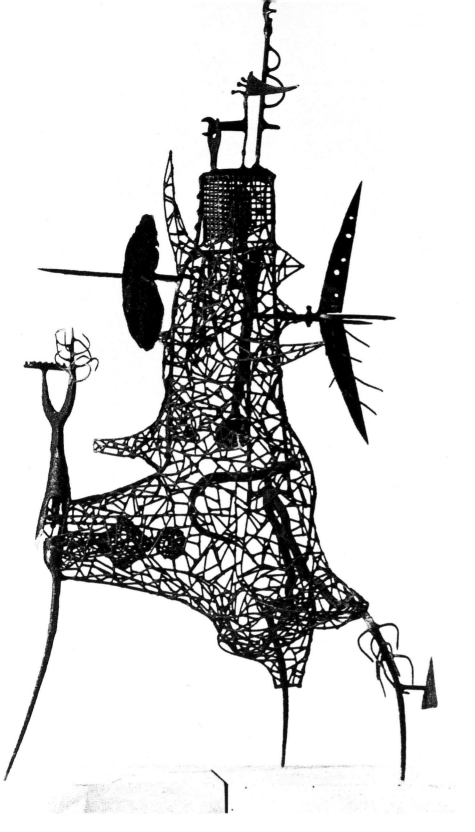

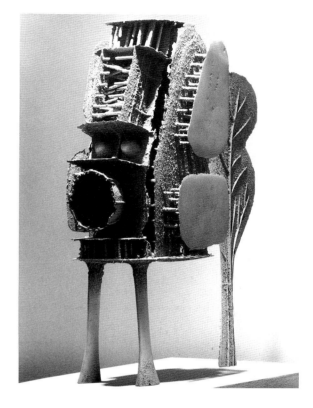

Shinkichi Tajiri

87 Wounded Knee, 1953, iron, painted
black and red, 105 x 50 x 33 cm.
Bonnefanten Museum, Maastricht.
88 Samurai, 1964, bronze, h. 80 cm.
Property of the artist.

depicted in these one-metre long iron sheets worked with acid and nails. The result of such treatment, strangely enough, is a refined form of poetry. And just as with Jean Fautrier's **Hostages** one forgets the depressing subject matter.

As part of his first series of welded-iron works he already made a rather aggressive warrior **Le Guerrier** in 1952 (fig. 119), not from a network of metal lines, but standing on three firm legs and with a violently spiky appearance. This typical Tajiri warrior is a recurring theme in his work in other techniques. He has also welded various playful sculptures, both suspended and free-standing, including **Mounted Warrior** from 1954, in which he incorporates all kinds of glass objects (fig. 91) which are obviously based on **Les Poupées** by Robert Jacobsen.[128] In 1953 he began making heavier compositions in iron such as his robust **Samurai** of 1954. Taking all these pieces together, it is clear that Tajiri belongs to the first group of artists who began working with iron and various kinds of junk. His work and that of Robert Jacobsen was highlighted by Edouard Jaguer in his 1960 book **Poëtique de la Sculpture,** a survey of a new generation of sculptors working with materials which had until then been considered unsuitable. Significantly reproduced on the title page of the book is a drawing by their illustrious predecessor, the leading pioneer in the use of iron as a sculptural medium, the Spaniard Julio González. Both Jacobsen and Tajiri's pieces were shown at the famous exhibition overviewing this type of work **The Art of Assemblage** held in New York's Museum of Modern Art in 1961. The **Watts Towers** were also illustrated in the exhibition catalogue.[129]

Tajiri only began making sculpture on a regular basis when he settled in Amsterdam in 1956 with the Dutch sculptress Ferdi Jansen, whom he had met in Paris. Not only were Dutch artists interested in his work, but also museums and collectors. During 1950 in Paris he had already been visited by both the Dutch architect Aldo van Eyck and the museum director Willem Sandberg, who first bought a sculpture from him in 1953.[130] In that same year the art collector Martin Visser did likewise.[131]

Tajiri flourished in the conservative Dutch climate and was quickly taken up by the small circle of pioneering sculptors – Carel Visser, Wessel Couzijn and Pearl Perlmutter. In 1957 he was even one of the founders of a new avant-garde group of sculptors working in the capital, the Group A'dam, and as a Dutch sculptor took part in the exhibition **Dutch Sculpture** at Museum Boymans-van Beuningen in Rotterdam.

Although he was not entirely free from poverty even in Amsterdam, he was soon inundated with work. Once again it was his inventiveness that enabled him to create new opportunities. These even proved essential to the entire nature of his work. At first he still made welded-iron sculptures, including his rather aggressive-looking **Carnivorous Plants**, whose vertical spiky compositions were similar to the work of Gonzalez in the 1930s.

Tajiri subsequently discovered that red porous bricks, familiar to him from Chicago and which could be exposed to high temperatures, were available close to where he was living. These could be hollowed out and filled with molten bronze. For four guilders a kilo Tajiri could cast his sculptures at a foundry located in the red-light district that made ship's screws. At the same time he was able to employ a method of casting in sand in this foundry in which two sides of a form were hollowed out of containers filled with a thick oily layer of sand.[132] Having placed one container on top of the other to create the negative forms, the metal could be poured – as in the porous brick technique – through tiny ducts to the hollow interiors. With these special casting methods Tajiri produced highly original pieces of sculpture.

Using the sand method the sculptor created a play with flat forms from which he again made various suspended sculptures. Later he returned to this method and used it on a wide scale for casting his 'knots' originally made of wood. It was, however, the casting method in porous stone that was particularly suitable for what he wanted to express at that time – aggression and its bitter consequences, the damage it inflicts on people and things and the inexorable law of mortality which binds us in a mysterious way to a great historic past. With this method the material has an important contribution to make. The porous stone enables the bronze to flow into every one of its hollows and small cavities and when the metal solidifies it produces a spiky surface. His Dutch colleagues were unable to use this cheap casting method since, whenever they tried, they only succeeded in producing 'Tajiris'.[133] Among the around fifty sculptures he made with this technique

between 1957 and 1964 are warriors, such as Samurais (fig. 121 and 88) from 1961 and 1964, as well as Atomized City from 1957, Fort from 1963 and Sept Plane from 1964. These are all images that refer to the destructive force of war, but of a war that apparently happened long ago. In fact with their surface brimming with random spikes, the sculptures look as if they were exhumed and are now displayed for our benefit as evidence of atrocious events of days long gone. One has the same sense of confrontation with mysterious exhumed objects in the many temple and pagoda-type objects he cast in red brick, such as Mediation Pillar from 1957, his towers of Babel (fig. 122) and the grave-type forms such as Obiït from 1963, based on the religion of Tajiri's native country.[134]

During the same period Tajiri also made work of a totally different nature, based on the one hand on experiences that had evidently deeply moved him and on the other arising out of yet another 'discovery' – the so-called drip style in sculpture (comparable to Jackson Pollock's painting method). To express his sense of the awesome power of nature's vitality he felt when his two daughters were born, he used remnants left over from casting as material for new sculptures. Welding these remains together, he composed plant-like sculptures which appeared to be germinating and growing in abundance and in which a seed boll about to explode increasingly formed the centrepiece, as in Seed No 5 from 1959. Around 1961 these evolving objects solidified into a one-off depiction of a large, female genitalia,[135] and in manifold variations of the male sex organ, such as Seed dated 1964. These would often take the form of a warrior, as in Guardian from 1961.

Overflowing with new ideas, Tajiri created three madly kinetic sculptures (adorned with, what seems to me, Indian feathers) entitled Mechanical Fighting Machines (1957, fig. 117), which could actually do battle with each other.

In 1964 he revived his old interest in aviation construction and assembled imaginative aircraft models from shiny steel, aluminium and plastic. These are still in the form of male creatures walking on high legs that have become machines and in which the phallus and the projecting rifle or gun have become one. Here the two basic, contrasting themes that constantly recur in his work, sometimes treated separately but more often intertwined, appear to have become one provocative synthesis in these smooth, detached pieces. One relates to an indictment of the absurdity of (male) violence, the other to the violence that accompanies eroticism or even downright aggression towards women.[136] With these imposing mythological or archetypal creatures, Tajiri rounded off a long visual story in which he expressed the forces that tried to snare him both from the outside world as well as from his own inner self.

Having long been involved with experimental photography, Tajiri then arrived at his vast, symbolic knots executed in various materials which, as starting points for contemplation, emanate a perceivable power in their very calmness. In recent years he has picked up his warrior theme again working on a series of forty-seven samurai (fig. 123) who, following their ethical ronin principles which Tajiri admires so much, commit seppuku (suicide) to save their honour.[137] However, for many of these warriors, which are cut out of Centa foam and occasionally cast in bronze, the body – as with all his warriors in fact – is also the armour, the phallus is also the weapon!

Tajiri was often mentioned in connection with Cobra and exhibited with former Cobra members. In his highly individual way, his sculpture was very much in tune with the mythical world that typified Cobra and, like those artists who belonged to the group, he allowed the material he employed to play an important, autonomous role in his work.

Three-dimensional experiments by other remaining Dutch Cobra exponents

Jan Nieuwenhuys (1922-1986), Constant's brother, was only involved with the Cobra movement for a short time but he probably made many assemblages or objects between 1948 and 1949. It was chiefly this kind of work that were shown at the exhibition Gouaches by Rooskens and Objects by Jan Nieuwenhuys from 30 October to 13 November 1948 at Gallery Melchers, Amsterdam. Unfortunately none of this work has survived. Only one photograph of a totem-like piece entitled Red Bull, reproduced in the spring of 1948 in the first issue of Reflex, testifies to his activities in this field.[138]

The painter Wolvecamp never worked in the three-dimensional. On the other hand, Anton Rooskens and Lucebert (1924-1994) were certainly captivated by pottery, and especially in their later development threatened to abandon the two-dimensional plane.

From his early years in the province of Limburg Anton Rooskens (1906-1976) knew a director of the ceramic department of the brick factory at Tegelen. The latter was willing to give artists the opportunity to experiment, and having worked there with several Amsterdam colleagues, Rooskens introduced Appel, Constant and Corneille to the factory in 1948.[139] Rooskens appears to have painted various plates there at the time. It was only in 1973, in collaboration with ceramic studio Struktuur 68, that he turned his attention to three-dimensional work. In that year the studio produced seventeen of his designs for ceramic relief panels, each 50 x 60 centimetres and between two and six centimetres thick.[140]

In the years prior to his death Lucebert (1924-1994) was inspired by Picasso and Jorn's enthusiasm for ceramic art. With his unstoppable flow of creativity during those years, he threw himself into working with clay. He had already considered painting ceramics – in 1951 and 1952 when he sometimes applied Picasso-inspired depictions onto the products of his friend the potter Frieda Koch. He occasionally made his own figures in clay, such as the glazed relief Owl (h. 14 cm) 1952.[141]

In 1990 and 1991 Lucebert was particularly active making pottery in Berlin. Here he was able to work at the ceramic studio of Kattrin Kühn, the so-called Droysen Ceramic Studio and Gallery. Besides decorating plates and vases, he also modelled several fantastical creatures in clay in his highly recognisable curvilinear signature (fig. 112-114).[142] Lucebert then contacted the ceramic studio Struktuur 68 in The Hague. A commission to make a 20 metre column covered with painted tiles for the Red Cross Hospital in the North Holland town of Beverwijk was produced by the studio after his death according to a 1993 design.[143] In 1996 the studio also produced an enormous version of a small imaginary pottery animal Lucebert made in 1990 for the Kranenburg Museum in his former home town of Bergen in North Holland.[144]

Lotti van der Gaag

In conclusion I would like to say something about the work of Lotti van der Gaag (b. 1923) who, like Appel and Corneille, settled on the rue Santeuil, Paris, in the late 1950s. Although never involved with the activities of the Cobra movement, her work undoubtedly belongs to the Cobra idiom, as her friend at the time, and later well-known art historian, Wim Beeren, remarked in his article 'Cobra in Retrospect' in the special Cobra issue of Museumjournaal in early 1962.[145] This was a first historical appraisal of the Cobra movement. In a letter of recommendation for a French scholarship for Lotti, Hans Jaffé, working for the Stedelijk Museum at the time and later a professor of modern art, wrote in 1952: 'She belongs to that group of young people who are engaged in a primitive form of art, a group that also includes Appel, Corneille, Constant and others. Among this group she is the only one exclusively making sculpture.'[146] As an art historian I agree with my colleagues, including Sandberg, who ranks Lotti unreservedly among the avant-garde of the 1950s.[147] He exhibited her work along with that of her friends and other innovators in modern art in key national and international exhibitions of the 1950s and '60s.[148]

Through her relationship with artist Bram Bogart, which began in 1946, Lotti, who worked at all kinds of jobs after leaving the lower rung of the Dutch secondary school ladder, began devoting more time to a desire to draw and sculpt. Her early work was greatly influenced by her distant ancestor Vincent van Gogh.[149] Deeply upset when her relationship with Bogart ended, she finally decided in 1948 to become a full-time artist. At the end of that year, the surrealist-inclined artist Livinus van de Bundt, an exceptional teacher and director of the Free Academy in The Hague (the art school Lotti was attending at the time) singled her out and gave her an attic in his school building. Here she worked all winter alone articulating her feelings of depression, which she was encouraged to express completely. The few surviving sculptures from about 150 made during this period may in Surrealist terminology be seen as a direct result of 'psychic automatism'. They appear to have

89 Shinkichi Tajiri, autumn 1949, in Amsterdam. (Photo Mrs Kokkorris Syriër).
90 Tajiri at his studio in Montparnasse, Paris, 1949. (Photo taken towards the inside wall).

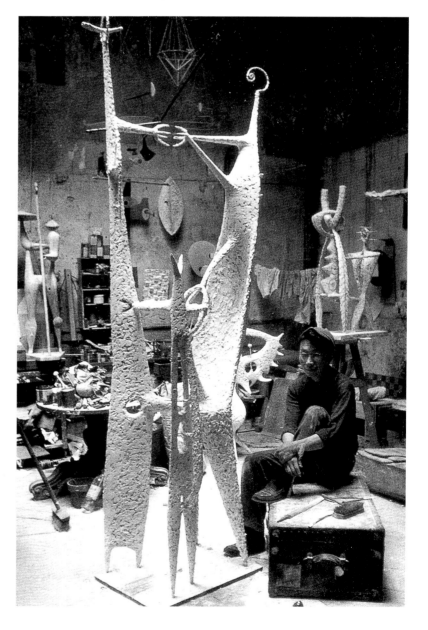

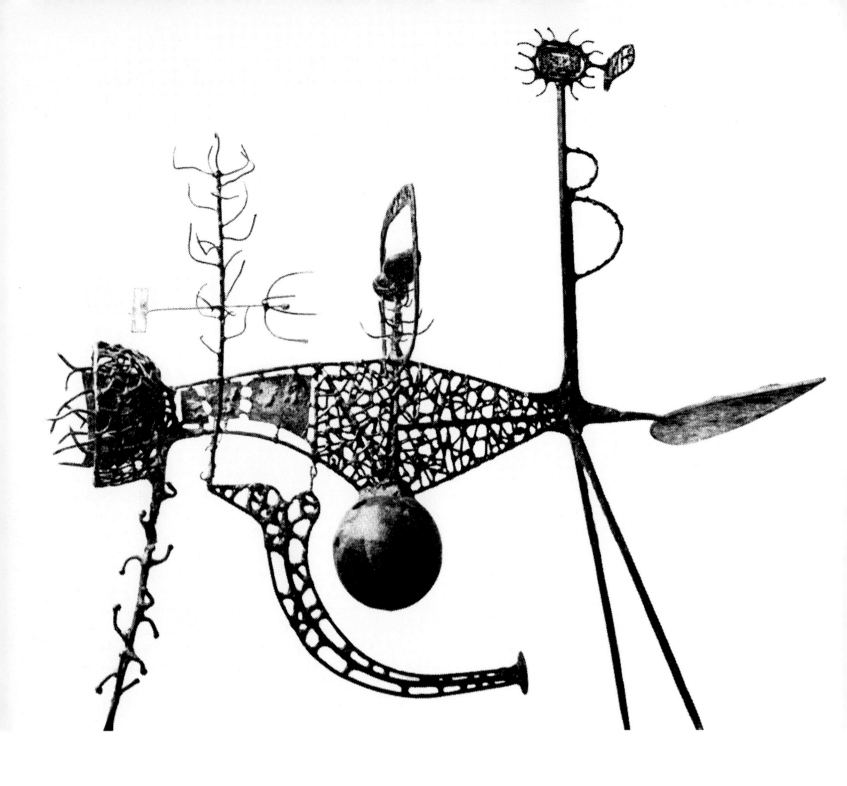

Shinkichi Tajiri

91 Mounted Warrior, 1954, iron and
glass, h. 65 cm. Location unknown.

been made from the uncontrolled primitive urge through which material is brought to life and seem to represent the earliest stages of life. It is the moment when it is still unclear whether life will choose to be in animal or human form and contains something uneasy and alienating. In a photograph taken at the time Lotti stands in front of several of these white clay sculptures, including Dance Urge from 1949, which she was soon able to show at her first exhibition in a gallery (June 1950 in The Hague). Her work was also included in museum director Willem Sandberg's 1952 exhibition The Devil in the Visual Arts in which several of her pieces, among them Hanging Figures, from 1948 and 1949, made from coils of clay were suspended by threads from the ceiling of a dimly-lit room and lit by spots. Newspaper art critics of the day described her work in terms of the primitive, although at that time she was not yet acquainted with art of this kind.[150]

In a sense Lotti may be judged a genuine outsider. The human figures and forms of her later sculptures and paintings appear to have stemmed from the same unconscious source as her first hybrid creatures in clay. They rarely recall directly the work of other artists, although Lotti's technique was certainly influenced by others.

Highly impressed by the exhibition 13 Sculptors from Paris in which Lotti saw work by Brancusi, Laurens, Lipchitz, Zadkine, Giacometti and Richier, she desired to broaden her horizons. At the end of 1950 with a rucksack and no more than fifty guilders to her name, she travelled to Paris. Her objective, as she once remarked during one of the many conversations we have had since 1982, was to take lessons with Zadkine whom she had admired for some years. From that time, albeit with many return visits to the Netherlands, she has lived in Paris, where until 1962, she existed under the most abhorrent conditions at the malodorous warehouse for cow hides on rue Santeuil with her daughter Isis, born in 1954. During this period she was able to build up an impressive body of sculpture.

From 1951 on in Paris, under Zadkine's influence, Lotti began opening out the previously solid forms of her sculptures. Intimations of this can already be seen in 1950 in sculptures such as Amazed Woman. She also began to use an ingeniously constructed armature around which she applied the clay or plaster that she mixed with other materials. This method increasingly allowed her to construct her sculptures from intertwining forms which combined suggest a fantastical creature. This play with forms, many of which you can peer straight through, and which when moved even slightly reveal entirely new aspects to the observer, became the distinguishing feature of Lotti's work. This, however, made them both highly fragile and extremely difficult to cast in bronze. Fortunately many of her pieces were cast, as it was actually a pre-condition to participating in certain exhibitions. The creatures that she evoked with this play on form were initially still part human and part animal fantasy figures. However, the sense of depression they had once conveyed was now largely cast aside. These sculptures emanate vitality and have a childlike quality, such as her Moon Man from 1951 (fig. 92), Waiting Person, also from 1951 (fig. 94) and her Bird of Prey executed in 1952. They come close to the work of her neighbours occupying the same floor of the premises on rue Santeuil: Appel and Corneille. However, she never applied colour to her sculptures. Colour can be found here and there in the powerful and sometimes extremely barbaric drawings that she made at the time and which can be seen as a source of ideas for her sculptures.

Gradually more organic forms crept into Lotti's work. Creatures such as Tree Gods from 1953 and 1959 and Urge-animal from 1957 (fig. 93) seem to be made of vegetal forms or remain virtually invisible absorbed by intertwined jungle-like vegetation, as in Balghol from 1958. Certain of these compositions, especially those made in the second half of the 1950s, tend towards the abstract. Her method of construction gave her the freedom to make sculptures such as Sun Cymbals, 1958 (fig. 96), made up of two parts and which could be put together in various ways. In the 1960s crosses and arrows began to appear in her work. Absorbed into the fashion of the time, Lotti began including 'found' materials in her now clearly primeval clay creations in 1962. Occasionally she even made these body parts move.

Although she exhibited her sculptures widely and completed several monumental commissions, she decided in 1974 to stop making any more sculpture partly because she could not afford to have them cast.

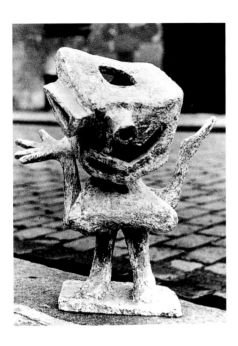
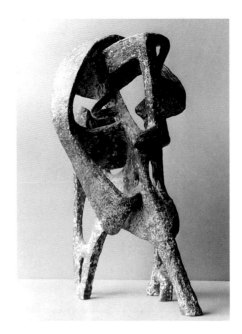
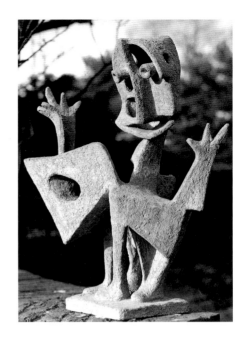

Lotti van der Gaag

92 Moon Man, 1951, bronze (original terracotta), 45 x 60 cm. Wil van Eck-Nieuwenhuizen Segaar collection, The Hague.

93 Urge Animal, 1957, bronze (original terracotta), 48 x 26 x 22 cm. Netherlands Collection.

94 Waiting Person, 1951, bronze (original terracotta), 62 x 50.7 x 36.5 cm. Museum Boijmans van Beuningen, Rotterdam.

95 Lotti van der Gaag with a sculpture subsequently lost. Rue Santeuil, Paris 1951.

96 Sun Cymbals, 1958, terracotta (in two parts), 63.5 x 60 x 51.5 cm. Stedelijk Museum, Amsterdam.

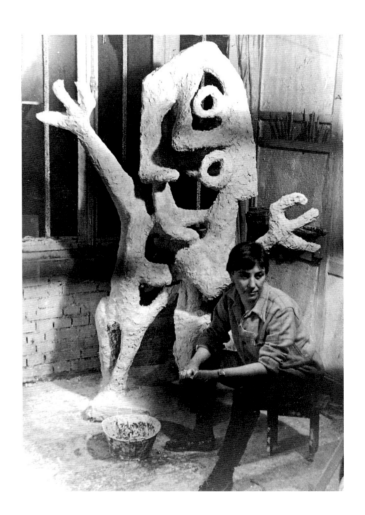

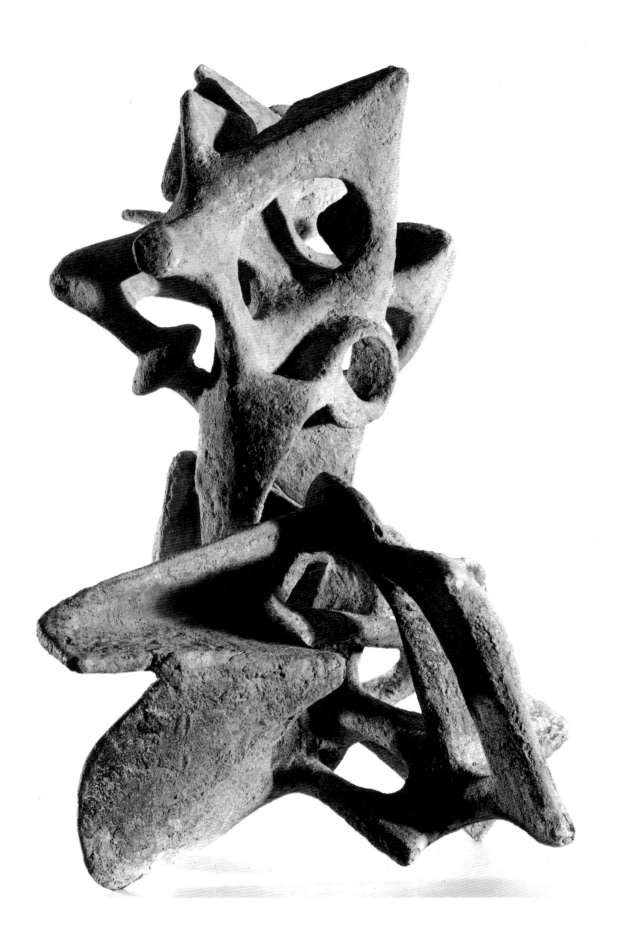

The large body of paintings she subsequently built up, begun in 1960, displayed the same characteristic play of intertwining forms so typical of her sculptures. From 1964 she also conjured up fantastical creatures in bright colours.

1 See José Boyens, 'Nederlandse expressionistische beeldhouwkunst van 1910-1935 in internationaal perspectief ', in Piet Boyens and José Boyens, *Expressionisme in Nederland 1910-1930*, Zwolle/Laren, 1994, pp. 214, 216 and 217. See also Ype Koopmans, *Muurvast & gebeiteld. Beeldhouwkunst in de bouw 1840-1940*, Rotterdam, 1994 (Part 1), 1997 (Part II), p. 179. The sculptor Johan Polet was inspired by primitivism for a short time and was an admirer of Zadkine's work. See Koopmans, op. cit. p. 162.

2 See Carel Blotkamp, *Carel Visser*, Utrecht/Antwerp, 1989, p. 40. The exhibition included works by Arp, Brancusi, Giacometti, Gonzalez, Laurens and Lipchitz.

3 See A.M. Hammacher, in his book on Dutch sculpture *Beeldhouwkunst van deze eeuw*, in the series 'De schoonheid van ons land', Amsterdam, 1955, p. 11.

4 See Caroline Boot and Marijke van der Heijden, 'Gemeenschapskunst', in the catalogue *Kunstenaren der idee. Symbolistische tendenzen in Nederland ca 1880-1930*, Gemeentemuseum, The Hague, 1978, p. 38.

5 See E.J. Lagerweij-Polak, *Hildo Krop*, Amsterdam, 1992, and Koopmans, note 1, above.

6 See Lieske Tibbe, *R.N. Roland Holst 1868-1938. Arbeid en schoonheid vereend. Opvattingen over Gemeenschapskunst*, Nijmegen, 1993, pp. 280-289.

7 See Hammacher, note 3, above, p. 26.

8 The exhibition, which with minor adjustments had transferred from the Kunsthalle, Basle, 'escaped the notice of most Dutch sculptors, or … it was ignored'. The exhibition was even considered to be 'a totally outdated intellectual viewpoint' and 'had arrived around twenty years too late'. However, the 1939 exhibition *Rondom Rodin. Hondered Jaar Fransche Sculptuur* tracing a century of French sculpture, held in the same museum, was deemed 'the most important Dutch event in the field of modern sculpture'. See Koopmans, note 1, above, pp. 217, 218 and 243.

9 A similar scheme had already existed in France since 1936 and Scandinavia also had ' state intervention regarding the visual contribution towards government buildings'. See Cor Blok, 'Van representatie tot identificatie. Een kretologie van de percentageregelingen', in *Kunst en Omgeving*, edited by Stichting Kunst en Bedrijf, The Hague/Amsterdam, 1977, pp. 150-151.

10 The sculptor and painter Jaap Mooy told me this in autumn 1965.

11 In my article on the Dutch Cobra movement 'De Nederlandse bijdrage aan de Cobrabeweging en verwanted in schilder- en beeldhouwkunst', in Geurt Imanse (ed.), *De Nederlandse identiteit in de kunst na 1945*, Amsterdam, 1984, I put forward for the first time the three-dimensional work of Dutch Cobra artists within this context in the paragraph 'Cobra en de beeldhouwkunst', pp. 50-58. This view was taken up by Paul Hefting in his book *De eigen ruimte. Beeldhouwkunst in Nederland na 1945*, Amsterdam/Brussels, 1986. In his introduction Hefting devotes more attention than Hammacher did (see Hammacher, note 3, above) to the few abstract and/or experimental sculptures made before 1945 in the Netherlands. Hefting also mentions certain sculptors such as Piet van Stuivenberg and Koos van Vlijmen, who had been working in an abstract-geometric manner since 1945. In a sense, Cobra sculpture was the precursor of the extreme experimental Dutch sculpture current since around 1980 that Hefting describes. In 1994 experimental Cobra sculpture as well as the abstract-geometric works mentioned here were again (more or less) not seen as part of 'free sculpture' in the Netherlands. See Louk Tilanus, 'Het vrije beeld 1900-1960', in the catalogue *Er groeit een beeldhouwkunst in Nederland*, Frans Hals Museum, Haarlem, 1994, p. 36, which strongly echoes Hammacher's vision..

12 See Eugène Brands, 'Omkijken naar Cobra. De beet van Cobra', in the catalogue *Eugène Brands 1948 Cobra 1951*, Delta Gallery, Rotterdam, 1964; W. Stokvis, 'het poëtisch universum van Eugène Brands', in the catalogue *Eugène Brands*, Galerie Nouvelles Images, Amsterdam/Frans Halsmuseum, Haarlem, 1979, pp. 7-22; E. Wingen, *Eugène Brands*, The Hague, 1988, pp. 15, 21, 24 and E. Wingen, 'De andere kant van Eugène Brands: assemblages en collages', and 'Hout, papier en gevonden voorwerpen de weg van Zandvoort naar Corfu', in Leo Duppen et al. (compilers), *Eugène Brands: Collages en Assemblages*, Amsterdam, 1997.

13 In a letter Brands wrote to me on 8 January 1981 he said he no longer wanted to go into his Surrealist period. The fact that the objects he made had not survived was 'a clear sign' that 'his ideas, meanwhile, had evolved in a different direction'.

14 The diverse influences Brands experienced during this period are namely to be found in drawings and collages from the Frans Boom collection (87 works in total), which are preserved at the Print Cabinet, Leiden. Boom met Brands in 1943 through a shared interest in American Blues music (Brands told the student Pieter Jongert about this meeting when the latter wrote something about the collection).

15 See note 8, above of this chapter.

16 See the catalogue, *Surréalistische schilderkunst* with an introduction by George Hugnet, Amsterdam, 1938.

17 For more on Elburg's Surrealist poems see my article, 'Jan Gommert Elburg, de dichter: een beeldend kunstenaar', in Jan G. Elburg, *Vroeger komt later*, Amsterdam, 1986, pp. 7-32.

18 See Agnes Grondman et al. (eds), *De automatische verbeelding*, Amsterdam, 1989.

19 This drawing is part of the Boom collection, see note 14, above.

20 During the war, when he lived in Amsterdam again, Brands had close contact with Louis Lemaire, a dealer in Asian and ethnic art, for whom he copied Asian and African masks from books. In the same period he made masks himself and began collecting primitive art. His collection of authentic folk music dates from before the war. See my article, note 12, above, pp. 9, 15 and 16; and Duppen, note 12, above, p. 15.

21 On the drawing Brands has written *Proeve van illustratie voor 'Taal der dingen…'*. (Sample illustration for the 'Language of Things'.) The collector to whom it belongs (see note 14, above) wrote underneath the drawing on the left-hand side in Dutch: 'received from Eugène 8 Sept, 1944' and on the right: 'fantasy sketch for essay'.

22 See my writing, 'He poëtisch universum van Eugène Brands', in the catalogue *Eugène Brands*, Galeries Nouvelles Images, Amsterdam/Frans Hals Museum, Haarlem, 1979, p. 20.

23 Both photographs are illustrated in Duppen et al (see note 12, above, pp. 6

and 63). In an interview with the artist in spring 1979, Brands told me that, behind him, for the photograph he arranged the entirely white painting Lifeline (done in 1938/39), which probably no longer exists and which had a bright red line running vertically through it.

24 During a telephone conversation on 8 March 1979.

25 During my interview with him in 1979 in relation to a text I was writing for the exhibition at the Nouvelles Images Gallery, he confided in me at length about his work at the time, and showed me his writings and photographs of his assemblages. However, as he no longer wanted to be reminded of the time when he made these Surrealist objects, he did not want everything we discussed made known. This was reiterated later in a letter of 8 January 1981 to me (see note 13, above). Evidently by 1988 he had changed his feelings concerning this.

26 In the letter of 8 January 1981 Brands wrote to me (see note 13, above) he mentions the fact that his Surrealist objects had not survived: 'this is actually proof enough that my ideas and work had meanwhile developed in a different direction'. Further on, he writes: 'You must realise that the period of Occupation was for me, a born optimist, an extremely difficult and depressing time. I truly hope you can relate to this and that this entire Surrealist period, including the visual and written work, gives me the feeling that this all happened 40 years ago.

27 In the catalogue of his exhibition Eugène Brands Panta Rei at Nouvelles Images Gallery, The Hague, 1977, Brands writes enthusiastically about this 'indisputable truth', in which he sees the spiral motif, that occurs so much among primitive peoples, as a symbol.

28 The few exceptions included the artist, art connoisseur, collector and art school teacher Paul Citroen and the artist and art school teacher Willem Schrofer. See Adi Martis, 'Kunstonderwijs een voedingsbodem voor geometrische abstractie', in Jonneke Fritz-Jobse and Frans van Burkom (compilers and eds), Een Nieuwe Synthese, The Hague, 1988, pp. 60-72; Herbert van Rheeden et al., Paul Citroen, Zwolle Wije, 1994, and Elsje Drewes (with an introduction by Cor Blok), Willem Schrofer (1898-1968), Zutphen, 1998.

29 These were young artists who became members of the Cobra movement and many of their contemporaries alike. For a picture of artistic life in the Netherlands at the time, see the book I compiled and edited, De doorbraak van de moderne kunst in Nederland, de jaren 1945-1951, Amsterdam, 1984 (1), 1984 (2) and 1990 (3). Shortly after the Liberation the following exhibitions were mounted at the Stedelijk Museum: Georges Braque (20.10.-12.11.1945); Picasso-Matisse (5.4.-28.4.1946; Piet Mondrian (commemorative exhibition: 6.11.-15.12.1946); Calder-Léger (19.7.-24.8.1947); Kandinsky (19.12.1947-8.2.1948); Paul Klee (9.4.-14.6.1948)and '13 Sculptors from Paris', see note 2, (26.11.1948-1.2.1949).

30 His post-war experiments (including many abstract compositions) on paper as well as a few canvases can be traced in: Jean-Clarence Lambert, Karel Appel: Works on Paper, New York, 1980, and Michel Ragon, Karel Appel Schilderijen 1937-1957, Amsterdam, 1988 (originally Paris, 1988).

31 In my interview with him on 28 April 1998, Appel explained: 'I was aware of Van Gogh before the war. I often went to the Stedelijk Museum – you could get in for 10 cents – and that's how I got to know about him so much. I instantly recognised him by the material, from the way he applied the paint'.

And later: 'I loved Monet and the Impressionists'.

32 In 1965 I made photographs from Appel's own photo-album, including two of his studio on the canal Oude Zijds Voorburgwal (no.127).

33 A Jeanette by Matisse and a Woman's Head by Picasso are illustrated in Carola Giedion-Welcker, Contemporary Sculpture, New York, 1955, p. 20.

34 See William Rubin (ed.), Primitivism in 20th Century Art, New York, 1984, pp. 326-327.

35 See Introduction, note 4, p. 70, including notes 1 and 2. He destroyed many of his sculptures as he was suddenly evicted from his studio in 1948 and made homeless. A few survived as friends had preserved them. Appel told me this on 28 April 1998.

36 It is difficult to trace the exact date when Appel's earlier sculptures were cast in bronze, though in the late 1960s there were already quite a few.

37 See Simon Vinkenoog, Het verhaal van Karel Appel, Utrecht, 1963, caption for ill. 8.

38 Telephone conversation with Appel on 27 April 1998.

39 'These were the curled hooks of a wheel of a seventeenth-century building used when moving house. A rope went through it and the furniture was then hoisted up', Appel told me (see note 31, above). Appel very much enjoyed my interpretation of Passion in the Attic, which he completely endorsed.

40 I recall him telling me this during one of our conversations in the 1960s. In the delightful book he wrote about himself, Karel Appel over Karel Appel, Triton Pers, Amsterdam, 1971, he also describes (p. 15) his excursions along the garbage cans at the time. Many of these assemblages were later dated 1947 by him, although it is likely that many date from 1948. (It is curious that much of what he wrote in the book was included in English in Roland Hagenberg (ed.), Karel Appel. Dupe of Being, Paris, 1986, which was then translated into Dutch again by Nelleke van Maaren (thus not in Appel's own words) and given the date 1986, later to appear in R.H. Fuchs (director of the Stedelijk Museum) collection of writings on the artist, Karel Appel Ik wou dat ik een vogel was, Gemeentemuseum, The Hague, 1990. (See note 67, below, for an explanation of Fuchs's title, which he himself did not supply.).

41 Told to me on 28 April 1998 (see note 31, above). Appel also told Fuchs that he saw Schwitters's work for the first time in 1956 in an interview they had in Monaco in September 1990, which appears on p. 115 of Fuchs's collection (see note 40, above). However, in his short article 'Het bezoek' (The Visit), pp. 5-33, from the same collection, Fuchs repeatedly and emphatically implies that Schwitters must have already been of immense significance to Appel shortly after the war (both for the Dutch artist's assemblages and for his paintings). The name Schwitters recurs at least ten times in this context! The well-known art historian Sam Hunter in his article 'Wolken, windmolens, naakten en andere mythologieën' (pp. 49-61) from the same collection, even suggests on pp. 52-53 that the Schwitters exhibitions Appel saw just after the war already had a marked influence on him in 1948! As Appel himself confirms, he certainly did not see the Schwitters exhibitions of 1944 and 1950 held in London, or the ones in Basle (1948), New York (1948 and 1952) and Paris (1954). He did, however, see the one in 1956 in Amsterdam. In this context, see, for instance, the catalogue Kurt Schwitters, Centre Pompidou, Paris, 1994, p. 388. In the same catalogue

Rudy Fuchs wrote an article 'Conflicts avec le modernisme ou l'absence de Kurt Schwitters', pp. 363-365, in which he underlines the fact that Kurt Schwitters is far more important to the history of modern art than had at first been realised.

42 Interview of 28 April 1998, see note 31, above.

43 Appel said this in 1983 after seeing probably more of Heerup's work than he had ever seen before at any one time at the opening of the new wing of the Louisianamuseum, Humlebaek, Denmark. See Michel Ragon, Karel Appel, Schilderijen 1937-1957, Amsterdam, 1988 (original title: Karel Appel, Peinture 1937-1957, Paris, 1988), p. 378. (It is doubtful whether Appel saw Heerup's skraldemodeller during the Cobra period and as I've already said, as far as I know, it was neither exhibited nor reproduced).

44 Appel gave a colourful account of this to Peter Bellew which appeared in his monograph Karel Appel, Milan, 1968, p. 3. Appel also writes about this in his own book (see Appel, note 40, above), p. 15.

45 See Vinkenoog, note 37, above, caption for ill.15.

46 They also recall the brightly painted totems of the Inuit, though the latter have a much more complicated form than a child's drawing.

47 See Ragon, note 30, above, ills. 190, 258, 259 and 191, respectively.

48 Appel confirmed this during our interview, see note 31, above. See also Ragon, note 30, above, p. 113. In his note 36, p. 14, Appel mentions planks of wood he stole and used to sleep on in his studio. Planks, of course, could also be found from other sources.

49 In the chapter on Denmark, Kerkhoven (1992), note 39, pp. 42 and 43 (ills 46 and 47), places one of Appel's reliefs alongside a Death Screen from the Kalabari Ijo tribe in Nigeria, which also shows various masks, partly with stylised human forms, attached to a wooden background.

50 See Ragon, note 30, above, ills 210, 242, 251, 257, 268 and 281. Here the precursors of his mural Asking Children, made in early 1949 for Amsterdam town hall, are clearly evident.

51 Neither the small (no doubt the preparatory study) nor the large version of The Tree of Life has survived. The architect Aldo van Eyck told Simon Vinkenoog how fellow architect Bakema, during a Cobra exhibition and an avant-garde architectural exhibition, which ran concurrently in the Stedelijk, saw the Cobra artists busy working on it in the museum. See Vinkenoog, note 37, above, p. 169.

52 See Ragon, note 30, above, pp. 17 and 315.

53 Appel approves of this interpretation (interview 28 April 1998). He thought he found the springs in the gutter.

54 Information from fellow resident Lotti van der Gaag.

55 The work referred to is Miró's Homme et femme, 1931, see ill. 5 (p. 44) in Gloria von Moure, Miró der Bildhauer, Museum Ludwig, Cologne, 1987.

56 Particularly Rauschenberg's Gift for Apollo from 1959.

57 The plaster works referred to are: Untitled (Stedelijk Museum Collection, Schiedam), which very likely dates from 1950 and not 1948 as given by Kuspit in the Introduction (note 1, p. 150), and Figure, 1951 (Prof. P. Sanders Collection, Schiedam), see Kuspit, Introduction (note 1, p. 42).

58 Several of these sculptures, including Young Soldier, from 1950, Cobra Bird and Elephant, were later cast in bronze and painted (apart from Cobra Bird). It is questionable whether these plaster works are in fact from 1950. Vinkenoog (see note 37, above, p. 96) recalls a letter from 1952 in which Appel writes: 'painted 12 plaster sculptures'. Yet all his painted plaster pieces date from 1950, so it is unclear which ones he is referring to here.

59 A series of tableware painted by Appel is incorrectly dated 1947-48 in Pierre Restany et al., Karel Appel Street Art, Ceramics, Sculpture etc., New York, 1985, ills 102-115. As far as I am aware, Appel never painted any pottery in that period.

60 This is put forward by Appel in Vinkenoog's book, see note 37, above, p. 127.

61 See Fuchs's interview with Appel in Monaco, note 41, above, p. 115.

62 Appel himself says he made eighteen in Vinkenoog's book (see note 37, above), whereas Restany (see note 59, above, p. 21) claims (without giving a source) that he made more than twenty-five such pieces.

63 See Restany, note 59, above, ills 38-60.

64 See Restany, note 59, above, p. 27 and ill. 9, pp. 195-201.

65 Interview with Alan Hanlon on 25 February 1972 with questions by Richard Graburn in Rothmans of Pall Mall, Canada (pres.), Appel's Appels, p. 18.

66 See chapter on Denmark, note 78, p. 23; Restany, note 59, above, ills 136-146, and Kuspit in the Introduction, note 1, pp. 68 and 69 (ills). It is likely that Kuspit incorrectly dated these windmills 1985. Notes from the Struktuur 68 studio in The Hague, where Appel made these pieces, state that he made the sculptures in 1988.

67 See Bregtje van der Haak, 'Karel Appel, 50 jaar schildersdrift', in Beelding, vol.4, no.10, December 1990-January 1991 issue, p. 22. Also Kuspit in the Introduction, note 1, ills on pp. 71, 73, 74, 76, 77, 79, 80, 83, 163-165.

68 This production had its premiere on 12 May 1987 at the Paris Opera and shortly afterwards in New York. In October 1994 it was performed at the Musiektheater, Amsterdam. See Jan Bart Klaster, 'Kippen, Koeien en dansers', in Het Parool newspaper, 3 October 1994, and Nico S. de Wal, 'De boerderij van Appel en Tanaka', in De Haagse Courant newspaper, 8 October 1994.

69 See Appel, note 40, above, p. 5.

70 See Klaster, note 68, above.

71 Appel's sets and objects for the opera Noach, by the composer Guus Jansen and the librettist Friso Haverkamp, which had its premiere at the Amsterdam Stadsschouwburg (Concerthall) on 17 June 1994 as part of the Holland Festival, were exhibited a month later in De Nieuwe Kerk, one of the city's churches. See Paul Luttikhuis, 'Opera Noach eerst sloom, maar later groots spektakel. Decors Karel Appel onmisbaar', in NRC Handelsblad newspaper, 18 June 1994. Appel's sets made for Mozart's Zauberflöte, which was premiered on 1 December 1995 in the Amsterdam Musiektheater, were exhibited between July and November 1996 at the Kunsthal, Rotterdam. See Die Zauberflöte, from the Musiektheater, December 1995, and Kasper Jansen, 'Prachtige Zauberflöte van Appel en Audi', in NRC Handelsblad newspaper, 2 December 1995. Also the art column in the same newspaper (2 July 1996) where Stedelijk Museum director Rudi Fuchs (initiator of the Kunsthal exhibition) is pictured moving one of the fifty objects exhibited.

72 In an interview with Frédéric Towarnicki from around 1985, see Restany, note 59, above, p. 164.

73 In Fuchs's interview, note 41, above, p. 116, he says: 'Whenever I was

involved with those objects, it was in order to free myself for my painting. In order not to become a classical painter or to get stuck in a painterly tradition'.

74 During our interview (see note 31, above), in reply to my question whether sculpture had gained the upper hand over painting, Appel replied: 'I just carry on painting. If I've been making sculptures for a while I just stop. I make just as many paintings as sculptures'.

75 I wish I were a Bird is the first line of a poem 'Winter of Hunger' in Dutch that Appel wrote at Ommen, the Netherlands, in January 1945 (see Appel, note 40, above, p. 91).

76 During an interview 18 June 1998.

77 See Stokvis, 1974, Introduction, note 4.

78 This relief, initially made in plaster and later cast in bronze, was made by Kollwitz to commemorate the death of her friend Ernst Barlach in 1938. See, for instance, Mina C. Klein & Arthur Klein, Käthe Kollwitz: A Life in Art, New York, 1975, ill. p. 140.

79 These small sculptures by Corneille were found again in his sister's attic in the early 1980s. At the instigation of art dealer Herman Krikhaar, each one was cast in bronze in a limited edition of six in 1987 (information from Krikhaar on 12 February 1985).

80 See Kerkhoven, chapter on Denmark, note 39, 1992, p. 52 and 1995 p. 48. See comments relating to Brands and his contact with Lemaire below (note 20).

81 Ibid., p. 8 and p. 7 resp.

82 Several of these works are illustrated in Claude Michel Cluny, Mains et merveilles, Paris 1994.

83 Corneille made two designs, Bird with Sun and Oiseau, communication, a kind of flying fish, the latter was produced in a small and large version. Source: imprecise information from the artist; Jaski Gallery, Amsterdam (client), and Glasobjecten BV Van Tetterode. Corneille also made a number of brooches around the same time.

84 Details from Nico Koster, Jaski Gallery, Amsterdam.

85 Ibid, a telephone conversation with Corneille on 28 July 1998.

86 He still keeps these heads, 20.5 and 21.5 cm high, at home.

87 Having missed the entrance to the Rijksacademie in Amsterdam in 1938 Constant followed the preparatory or first year at the Kunstnijverheidsschool where he learned many different techniques. The director of this school was a certain Smits, a violin maker. Information from various interviews with the author on 28-7 and 21-9-1998.

88 See my article, 'De Stijl en Cobra. Nederlands tegenstrijdige bijdrage aan de kunst van de twintigste eeuw – tegenstellingen, parallellen, overeenkomsten!', in Aspecten van het Interbellum. Leids Kunsthistorisch Jaarboek, VII (1988), The Hague, 1990, p. 201.

89 Information from Constant on 24 June 1998. Constant thought he gave the work to the photographer Ad Windig for taking the photographs. Later, however, Windig, who has since died, did not remember anything about this.

90 Ibid, see note 89, above.

91 Ibid, see note 89, above. Constant assumed that the work was still in the possession of Christian Dotremont's brother, Guy, in Belgium. However on inquiry this was not the case.

92 On 24 June 1998 Constant told me that this wall, after having been properly restored, was now part of the interior of an entirely new house.

93 See Ed Wingen, 'De onderbroken vriendschap van twee Cobra-schilders', in De Telegraph newspaper, 24 March 1998, and an anonymous piece, also on the friendship (undoubtedly written by Ed Wingen), 'Een hernieuwde vriendschap', in the column 'In Beeld. Aktueel. In beeld', in the art monthly Kunstbeeld, vol. 8, no.7, April 1984, also under chapter … of this publication.

94 See Stokvis, 1974, Introduction, note 4, p. 88, and Cluny, note 82, above, pp. 188 and 189.

95 See Freddie de Vree, Constant, Schelderode, Belgium, 1981, p. 30.

96 See Stokvis, 1974, Introduction, note 4, p. 241.

97 See Stokvis, note 88, p. 185.

98 A short news item on a play sculpture by Constant being placed in one of Amsterdam's municipal playgrounds, with an illustration of the scale model, appeared in Het Parool newspaper on 10 November 1955. Only one of his two designs for such sculptures The Spin, made from pre-stressed concrete, was used for various play areas in the city, but they all had to be removed again (information provided by Constant on 28 July 1998).

99 See Guy Habasque, 'From Space to Time', in Nicholas Schöffer (Introduction by Jean Cassou), Neuchatel, 1963, p. 10; Nicholas Schöffer, La Ville cybernétique, Paris, 1969. During this period Constant corresponded with Schöffer (see archive R.K.D.).

100 See Ludo van Halem and Marcel Hummelink, 'La fleur mécanique. Een constructie van Constant', in Jong Holland, vol. 10, no. 2, 1994, pp. 44 and 45.

101 This was published in 1946 in Argentina by Fontana's pupils at the Academia d'Altamira in Buenos Aires. It appeared in Dutch translation by Henk Peeters in the magazine De Nieuwe Stijl, Amsterdam, 1965, Part 2. Lucio Fontana had taken part in a ceramics experiment organised by Jorn in 1954/55 in Albisola (Italy); see op. cit., note 78, chapter 2 above.

102 See Constant, Bibliothèque d'Alexandrie, Paris, 1959, in which he published extracts from letters mailed to the Situationist International in September 1958.

103 See chapter on Denmark under Asger Jorn.

104 See Stokvis, 1974, Introduction, note 4, p. 169 and detailed literature on the movement, including the catalogue of the exhibition Situacionites, Art, Politica Urbanis, Inc. MACBA, Barcelona, 1996

105 See Stokvis, 1974, Introduction, note 4, p. 20 and p. 20, note 5.

106 See Cluny, note 82, above, p. 200 and 202.

107 See Constant, New Babylon (Introduction by Hans Locher), published in conjunction with an exhibition at the Gemeentemuseum, The Hague, 1974, and Constant, New Babylon, Constant, Art et Utopie (Introduction by Jean-Clarence Lambert), Paris, 1997.

108 In my article, see note 88, above, p. 204 (including note 86) I mention in detail the fact that this was Constant's source for his Utopia, as he himself confirmed to me. See Chapter 3 (note 2) below for the passage from Marx and Engels.

109 This statement is part of an address made at a congress Le Mouvement pour un Bauhaus Imaginiste held in Alba, which Constant attended in 1956. See Stokvis, 1974, Introduction, note 4, p. 181, and p. 198 (note 88). In his later development in the 1980s, when he no longer had any connections with

Cobra, Constant made three bronzes of between 30 and 35 cm high in a limited edition. One of these figures with a bird's head was called Mephistopheles or El Medico; the others Harakiri and Tors.

110 See the catalogue Informele Kunst 1945-1960. Lyrische Abstractie, Cobra, Materieschilderkunst, Rijksmuseum, Twenthe, Enschede, 1982.

111 Theo van Velzen in his penetrating article 'Signalement van Tajiri', in Museumjournaal, series 11, no.6, 1966, makes the same association.

112 Ibid., p. 167.

113 See Shinkichi Tajiri , Autobiographical notations/Autobiografische aantekeningen, Kempen Publishers, the Netherlands, 1993, p. 22.

114 See Hestia Bavelaar and Els Barents, Shinkichi Tajiri, The Hague, 1990, p. 14. This publication was of general interest when writing this short overview of Tajiri's work.

115 See Marcel Vleugels, 'Ik heb gekozen voor onvoorspelbaarheid', in Willem K. Coumans et al., Tajiri, Heerlen, 1991, p. 48.

116 See Tajiri, note 113, above, p. 36.

117 See Stokvis, 1974, Introduction, note 4, p. 215 (based on an interview in 1964). He confirmed this again on 28 June 1998, adding that David Smith's work had also had an important influence on him.

118 See Bavelaar and Barents, note 114, above, pp. 18 and 19.

119 The poem appeared in the catalogue, Dialogue. Shinkichi Tajiri, Carl-Henning Pedersen, Else Alfelt 1948-1998. Carl-Henning Pedersen og Else Alfelts Museum, Herning, 1998, p. 53.

120 Ibid., p. 55.

121 Interview with the artist on 28 June 1998. See also Bavelaar and Barents, note 114, above, p. 24.

122 As Hestia Bavelaar rightly points out (see Bavelaar and Barents, note 114, above). Only one warrior is mentioned in the 1949 Amsterdam exhibition. I noted this in my thesis, see Stokvis, 1974, Introduction, note 4, p. 215. However, two warriors are illustrated there, which I did not know about before. In the left-hand photograph Tajiri is working on a sculpture which never survived, while in the centre photograph is the remaining sculpture.

123 See Bavelaar and Barents, note 114, above, p. 22.

124 An observation by Helen Westgeest in Tajiri. Stille dynamiek en eenheid in pluriformiteit, Zwolle, Amstelveen, 1997, p. 31.

125 See Bavelaar and Barents, note 114, above, p. 22.

126 Tajiri told me this on 28 June 1998.

127 This engraving was included in the catalogue Tajiri sculptures, drawings, graphics, books, video tapes, films, with reproductions of a series of his engravings (made with the assistance of three draughtsmen) and with an introduction by Dick Hillenius, which was published to mark a retrospective of his work in 1974 at the Museum Boymans-van Beuningen, Rotterdam, and the Bonnefantenmuseum in Maastricht, Venlo, 1974. His Wounded Knee engraving placed on an American flag was illustrated first in the catalogue.

128 See Edouard Jaguer, La Poétique de la Sculpture. Sculpture 1950-1960, Paris, 1960, ill. p. 38, and also note 114, ills on pp. 64, 66 and 67 (under).

129 Ibid., note 128, and the catalogue The Art of Assemblage, The Museum of Modern Art, New York, 1961 (written by William Seitz), p. 77 (Watts Towers) and p. 146, which has an illustration of Jacobsen's comical Head with Keys (1957) alongside a Samurai (1960) by Tajiri.

130 Tajiri told me about these visits on 28 June 1998. For the work Sandberg purchased, see Geurt Imanse 'The Cobra Collection at the Stedelijk: some facts', in the catalogue, Cobra at the Stedelijk Museum, Amsterdam, Musée National d'Histoire et d'Art Luxembourg, 1994 (also in Dutch and French), pp. 47, 55 and 63.

131 See Bavelaar and Barents, note 114, above, p. 46.

132 Tajiri told me this in 1964 and this was mentioned (p. 164) in my short biography on him for the catalogue for the Cobra 1948/51 exhibition, which I curated and which was held at the Museum Boymans-van Beuningen, Rotterdam between May and July 1966. This exhibition was then shown in the summer at the Louisiana Museum Humlebaek, Denmark, and the catalogue text translated into Danish for the museum's Louisiana Revy, vol.7, no.1, August 1966. The casting in sand, which was so important to his work, was never mentioned in any of the publications about him, including his own!

133 See Bavelaar and Barents, note 114, above, p. 53.

134 See Bavelaar and Barents, note 114, above, p. 50.

135 A reference to the sculpture The Explosive Forces of Nature, a fountain for the AKU building, Arnhem. See Bavelaar and Barents, note 114, above, p. 59, ill. 46.

136 In 1953 he made the strange-looking Fétiche anti-fertilité (Fetish against Fertility) from iron, glass and wax, in which in a metal frame containing shields, which he also used, for instance, in his Mechanical Fighting Machines, a woman's torso can be seen filled with pins. This sculpture does not express aggression from erotic feelings, but aggression from aversion. See Edouard Jaguer, note 128, above, ill.68. In the photographic book Seltsame Spiele. Wie der Bildhauer Tajiri Mädchen und Metall zähmt, Frankfurt, 1970, featuring the work of photographer Leonard Freed, including a game with pistols between a man and a woman whereby the latter is clearly coming off worse, are photographs of Tajiri's cannon-like sculptures with their protruding phalluses aimed at the very feminine, vagina-like material sculptures of Ferdi, his wife (1927-1969).

137 See Westgeest, note 124, above, for this later development.

138 See Stokvis, 1974, Introduction, note 4, p. 68 and p. 68, note 1.

139 See Stokvis, 1974, Introduction, note 4, p. 74 and p. 74, note 9.

140 Figures obtained from the studio.

141 See catalogue, Christies. Modern and Contemporary Art, Amsterdam, 22 May 1991, p. 612 (with illustration). See also chapter on Denmark, note 78, p. 14.

142 See catalogue of the exhibition Lucebert Keramik at the Kattrin Kühn Droysen Ceramic Studio and Gallery, Berlin, September to November, 1991, and Peter Bötig, 'Luceberts poetische Welten', in Neue Keramik, Part 2, 1991, no.11, Sept./Oct. Pp. 770-771.

143 See Lucebert, a publication from The Red Cross Hospital, Beverwijk, May 1995.

144 See De Volkkrant newspaper, 10 September 1996, with a coloured

photograph of the sculpture and caption on the day it was unveiled.

145 See Museumjournaal, Jan./Feb. 1962, series 7, no.7/8, p. 197. Wim Beeren also wrote a highly enthusiastic and celebratory article, 'Signalement. Lotti van der Gaag' in Museumjournaal, June 1963, series 8, no.10, pp. 255-261. I did not mention Lotti in the first three editions of my dissertation (see Stokvis, 1974, Introduction, note 4). Here I kept strictly to the names I found in Cobra publications and in lists of participants of Cobra exhibitions. In the fourth reprint (1990) I attempted to rectify this mistake. From 1984 on I also mentioned her in various other publications in connection with the Cobra movement. An overview of these was made by Laura Soutendijk in her unpublished doctorate thesis Lotti. Tussen Maanman en Zonstraketsel, Leiden, 1996, which I hope will form the basis for a monograph on the artist in the not too distant future. (There was never an official list of Cobra members or an official membership.)

146 This letter was quoted by Titus Cruls in the article he wrote for the catalogue Lotti, beelden, De Beyerd Museum, Breda, 1987.

147 Sandberg, who gave Lotti a solo exhibition in the Stedelijk Museum in January/February 1962 (opened by Bert Schierbeek), which was then shown at the Rotterdam Kunstkring (artists society), wrote to the curator of the Museum of Modern Art in Paris in 1983 pointing out that Lotti's work had not been shown at its Cobra exhibition the previous year, and the role she had played in the movement. See the text by Lineke van Wees, note 146, above. Rudi Fuchs, current director of the Stedelijk Museum also joined those who have allied themselves to this artist. He selected work by her for the exhibition Cobra at the Stedelijk Museum, which began a large European tour, opening in Luxembourg in 1993, and then travelling to Lisbon, Madrid, Amsterdam, Warsaw and Moscow (see note 130, above).

148 From 1955 on these include the third, fourth and fifth Sonsbeek exhibitions in Arnhem, the Netherlands, the group exhibition Holländische Kunst der Gegenwart, 1955, Berlin, Linz, Stuttgart, Recklinghausen; Contemporary Dutch Art/Junge Kunst aus Holland, 1956, USA, including Toledo (Ohio)/Bern; the Venice Biennial, 1958 and '150 years of Dutch Art', Stedelijk Museum , Amsterdam, 1963, whereby the catalogue was used for a long time as a reference work for Dutch modern art. In Paris Lotti was shown in 1961 at the '2ième Exposition Internationale de le Sculpture Contemporaine' in the Rodin Museum. See Soutendijk, note 145, above, for a detailed overview of the more than ninety exhibitions in which Lotti's work was shown during this period. It is strange that while the Cobra artists were always seeking artistic talents to supplement their numbers (compare the way in which artists such as Tajiri, Stephen Gilbert, William Gear, Zoltan Kemeny – and following in his wake, his wife Madeleine – became involved), they did not think to look at the studio next to them and spot the work of Lotti van der Gaag.

149 See the family tree of the Van der Gaag and Van Gogh families, which came together in the seventeenth century (this was mailed to me in February 1989).

150 See Soutendijk, note 145, above, pp. 9 and 10.

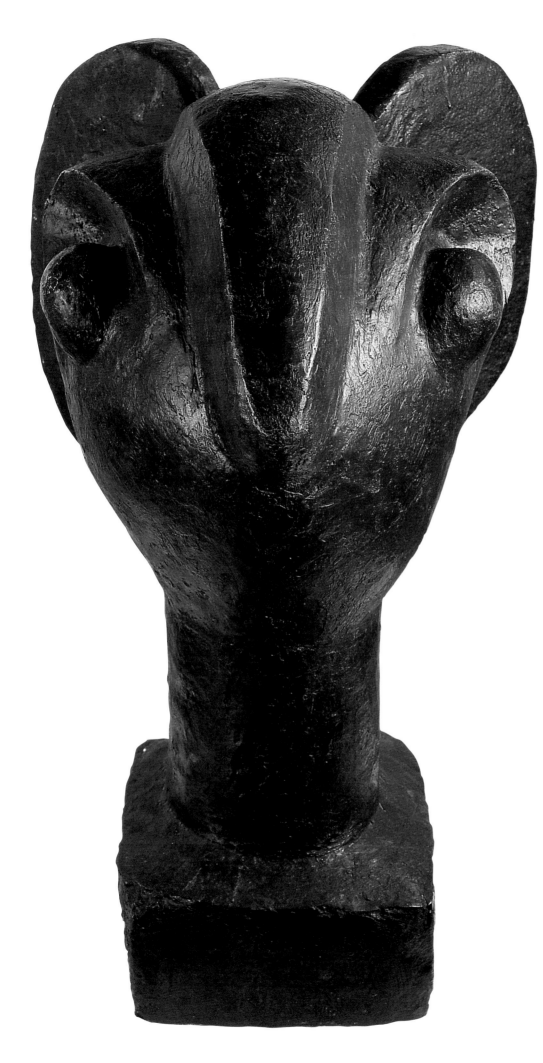

Karel Appel

97 Bird's Head, 1947, bronze (original
plaster), h. 72 cm. Cobra Museum for
Modern Art, Amstelveen.

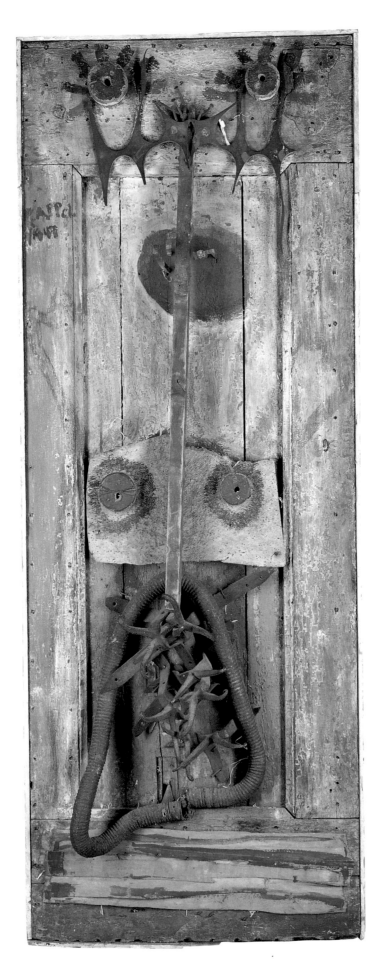

Karel Appel

98 Passion in the Attic, 1947,
assemblage of found objects on a wooden
shutter painted with gouache, 157 x 61 cm.
Cobra Museum for Modern Art,
Amstelveen.

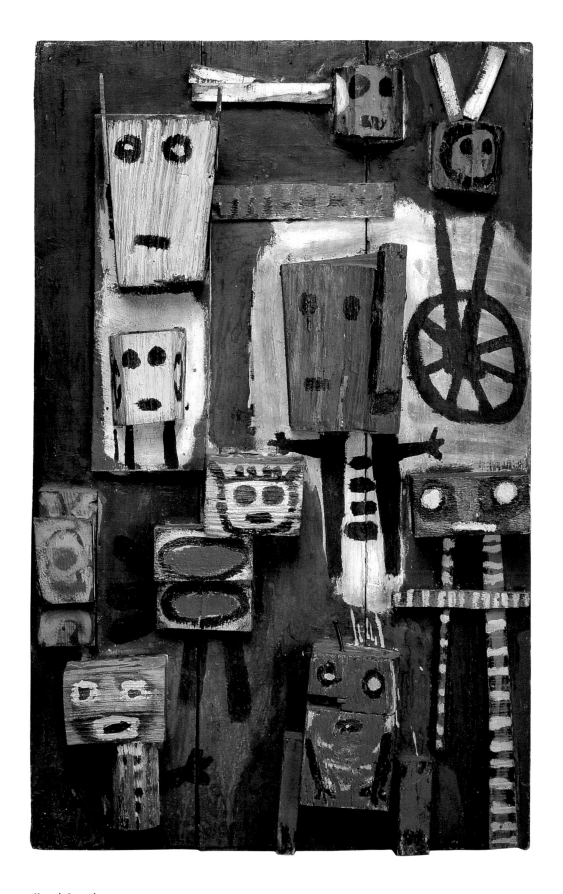

Karel Appel

99 Asking Children, 1949, gouache on
wooden relief, 104 x 67 cm. Stedelijk
Museum, Amsterdam.

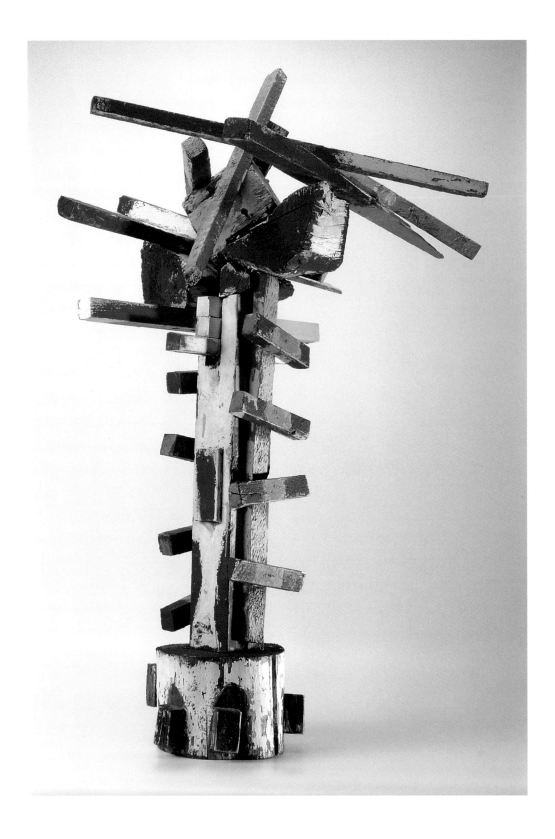

Karel Appel

100 Tree, 1949, assemblage, painted wood, 98 x 75 x 62 cm.

101 The Bridge, 1948, assemblage of wood and wire painted with gouache, 84 x 24 x 10 cm.

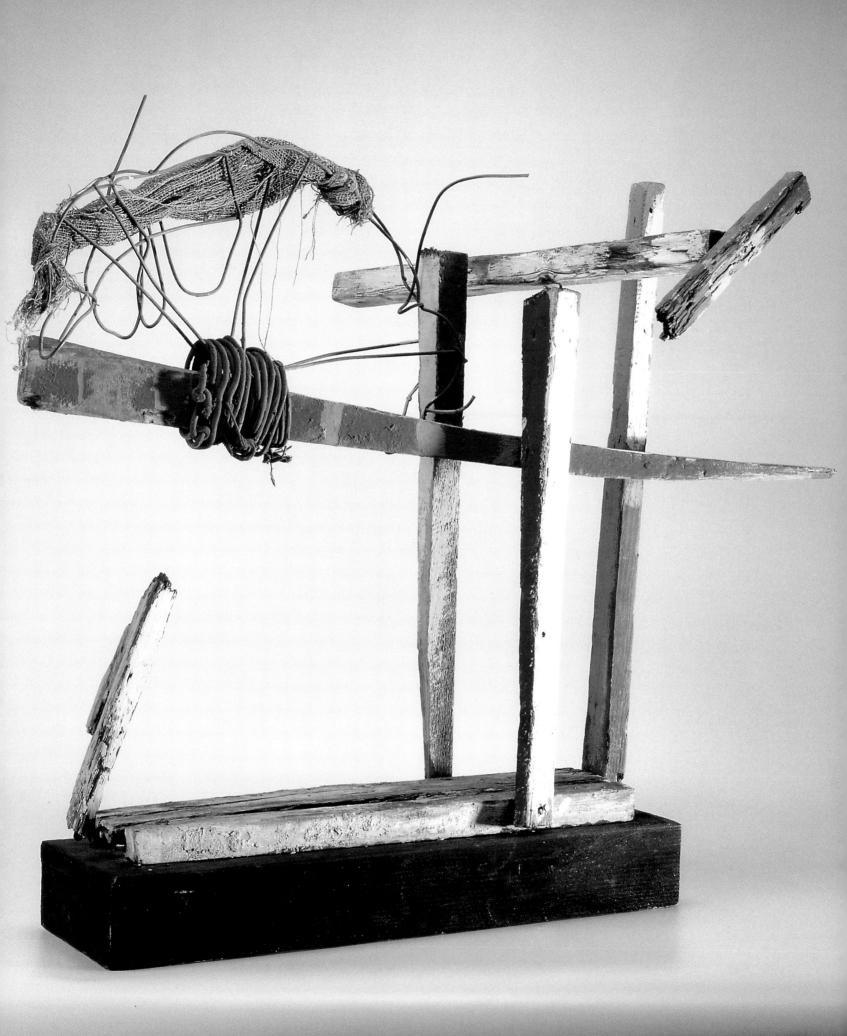

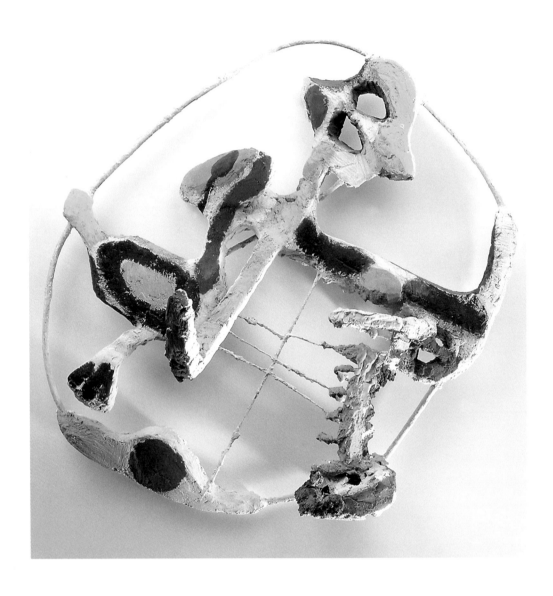

Karel Appel

102 Sculpture with Bird, 1950,
gouache on plaster and wire, h. 57 cm.

103 Cobra Bird, 1950, bronze (original
plaster, painted), 42 x 33 x 53 cm. Cobra
Museum for Modern Art, Amstelveen.

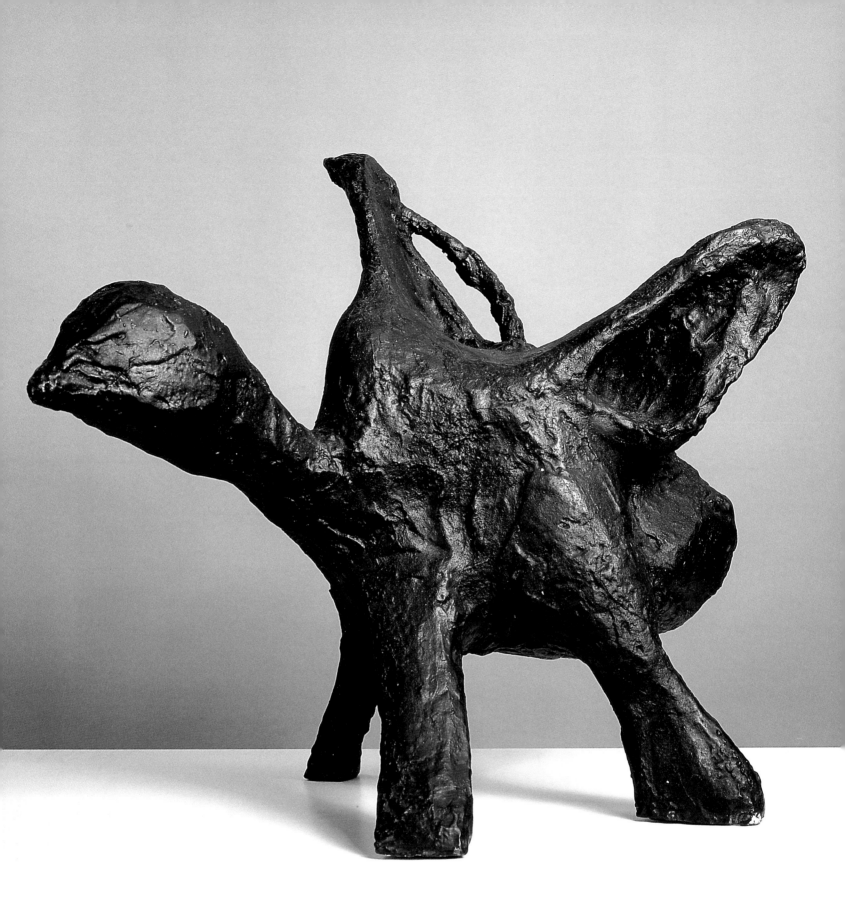

Eugène Brands

104 Sign in Orion, 1948, wood and canvas painted assemblage, 80 x 68 cm. Stedelijk Museum, Amsterdam.

105 Relief IX, 1948, assemblage of painted wood, fur and horsehair, 63 x 43 cm. Stedelijk Museum, Amsterdam.

Eugène Brands

106 The Summer, 1949, painted
assemblage, wood, 76 x 83 cm. Stedelijk
Museum, Amsterdam.

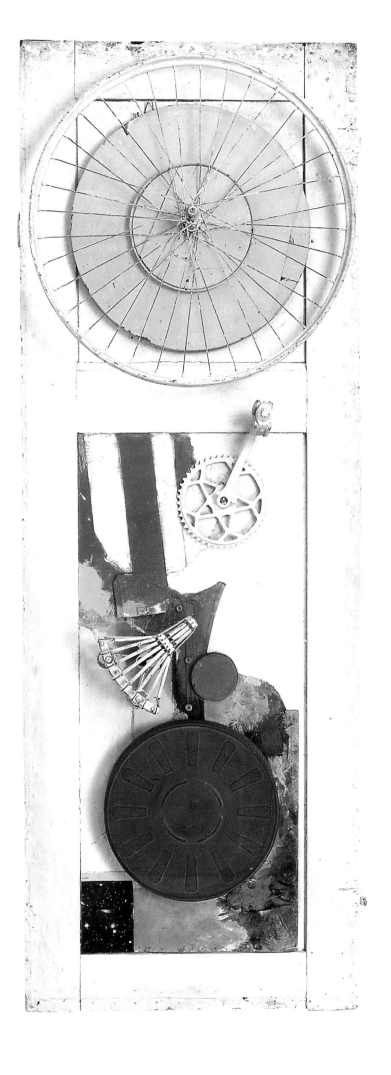

Eugène Brands

107 The Lovely Bike Ride, 1966-1967, painted assemblage of metal objects on wooden panel, 200 x 70.5 cm. Cobra Museum for Modern Art, Amstelveen.

Eugène Brands

108 Kalimantan, 1996, painted assemblage of found objects on wood, 27 x 42.5 cm.

Corneille

109 Le pêcheur (The Fisherman), 1951, bronze (original plaster), 63.5 x 43 x 19 cm, signed and dated centre right. Cobra Museum for Modern Art, Amstelveen.

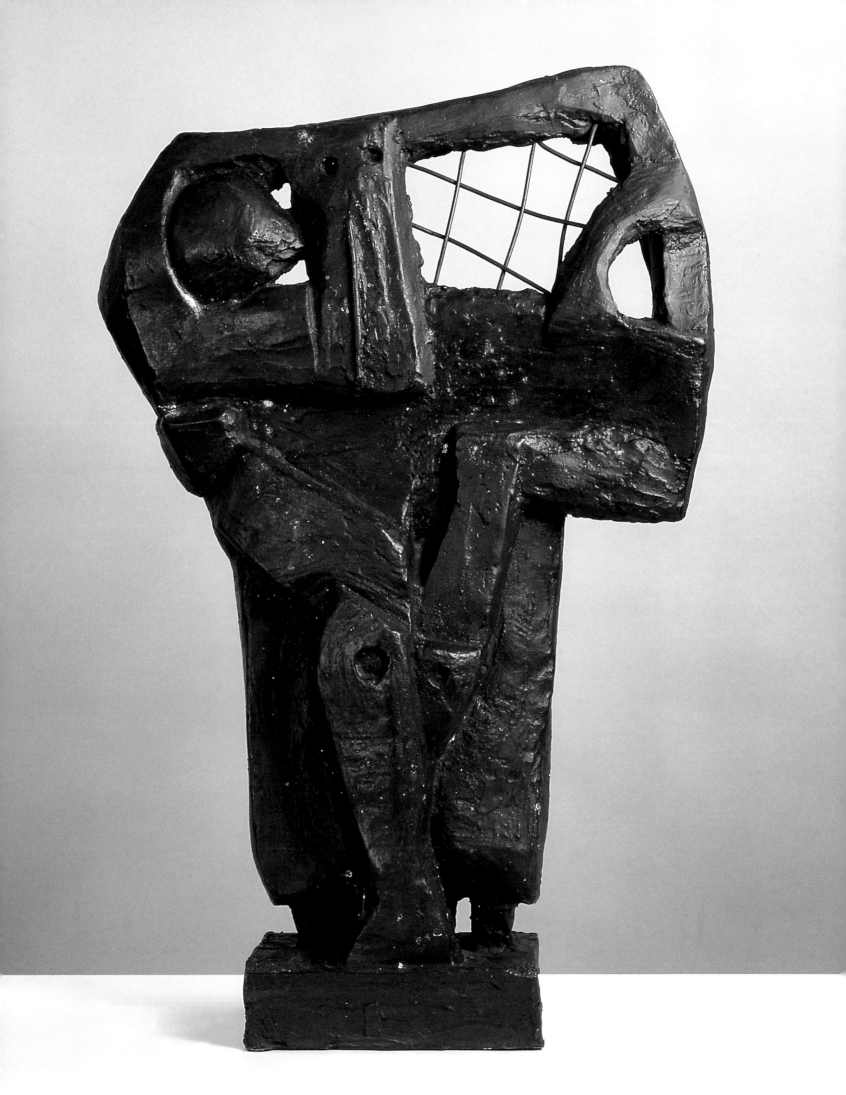

Constant

110 Untitled, 1947, painting on bark,
45 x 31 cm. Cobra Museum for Modern
Art, Amstelveen.
111 Cat, 1948, oil on wood, 80.5 x 43 cm,
signed and dated bottom centre. Stedelijk
Museum, Amsterdam.

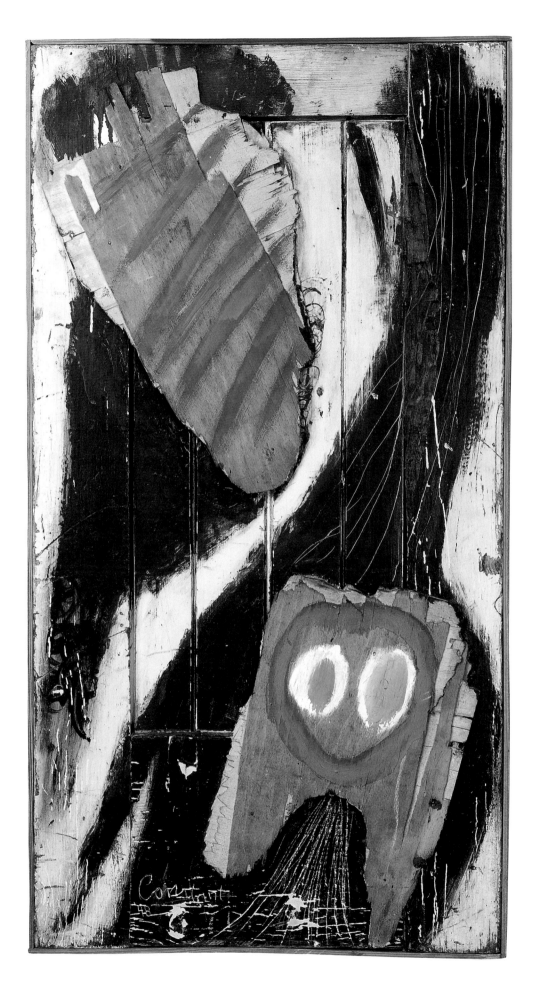

Lucebert

112 Untitled, Feb. 1994, ceramic, c. 29 x
32 x 19 cm. Tony Swaanswijk collection.

113 Lucebert's ceramic, Untitled
(Feb. 1994), beside the giant copy under
construction at the Struktuur 68 studio in
1994, shortly after Lucebert's death,
executed on a scale of 1 to 10.

114 Untitled 1994, ceramic, h. 3 metre,
base c. 3.20 x 1.90 m. Made by Struktuur 68,
The Hague, after a model by the artist.
Placed in 1994 in the garden of Museum
Kranenburgh in Bergen, North Holland.

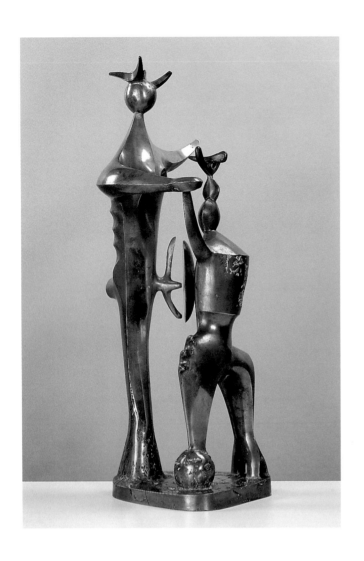

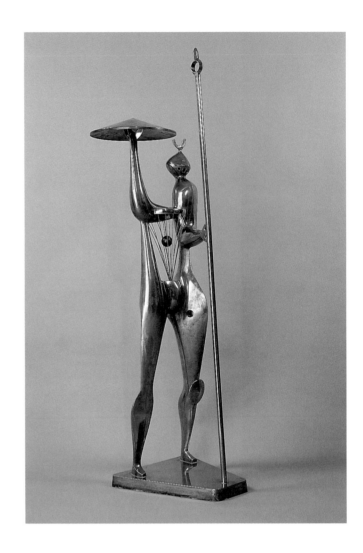

Shinkichi Tajiri

115 David and Mrs Goliath, 1949,
bronze (original plaster), h. 55 cm. Cobra
Museum for Modern Art, Amstelveen.
116 Guerrier (Warrior), 1949, bronze
(original plaster), 135 x 33 x 39 cm. Cobra
Museum for Modern Art, Amstelveen.

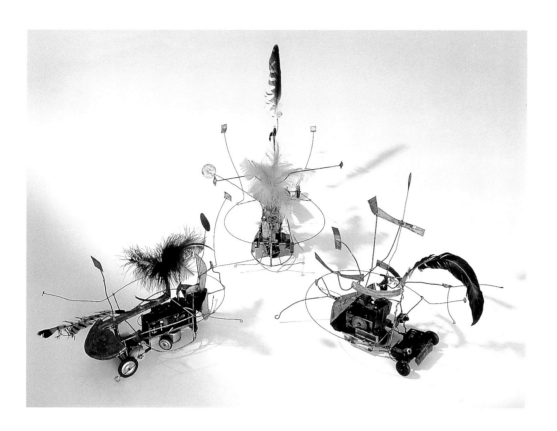

Shinkichi Tajiri

117 3 Mechanical Fighting Machines,
1957, h. 20 to 30 cm, electronic engines,
iron, feathers. Property of the artist.
118 2 pages from his Notebook, 1950-
1952, pen and watercolour on paper.
Property of the artist. (The drawing on the
left of the right-hand page may be a
sketch for an – unexecuted – sculpture).

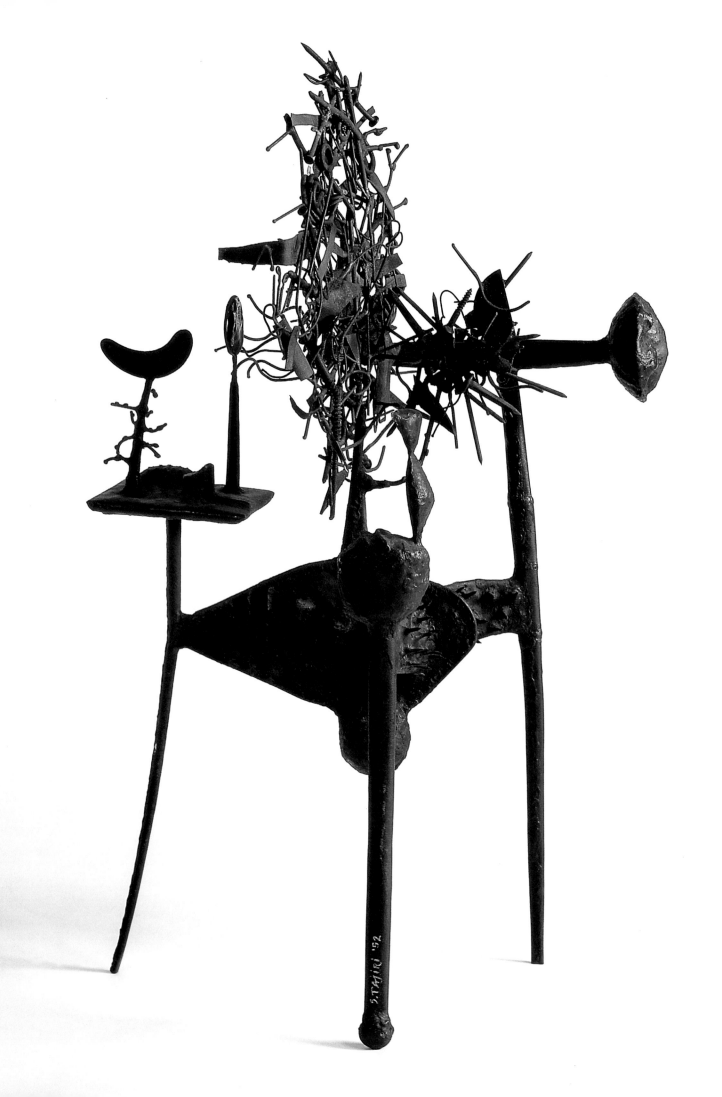

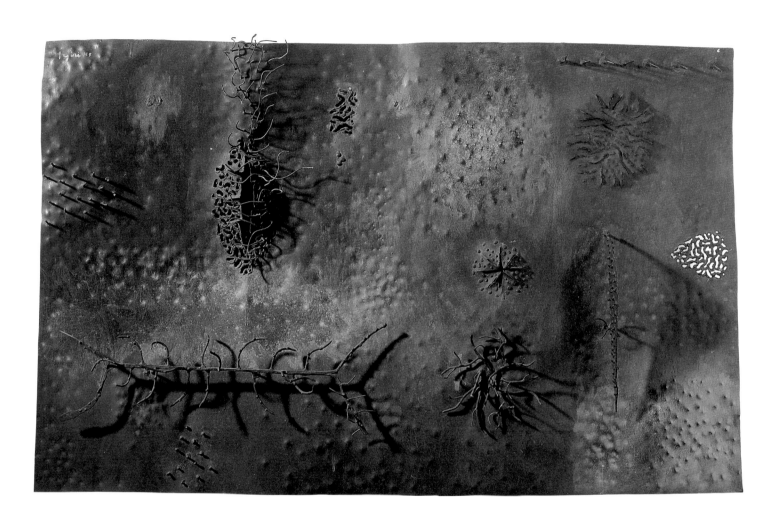

Shinkichi Tajiri

119 Guerrier (Warrior), 1952, iron,

h. 60 cm. Cobra Museum for Modern Art,

Amstelveen.

120 Scorched Earth, 1955, iron relief,

60 x 100 cm. Gemeentemuseum,

The Hague.

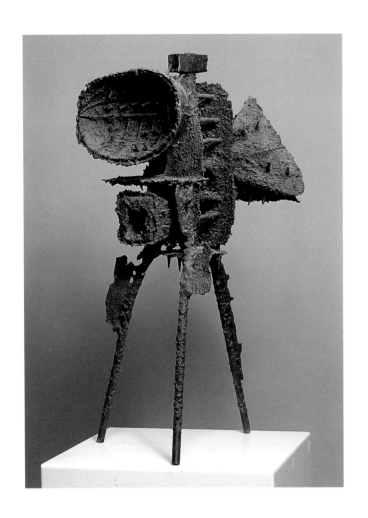

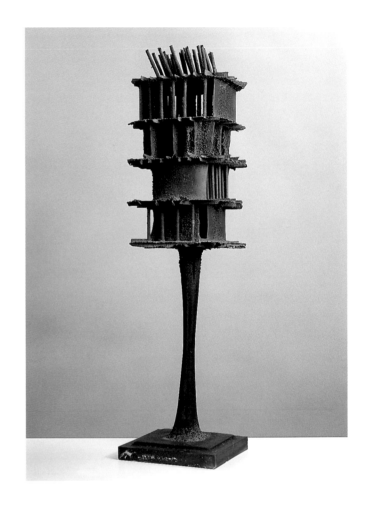

Shinkichi Tajiri

121 Samurai, 1961, bronze, 51 x 25 x 24 cm.
Cobra Museum for Modern Art, Amstelveen.
122 The Tower of Babel, 1964, bronze,
h. 77 cm. Cobra Museum for Modern Art,
Amstelveen.

123 Ronin, 1996-1997, Centa foam,
h. 270-300 cm.

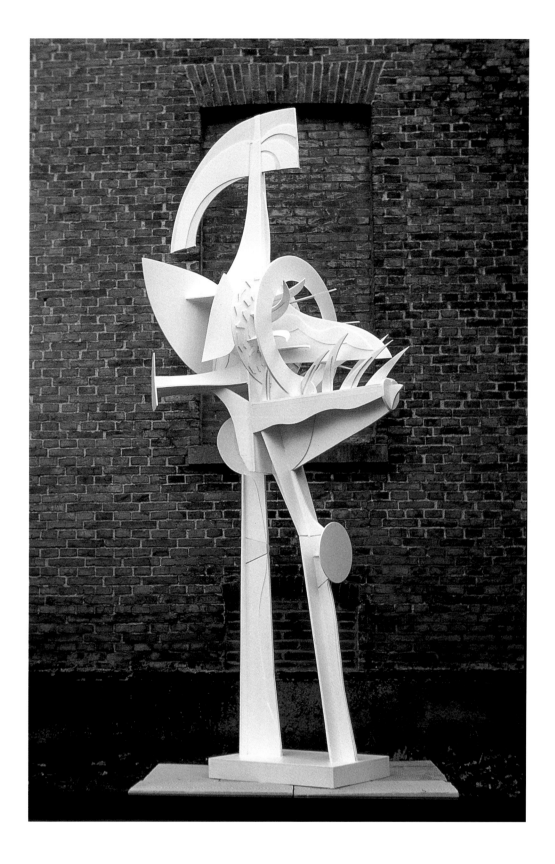

124 Reinhoud and Pierre Alechinsky in Paris, 1961.

125 Christian Dotremont and Pierre Alechinsky involved in a joint piece, the screen L'Abrupte Fable, (The Abrupt Fable), 1976.

Group photo of Cobra members and friends at the entrance of the Paleis voor Schone Kunsten in Liège, 6 October 1951, the day of the opening of the Second International Exhibition of Experimental Art – Cobra.

Top row, left to right: Corneille, Robert Kaufmann, attendant, Jean Raine, Theo Wolvecamp, Tony and Karel Appel, K.O. Greis

Centre: Janine and Corneille Hannoset, Shinkichi Tajiri, Micky Alechinsky, Reinhoud, Pierre Alechinsky, Luc de Heusch

Front: Michel Olyff.

Cobra

Belgium

Ideology or style

The Belgian contribution to Cobra is more difficult to evaluate than that of Denmark and the Netherlands. If, as its theorists wanted, one views the movement as one in which everything was possible, neither bound by specific restrictions or directions of discipline or style, (a view which was directly connected with the Marxism to which they adhered), then the only significant communal factor is the collaborative aspect. This was particularly the view held by the Belgian poet (and later painter) Christian Dotremont (1922-1979),[1] the organisational force behind the Cobra Movement (fig. 126) who, with his fervent (Marxist) conviction and commitment to anti-specialism, became the movement's principal unifying element. He in fact adhered to Marx's conviction that bourgeois society's extreme specialism was the main reason why people had become alienated from one another.[2] Dotremont encouraged inter-collaboration within Cobra not just through the many publications he either headed or set up – including the journal Cobra – and a series of exhibitions, but mainly through his instigation of the peinture-mot, word-painting, a creative collaboration between poets and painters on paper or canvas. This became a hallmark of the movement. Dotremont took particular pride in the fact that 'non-poets' wrote poetry and 'non-painters' painted. The peinture-mot which was practised long after Cobra had come to an end, formed Belgium's distinctive contribution to the 'Cobra jargon'.[3]

Cobra is crystallised in art history as a movement that led to spontaneous, expressionist manifestations in the visual arts, with a strong emphasis on mythic fantasy in which word-painting provided an underlying substrata. That the artists themselves – at least the Danish and the Dutch – also thought in terms of a Cobra jargon or even style is borne out by the fact that as the movement developed they sought to attract other artists who were working in a more or less similar style.[4] Moreover an explicit demonstration of the 'Cobra style' was given at the end of 1949 when Appel, Constant, Corneille and Jorn, assisted by Jorn's friend the ceramicist Erik Nyholm, jointly and with very rudimentary brush strokes ('improved') over-painted an aesthetic abstract picture by their Danish colleague Richard Mortensen, adding examples of their exuberantly simplistic fantasy world. Signed by all five, this picture, which highlights their radical distaste of Mortensen's style that was creating a furore in Paris at a time where Geometrical Abstraction was all the rage, has become known as the first Cobra modification.[5] In a letter dated February 1965 in answer to a question I had put to him, Dotremont reveals that he, too, recognised that there was already something different happening in Denmark than in Belgium around 1948: 'The Cobra Danes, the majority of the Cobra Danes, were naturally the first to have a lucid vision of Communism, Marxism, recognising a connection between this political, ideological, anti-bourgeois, populist stance and folk art.[6]

Belgium, on the other hand, proved a breeding ground for a spontaneous expressive approach with an emphasis on fantastic imagery, particularly in painting. Indeed Hieronymus (Jerome) Bosch and Bruegel are primarily associated with Belgium, or at least the Southern Netherlands, although in fact both came from Dutch Brabant.[7] Belgium also spawned James Ensor who drew particular inspiration from folk art. Jorn, whose graphic work was strongly influenced by Ensor,[8] wrote to Constant in 1950: 'One can only arrive at the truth by allowing one's fantasy to embrace all that is most improbable in the same way as Bruegel and Bosch, but then using a painterly language, like that of the ancient Indians, the Vikings, the primitives, and not a surrealist-naturalist language.'[9] Around 1910 Belgium also saw the birth of a wonderful peasant Flemish Expressionism, as manifested by the works of painters like Constant Permeke and Gustaaf de Smet and the sculptor Oscar Jespers! And with the powerful Surrealist movement which emerged as early as 1925 in the Walloon provinces, Belgium tapped into the realm of the subconscious, the spawning ground of fantasy.

Belgian sculpture

Sculpture has always been an important feature in Belgian art, and with the development of large urban centres in the thirteenth and fourteenth centuries it acquired an added impetus. Although Haarlem-born (and thus of Dutch origin), Claus Sluter in all probability received his training in Brussels, where we know he was a member of the Brussels guild of stonemasons and builders. From the mid-sixteenth to the mid-eighteenth century Antwerp became an internationally important centre for sculpture, producing such figures as Cornelis

Floris, Duquesnoy father and sons, the 'old' and the 'young' Artus Quellinus, and Rombout Verhulst. At the end of the nineteenth century Belgium – at that time strongly orientated towards France – came to the fore with the internationally acclaimed Realist Constantin Meunier and the Symbolist Georges Minne, feted in literary circles and known for his elongated, languid male figures. And in the last twenty-five years of the century Rodin was to send shock waves through the Belgian sculptural world. His sojourn in Brussels during the 1870s when he was working on the decoration of the stock exchange would certainly have been influential in this respect. Nevertheless Rodin's impact was not really felt until the beginning of the twentieth century in the impressionistic work of Rik Wouters, who was primarily known as a painter. Indeed Flemish Expressionism, which evolved as a reaction to the 'superficiality' of Impressionism, spawned a number of sculptors and sculptural works. Both Jespers, a leading figure, and the graphic artist Josef Cantré were active in the field. These two artists drew inspiration from Cubism as well as forms of primitive art; at that time Belgium had plenty to offer in that field in the form of the various collections mainly culled from the former Congo.[10]

Abstraction also played a role early on in Belgian sculpture as reflected in the geometric sculpture of Georges van Tongerloo and in Paul Joostens and Victor Servrancx's assemblages of the 1920s. The degree of interest in sculpture is reflected in the fact that in 1950 the old sculptors' centre in Antwerp became the home of the newly established Open Air Sculpture Museum 'Middelheim'.

Where Cobra took up

In Belgium Cobra grafted itself onto the evolving Surrealist movement that continued long after the Second World War. Apart from the major painters René Magritte and Paul Delvaux, this was largely made up of writers to whom an expressionist idiom was alien. Thus the input to the movement by the 'Belgian Cobra' via the group Le Surréalisme Révolutionnaire, started by Dotremont in 1947, was largely of a surrealist nature. Dotremont asked Surrealist writers for contributions to the magazine Cobra of which he was 'editor-in-chief'. The third issue of the magazine was entirely devoted to Belgian Surrealist film.[11] During this period the group produced little of note in the visual arts apart from some activity in the field of photography. An exception was the exhibition L'Objet à Travers Les Âges (The Object through the Ages).

Writing from memory in 1966, Dotremont enumerated the series of exceptionally surrealist-seeming objects showcased in this exhibition, which ran from 6 to 13 August 1949 in a small gallery in the Paleis van Schone Kunsten in Brussels; unfortunately we no longer have a list of the exhibited works (he forgot, however, that Constant had also exhibited several of his wooden objects at the show).[12] 'Bourgoignie, Calonne, Havrenne, Noiret (an architect, a composer and two writers respectively, all of whom also wrote poetry and drew [W.S.]) and I', relates Dotremont, 'exhibited a compass drawing, a telephone, an immense wall poem ("Isabelle"), a bottle full of words, a suitcase, the head of a wax shop-window dummy [...], coins arranged on the racks of a velvet-covered jewellery case, potatoes etc.' He particularly wanted to draw attention to three specific exhibits: 'a basket with various objects which were put at the disposal of the public, a conventional brochure on the perspectives of music to which a doorbell was attached and on which visitors were requested to place their signature, and the potatoes.' Dotremont felt that these objects were more 'Cobra' than Surrealist because they were neither 'poetic' nor 'luxurious', in the way that he felt the Surrealist objects were, but 'real', 'vulgar' and 'aggressive', as he put it in his letter to me of 1-2-1965. He took the potatoes that he himself had exhibited as an example. 'I had suffered from terrible hunger during the war: hence the potatoes [...] In order to understand Cobra, my potatoes, painting, life, the disbandment of Cobra, one must remember that most of us had suffered terrible hunger. [...] These potatoes were a living expression of what Cobra was.'

Among the very few artists from the Surrealist movement who became involved with 'Belgian Cobra' were Raoul Ubac (1910-1985) and Pol Bury (b. 1922), both of whom worked intensively in sculpture. In 1946 Ubac, who moved from Belgium to France at the age of nineteen, began producing slate engravings inspired, among other things, by rune stones, that show close parallels with what the Danes and the Dutch in the Cobra Movement were seeking to achieve. Bury, who dabbled with Surrealism for a period, followed by a phase where his paintings displayed a vague linear abstraction, was to devote himself entirely to sculpture

126 Christian Dotremont, 'secretary general' of the Cobra journal, at his typewriter on Rue de la Paille, Brussels, 1950. On the wall, right, the wooden relief, Whale (1948) by Constant, now lost. (Photo Serge Vandercam).

127 Christian Dotremont, 1971.
(Photo Pierre Alechinsky).

Christian Dotremont

128 Drawing a 'logoneige' (logogram),
Ivalo, Finnish Lapland, 1976.

129 Nulle part qu'ici le vif ailleurs,
(Nowhere but here is life more distant),
snowgram, Ivalossa, Finnish Lapland, 1976.
(Photo Caroline Ghyselen).

after 1953. But in creating the kinetic sculptures based on geometric forms, for which he became widely known, he went down a path that diverged radically from that of Cobra.

In the course of 1949 links were established with artists from a quite different sphere. In March of that year the young painter Pierre Alechinsky, who in retrospect ranks as the most important Belgian Cobra artist, joined Cobra. However, it was not his work alone that was to exercise a decisive impact on 'Belgian Cobra', but also that of his academy friends, particularly after the movement itself had long since ceased to exist. In the summer of 1949 Alechinsky, together with several friends who had either just left or were still attending the occasional class at the academy (École Nationale Supérieure d'Architecture et des Arts Décoratifs in l'Abaye de la Cambre in Brussels), refurbished a large dilapidated building in rue du Marais in the old centre of Brussels as studios. Here in this building, which was to be the scene of many Cobra activities and that Dotremont was to dub the Cobra house,[13] the movement came into contact with Alechinsky's friends, among whom Reinout D'Haese and Serge Vandercam. These artists developed somewhat later or were several years younger than their Dutch counterparts (themselves some ten years younger than the Danish members) and together with Alechinsky in Belgium around 1958 they were to pick up on the later developments of the 'Cobra language' or style, which in my opinion forms the most important historical contribution to this movement.[14]

The increased interest these artists in Belgium took in Cobra after 1956 was undoubtedly an important factor. Indeed, Cobra unexpectedly underwent a kind of rebirth with the opening in late December 1955 of the Taptoe meeting-centre on Oud-Koren Plein 24-25 in Brussels. When the centre was first set up by the art-lovers Clara and Gentil Haesaert, in collaboration with several artists and poets (among whom Serge Vandercam and Hugo Claus, who were both briefly involved with Cobra, one as a photographer the other as a poet), it had not been with Cobra in mind. It was simply intended as an exhibition space and cafe for young artists and poets. Right from the outset, however, there had been contact with the French poet Edouard Jaguer, who founded and published his own cultural journal **Phases** (that also acted as a springboard for exhibitions) and who also gathered around him many former Cobra members. Jaguer suggested to the organisers of Taptoe, who were looking for exhibitors in Paris, that they should contact Alechinsky. He in turn suggested they visit Asger Jorn, who was immediately enthusiastic. Taptoe soon became a place where you might meet not only Alechinsky, Hugo Claus, Serge Vandercam, and the sculptor brothers Rein and Roel D'Haese, who had also been actively involved with the opening of the centre, but Asger Jorn as well! This renewed contact led to an exhibition being mounted at Taptoe in 1956 which showed recent work by several Belgian artists and two foreigners with whom a strong bond had been established, as well as work by Asger Jorn and Karel Appel. In addition Dotremont, who soon became involved with Taptoe, showcased fifteen works, selected from the early Cobra years, by Appel, Constant, Corneille, Carl-Henning Pedersen, Anders Österlin and Asger Jorn (including the 'word-painting' **Les poèmes ne lisent jamais** [Poems never read], created in collaboration with Dotremont), making this the first Cobra exhibition after Cobra.[15]

It must have been this renewed contact that prompted **Christian Dotremont** and other old Cobra members to rekindle the **peinture-mot** in the years that followed. To a certain extent he saw this genre as the ultimate 'Cobra moment', or a sort of initiation ritual for those not yet associated with the movement. In an autobiographical note that appeared shortly before his death in 1978 Dotremont commented: 'En 1956 entreprend de réaffirmer Cobra' (In 1956 attempt to breathe new life into Cobra).[16] From 1962, however, Dotremont devoted himself more to painting, working like an Eastern calligrapher with his own handwritten texts to create written improvisations which he called 'logograms'. These were given a three-dimensional application during 1963 in Finnish Lapland when he took a stick and wrote in the snow and ice (something he repeated on several occasions in the 1970s); he subsequently photographed the result of these so-called **logo-ice** or **logo-snow-writings** (fig. 128 and 129) In 1964 he went on to paint these 'logograms' on suitcases, dubbing them 'valisograms'. Six years earlier he had already applied them to Serge Vandercam's huge lumps of clay or mud at a time when the latter was painting and working with ceramics entirely in the Cobra idiom.

The new development in Jorn's work, which revealed a clear break with his earlier, rather stiff,

emphatically linear painting style, made a huge impact on the Taptoe artists. In his history of Taptoe's brief existence (1955 to 1957), written to accompany the commemorative exhibition of the centre in 1988, Piet de Groof (pseudonym of the art promotor Walter Korun, one of the founders of Taptoe) has suggested that Jorn's new found freedom with paint was probably prompted by his experiments with ceramics at Albisola, where he had abandoned himself entirely to working with clay.[17] It was since this renewed contact, that Alechinsky's pictures, Reinout D'Haese's sculptures and Serge Vandercam's paintings and ceramic figures revealed the emerging mythical creatures which originally betrayed the particular influence of the work of their inspirational Danish colleague. In 1962 this renewed enthusiasm for the old Cobra spirit yielded the first retrospective exhibition, undoubtedly through Dotremont's initiative, entitled Cobra et après (et même avant) mounted at the Galerie Aujourd'hui at the Paleis van Schone Kunsten in Brussels, showcasing mainly works on paper by forty-two former, or fleeting, members.[18]

But it was not solely Jorn's influence that made artists in Belgium in this period turn to creating fantasy creatures in paint, metal and clay! At that time Belgian sculpture was undergoing a broadly-based development, and one of its most significant aspects was a movement made up of artists working in various techniques and materials, but especially in ceramics, who were creating a world of mythic or archetypal creatures. The fundamental stimulus for this new development in ceramics came from the influential artist Pierre Caille, who had been appointed teacher of ceramics at the École Nationale Supérieure d'Architecture et des Arts Décoratifs (La Cambre) in 1949. Originally a painter, Caille had discovered the infinite possibilities offered by ceramics when carrying out a commission he had received through the famous architect Henry van de Velde to decorate the Belgium Pavilion for the World's Fair in Paris in 1937. The plasticity of the clay, the vigour of the colour in the enamel glazes inspired in him 'an interplay of metamorphoses'.[19] The great blossoming of ceramics as a fully fledged technique within sculpture, which manifested itself particularly in Pierre Caille's students[20] around 1960; the ceramics Serge Vandercam was producing under Jorn's influence, and the many fantasy-based artworks using other materials which were produced in that period, such as Rein and Roel D'Haese's metal sculpture, all reveal that links were being forged in Belgium for the first time which go back to the fantastical world of Hieronymus Bosch.

Raoul Ubac

Raoul Ubac (1910-1985), who was active in Cobra in various periods, was the first Belgian artist within the movement to produce a three-dimensional work. His close association since 1934 with the Surrealist movement in Paris – he contributed Surrealist photographs to the periodical Minotaure – brought him into contact with Christian Dotremont in 1940.[21]

Ubac worked in a variety of techniques and styles throughout his career. He was born in the Ardennes which gave him a strong feeling for the forest and the earth. As a youngster he had wanted to become a forester. In his youth he travelled extensively in Europe, seeking to capture his impressions – particularly of stones which fascinated him – in photographs (fig. 132) as well as on canvas and paper. In Paris he enrolled at the Sorbonne in the faculty of letters, but he soon left university to study drawing. He focused on experimenting with photography in which he was strongly influenced by Man Ray. In 1942, however, he abandoned both Surrealism and photography to devote himself entirely to painting and drawing. He developed an aesthetic abstraction which in postwar Paris led him to be associated with the lyrical abstract style prevalent in painting at that time, displaying a close link with painters such as Manessier and Bazaine.[22]

One day during a stay in the Haute-Savoie in 1946, he was attracted by the shape of a piece of slate and he picked it up and engraved a drawing on it with an old nail. This was the start of a fascination with slate which never left him. Some time later he also started working this material with sculptor's tools and the results are pure sculpture.

His work for Cobra reflected all his various activities in the visual arts. His photographs featured in the exhibition of experimental photography Les développements de l'oeuil: de Daguerre à Ubac (The Developments of the Eye: from Daguerre to Ubac), mounted in the Galerie St Laurant, Brussels in the

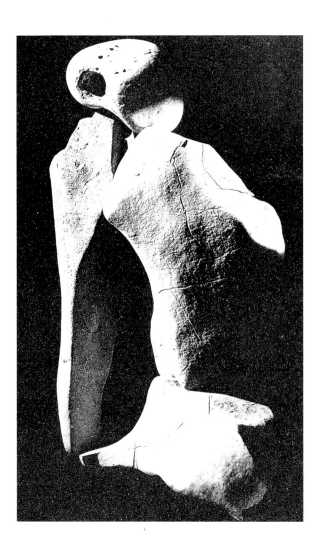

Raoul Ubac

130 Engraved slate reproduced in Cobra no. 6, published in April 1950 in Brussels.

131 Slate relief with cobra-head symbol and the word COBRA, used for the cover of Cobra no. 7, published in autumn 1950 in Brussels.

132 Pierre de Dalmatie (Dalmatian Stone), c. 1935, photo.

autumn of 1950, and announced on the invitation as being 'organised by Monsieur Cobra'. The catalogue of the final Cobra show in Liège includes two paintings and three gouaches, as well as two sculptures and one 'ardoise' (slate work) under the category Sculptures. It is possible that the two sculptures were also in slate and that the name 'ardoise' (slate) was used for his engraved slate reliefs. Either way, slate was the material which he continued to use for his three dimensional work.

With his 'ardoises' Ubac seems to experience the same longing to return to basics, the same need to express himself as a folk artist, as was manifested by the Danish and Dutch Cobra artists. For him, as for them, the material itself, the slate, played an essential role in the creation process. The Cobra magazine featured several of his 'ardoises' and for the cover of the seventh issue, published in Brussels in the autumn of 1950, he made a special slate engraving with a symbol for the head of the Cobra snake with the word COBRA scratched under it in a rudimentary, child-like way (fig. 131). The engraving of the word COBRA was re-used in the tenth issue of the magazine where it was placed above the opening article. That same issue also featured a reproduction of a piece of slate carved with enigmatic symbols which Ubac had made to illustrate Christian Dotremont's poem Ancienne Eternité (Ancient eternity). That other members of the movement also saw a relationship between Ubac's work and forms of folk art is borne out by the fact that an illustration of one of his slate engravings dating from 1947 was featured in the sixth issue of the magazine, which was entirely devoted to folk ar (fig. 130). At the top of the same page the magazine carries a reproduction of an interesting find made by the painter and tapestry designer Corneille Hannoset (who was briefly associated with Cobra) on the banks of the Semois in the Ardennes: a piece of slate depicting two figures engraved in a primitive, almost geometric style; a man and (probably) a woman.

During this period Ubac was too deeply caught up in the artistic life of Paris – where he enjoyed enormous success – to involve himself to any great degree with Cobra. At that time his work was already being showcased by the prestigious Galerie Maeght, which, nota bene, was given as his address in the catalogue of the Cobra exhibition in Liege! Alongside his painting, he was working increasingly with slate, producing engravings and reliefs but also free-standing sculptures in the form of torsos and/or steles (fig. 159), as well as architecture-related work. In his Notes sur l'ardoise (Notes on slate) of 1968 he writes about his favourite material, pieces of which he sometimes incorporated in his paintings: 'Slate is a stone which feels like a book thousands of pages thick [...] With certain torsos I have finally managed to create extremely flat sculptures which are nevertheless carved on both sides.'[23] Several religious works were commissioned from him in this technique, including a crucifixion (c. 1956)[24] and in 1964 a depiction of the Stations of the Cross for the chapel of the Fondation Maeght in Vence; this later work is particularly moving in its direct, rudimentary drawing style. The mysterious, inaccessible character of his large-scale stones reflect Ubac's attraction to monumental neolithic megaliths with their powerful, primeval resonance.[25]

These associations, however, are particularly evoked in his slate works, which he crafted with the same formal language as we see in his pastel-coloured paintings which fully reflect the aesthetic of the École de Paris of that time.

Reinhoud

In 1950 the sculptor Reinout D'Haese (b. 1928), who from 1960 simply called himself Reinhoud to distinguish himself from his older sculptor brother Roel (1921-1998), was introduced to the 'Ateliers du Marais' by Olivier Strebelle. The sculptor and ceramicist Strebelle (b. 1927), whom Reinhoud knew from the academy 'La Cambre', was responsible, along with Alechinsky, for the administration of this building with its exhibition space and many studios.[26] Reinhoud was one of the earliest occupants of the Ateliers du Marais. He set up his own forge in the courtyard, where he first started making sculptures from welded copper. In addition, as a smith, he was instrumental in helping to refurbish the building, including repairing locks. Shortly before this he had made a large weathercock for the academy which was reproduced in the last issue of the Cobra magazine. In the Ateliers du Marais he went on to make a goose, a dove, a dancer and an owl (fig.137, 138, 136 and 139). These simple figures made in copper or iron look like genuine pieces of folk art. With the exception of the owl, all these sculptures were exhibited in Cobra's last show in Liège.

Rein and Roel, who have ranked since the 1960s among Belgian's most eminent contemporary sculptors, grew up in Aalst in a strict Catholic family of ten children, presided over by an extremely severe father. The latter was an influential lawyer as well as a political activist and had been a leading figure in the Flemish movement in the 1930s. Both sons abandoned Catholicism in their youth and their artistic aspirations, inherited from their mother, kindled in them a love of France, in contrast to their pro-German father.[27] From an early age at the Jesuit College in Aalst they were both much more interested in making things than in their academic lessons.

Because of his limp, the young Reinhoud was always an outsider; he was taciturn and left-handed. But even at the age of five he was interested in materials. He would fashion animals – sheep, cats and dogs – out of paraffin wax or candle wax. And after he acquired a penknife at the age of eight he started carving figurines out of firewood, giving them separate limbs which he would attach to the body with wire. Later on he used packaging material to make miniature aeroplanes, cars, boats and puppets, for which he also made the clothes. He was also interested in insects, breeding caterpillars in a terrarium. A book that he had been given during the war about the Paris zoo, Le Jardin des Plantes, with engravings of tigers, giraffes, snakes and exotic birds, excited his imagination and he started drawing them; but his chief delight was to make wooden copies of the animals. So it is hardly surprising that with his early passion for tangible material he should choose a career in sculpture. His elder brother Roel, who had begun working as a sculptor at the beginning of the war, was a great help to him.[28]

In the autumn of 1945 his brother encouraged him to become apprenticed to a silversmith in Brussels where he learnt to work with copper and brass and how to handle a hammer and burin. Also on his brother's instigation he enrolled the following year at the National College of Architecture and Decorative Arts 'Terkameren' (La Cambre). However modelling clay figures from life, which he studied there under Oscar Jespers, did not interest him and he decided to take engraving lessons at the evening school for arts and crafts, for which he welded his copper-plate weathercock. Not long afterwards this cock provided him with his entrée to the Atelier du Marais and his life took a new turn.

The building in the Marais provided Reinhoud with his own studio for the first time. He and another old pupil from La Cambre, Corneille Hannoset, who was also working there as a sculptor, bought a gas welder.[29] But he only produced one or two works of any note; his real development as a sculptor was to come much later. Nevertheless this was an extremely important period for him as it brought him into contact with an international artists' movement. Moreover the friendship that was cemented between him and Pierre Alechinsky in the Marais years was to have far-reaching implications for both of them. But the first years were difficult, especially when the property in the rue du Marais was demolished in 1953 and Alechinsky moved to Paris, forcing Reinhoud to look for accommodation elsewhere. For a long time he had to earn his money by working as a welder on building sites or doing odd repair jobs, which left him very little time to sculpt. Apart from the aforementioned works in copper, he only produced a few welded-iron animals during this period.[30]

Reinhoud's association in 1955 with Taptoe and the renewed contact it brought with his old friends from the Marais launched him as a sculptor. Up to this point Reinhoud had been solely regarded as a coppersmith, but inspired by the stimulating climate of this new avant-garde centre he started making large-scale copper or iron insects, toads and beetles. Jorn was very enthusiastic. In May and June 1956 Reinhoud exhibited his 'insects' in Taptoe. This show, for which he was awarded the Belgian Prix de la Critique, marked a turning point in his development. That same year he and his brother Roel also took part in the group exhibition at Taptoe that was entirely devoted to Cobra.[31]

His friendship with Alechinsky deepened. After spending two months travelling with Serge Vandercam through Turkey, Alechinsky invited him in the autumn of 1958 to come and work in his summer studio in Sauvagemont in Walloon Brabant. There he produced some twenty sculptures which were a mixture of wild vegetation and fantastical animals, such as Alien, 1958. This period saw the start of an inspiring interaction between the two artists. Alechinsky's paintings (influenced by Jorn) were also developing along new lines towards an enigmatic and often turbulent jumble of forms, which begin to feature mythical creatures.

133 Reinhoud working in his studio in
North France, c. 1997.

134 Reinhoud among his sculptures in
North France, 1997.

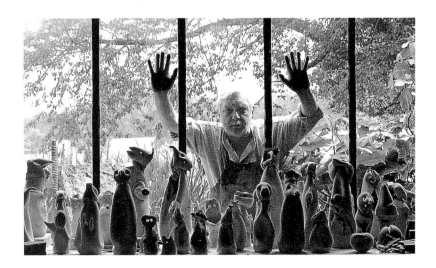

135 Serge Vandercam against the window
of his studio, Bierges, Belgium, 1998.

For Reinhoud's copper phantoms he would devise evocative titles. Both artists were very literary. Reinhoud took up Alechinsky's idea himself and continued to invent intriguing titles for his works.[32]

In 1959 Reinhoud went to live in Saint-Rémy-de-Provence on his own, 'where he shut himself up in his studio as though needing to catch up on lost time.' Ghostly creatures, like 'visions from hell', began to appear in his work.[33] We see this in the piece he entitled Le théâtre et son double (The Theatre and its Double) from 1960 depicting a horde of hideous insect-like creatures sporting heads with human features. In these years both the Koninklijk Museum voor Schone Kunsten in Brussels and the Middelheim Museum in Antwerp bought works by him and he was contracted to the Galerie de France, where he had been introduced by Alechinsky. In 1960 Alechinsky invited Reinhoud to come and live with him in La Bosse (Oise) about 80 kilometres from Paris. After the Marais period he had moved into an old school building where an empty shed served as his studio. In the following years, the work of these two artists became so intermeshed that it spawned some extraordinary collaborations, as when Reinhoud actually attached a sculpture to one of Alechinsky's canvases (fig. 155 and 156). They also exhibited together on many occasions, first in 1961 at the Stedelijk Museum in Amsterdam, then in the United States and in Denmark and Paris.

From the time that he went to live in La Bosse we see his plant-like copper insects increasingly assuming human features: not only do the heads resemble human beings but the bodies have taken on the human anatomy as well. As he developed, all the different facets of these creatures – made in copper or tombac (red copper), brass and sometimes even in silver or tin, and from 1968 occasionally in wood and even in papier maché in 1965 – continued to exist side by side. Haut Perché (Perched High), for example, created in 1961 (fig. 160) is entirely insect. When human features predominate they are strongly reminiscent of dishevelled monks entangled in the folds of their habits, as in Burnous of 1963 (fig. 162), or of penitent flagellants with their high conical caps walking barefoot in an Easter procession (fig. 134). Originally in the Middle Ages the high conical cap was the sign of a heretic, who was obliged to wear such a hat during their trial and final journey to the scaffold. With his creatures Reinhoud often turns the hat the other way round, so that it looks like a strange long beak (fig. 165). Indeed the long beak became a hallmark of many of his works, and we may assume that he was covertly alluding to the heretic's hat which here has become fused with its wearer. That he was intending to evoke the Inquisition with his oppressive human creatures (fig. 143 and 144) is borne out by the title L'Investiture (meaning literally the ordination of priests) of 1965, one of his most compelling works in papier maché (the perfect medium for carnival masks). This work which alludes to the power of the church is possibly also an allusion to his authoritarian father. Some of Reinhoud's other images, like Melmoth of 1966, where a skull can be seen lurking within a flapping robe, may suggest the fear of hell and damnation that grips the unfaithful. The heavily draped robes of these monumental figures are sometimes fashioned into the shape of insect shells. This is so pronounced in some works that the beaten-metal carapaces seem almost to form abstract plant or flower compositions, which cloak some vague human form as, for instance, in his immense work Situations de l'Entrelacs (Situations of Leafwork) of 1964-1965 or in Poke-bonnet (Spout Hat) of 1988 (fig. 161).

Alechinsky appears to have been particularly influenced by Reinhoud's metamorphic figures. Without any preconceived plan and using a ball hammer, Reinhoud would beat-out the shapes that he had previously traced on metal sheets with an aniline pencil,[34] applying the Dinant copper-chasing technique.[35] The forms and shells which he subsequently assembled, with no attempt to conceal the welded joint, show a remarkable affinity to the angular forms in which Alechinsky started to paint his enigmatic creatures in the 1970s: his acrylic painting on paper Cordelière (Franciscan Nun) of 1973 is a good example. In turn, under Alechinsky's influence, Reinhoud took up drawing in 1971 and the extensive series that followed clearly reveal Alechinsky's impact. Like the latter Reinhoud built-up his fantasy figures out of swirling forms, which are usually individually linked, whereas in Alechinsky's work they merge into one another with greater fluidity. And like Alechinsky, Reinhoud was also inspired by orange peel. Reinhoud's carapaces and the peels, which they jointly drew, reappear later in both their work.

In 1962 surveying the crumpled up sheet of an unsuccessful picture, Reinhoud hit on the idea of

Reinhoud

136 Avant la prise de Constantinople
(Before the Fall of Constantinople)
originally La danseuse (The Dancer) and
shown as such at the Second International
Exhibition of Experimental Art in Liège,
October-November 1951-, 1951, red copper.
Edouard Dumont collection, Brussels.

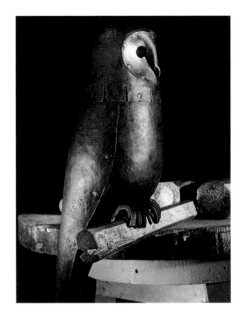
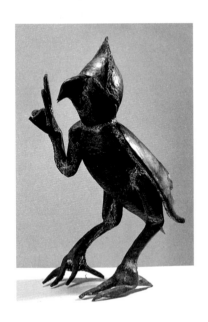
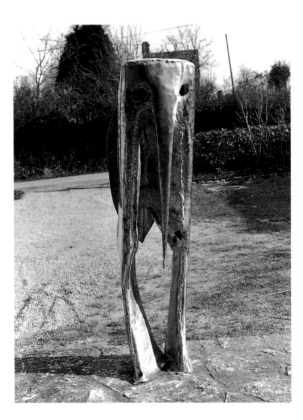
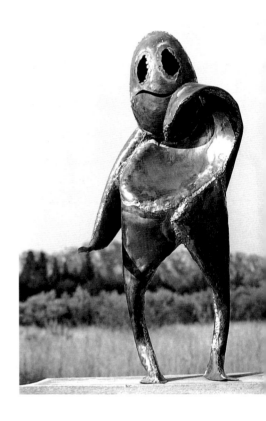

Reinhoud

137 L'oie (The Goose), 1951, copper,
46 x 15 x 32 cm.

138 Pigeon (Pigeon), 1950.

139 Hibou (Owl), 1951, iron.

140 Urbi et Orbi, 1977, copper, 45 x 21 x
31 cm. Ellen and Jan Nieuwenhuizen
Segaar collection, Antwerp.

141 Monsieur Le Maire (Mr Mayor),
1992, brass, 133 x 48 x 36 cm. Ellen and Jan
Nieuwenhuizen Segaar collection, Antwerp.

142 Un exemple si parfait du genre
(A perfect example of its kind), 1995,
red brass, 86 x 38 x 32 cm. Ellen and Jan
Nieuwenhuizen Segaar collection,
Antwerp.

'crumpling' sheets of metal. This engendered a series of his enigmatic monks and flagellants in this style, such as his comical piece Bibendum (an intoxicated monk?) of 1962 (fig. 145) or his horrifying Happy Days of 1963.

These figures bring a certain monumental allure to various metamorphoses of the human form, but Reinhoud also produced a host of small caricatural half-animal-half-human figures, like Fourbue (Exhausted), 1981 (fig. 161), or figures which either are or appear to be entirely animal, such as Urbi et orbi (1977), Monsieur le Maire (Lord Mayor, 1992) and Un example si parfait du genre, (An example perfecxt in its kind, 1995 (fig. 140-142), or entirely human, like L'existence grise (Grey Existence), 1968 and Comme tu voudras (As you like), 1969. The majority of these works are half-animal creatures which, with their thin insect-like arms, legs tapering to a point, long fingers ending in tendrils, reptilian tails, fish-heads and snouts like long, pointed caps, seem to have walked straight out of a painting by Hieronymus Bosch. Bosch particularly depicted St Anthony being plagued by such creatures. The more human figures, however, are redolent of the peasant characters seen in pictures by Bruegel the Elder. With this work Reinhoud portrays a view of humanity which is hardly optimistic, though not without humour.

Plagued by a strange illness which manifested itself in bouts of deep depression, he executed in 1968 a fourteen-part-series in silver-plated lead entitled Migraines, tormented creatures which, in place of a head, had gigantic hands with long pointed fingers. Another illness from which he had suffered since childhood led to a whole population of funny little creatures. From an early age stomach complaints had made it impossible for him to digest the soft part of bread and he became obsessed with it. In 1962 he started moulding the soft dough into an endless series (over three thousand) of minute dolls which he later coated in bronze or silver. In 1965 this peculiar sculptural activity prompted his friend Alechinsky, in whose house he often ate, to compile the book Titres et pains perdus (Lost titles and bread). That same year Reinhoud exhibited these works for the first time in Copenhagen at the Birch gallery, under the title Tak for brod (Thanks for Bread).

Since 1958 Reinhoud's œuvre had not undergone any great stylistic alterations; although it embraced a large variety of forms, the same motifs recur regularly. Technical discoveries were largely what inspired new aspects in his work, as we see in the Surrealist twist that he gave his sculptures by the addition, from 1980, of found objects, such as boulders to represent heads. An entirely new avenue was opened up for him in 1982 when he started making figures out of flat, left-over pieces of metal, which an etcher later engraved for him. This was the start of an entirely new genre. He went on to illustrate many books with these humorous, flat animal-like human figures, as well as with his drawings.

As a sculptor Reinhoud made a major contribution to the later development of the Cobra idiom with his world of fantasy creatures which, I believe, spring from his deep-rooted interest in medieval visions of hell, diabolical representations and the persecution of heretics. He was also active in various different capacities in later manifestations of the Cobra movement, as occasionally was his brother. The directly human-related figuration in Roel's work which depicts gruesome decay and putrefaction dominated by Surrealist elements, seems far removed from what I see as the essential Cobra spirit. Reinhoud – like Heerup, Jorn and Appel, for instance – always allows the material to assume its own mysterious role in predominantly ambiguous forms of mythic life, which he seems to bring forth from the material itself.

Serge Vandercam

Serge Vandercam (b. 1924), who was involved with the foundation of Taptoe in 1955, was already a familiar figure to those frequenting this new artists meeting-centre in Brussels. He first came into contact with Cobra in 1950 when Dotremont invited him to exhibit the Surrealist photographs he was shooting at the time in the exhibition of experimental photography and daguerreotypes, Les développements de l'oeuil (The Developments of the Eye) in Brussels. Dotremont provided an introductory text for the show which also featured photographs by Raoul Ubac and Roland d'Ursel,[36] a photographer who took part in a number of Cobra activities in Belgium.

Vandercam, like Ubac an extremely versatile artist, began his career as an experimental photographer.

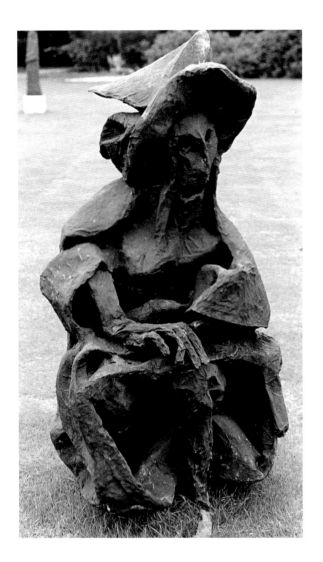

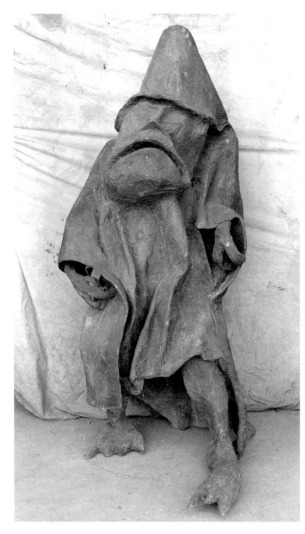

Reinhoud

143 Lynch, 1965, bronze (unicum, original papier maché), 160 x 80 x 7 cm. Private collection.

144 A contre coeur (Without Enthusiasm), 1965, bronze (unicum), 192 x 85 x 85 cm.

145 Le Bibendum, 1962, yellow brass, 38 x 24 x 22 cm. Ellen and Jan Nieuwenhuizen Segaar collection, Antwerp.

146 Bassoon, 1959, copper, 50 x 40 x 50 cm. Cobra Museum for Modern Art, Amstelveen.

In 1953 he turned to painting and gained recognition within the 'Jeune Peinture Belge'. In both his photographs and his early paintings an atmosphere of Surrealism predominates in which one senses allusions – particularly in the photographs – to his experiences in a German concentration camp during the war. The violence and thickness with which he applies the paint seem to presage his later expressionist phase; a period when Vandercam was also making films which won him various prizes.[37]

The encounter with Asger Jorn and his work in the Taptoe centre proved a watershed for Vandercam's artistic development. From that moment on his work took on a very direct, spontaneous quality. He immediately experimented with the combination of writing and image, sometimes together with his painter friend Jean Dypréau, a method of working that he dubbed peinture partagée (shared painting).[38] Later in the 1980s he was to return in greater depth to this form of collaboration with the poet Joseph Noiret, whom he knew from the Cobra years. Together they produced many paintings and collages in this genre. In the early 1960s his original, abstract painting style acquired a spectacular expressionist resonance which sometimes seemed to mirror the new developments taking place in Jorn's work at that time. He completely rejected the alienation of Surrealism, seeking – like Appel and Jorn – to abandon himself to his material, to the paint.

It was certainly Jorn's example that started Vandercam working with clay in 1958, the year that he sealed his 'blood-brotherhood' with the spirit of Cobra in the form of his so-called Boues or Slijken, chunks of clay in which Dotremont inscribed a text (fig. 150). In 1959 he went to Albisola to master ceramic work in the San Giorgio studio. He built-up an extensive œuvre in this technique, including dishes and vases, as well as fantasy figures. This medium became as important to him as painting. His ceramic figures – some of which retained elements of the basic vase form and which he sometimes crowned with comical animals' heads (fig. 135 and 167) or invested with theatrical gestures, such as Crie, Crache (Scream, Spit), 1971 – show a close affinity with Jorn's work. Vandercam, however, rarely uses the bright colours with which Jorn decorated many of his sculptures. But like Jorn, he frequently leaves whole areas of the clay unpainted, thus allowing the colour of the clay to enter into a dialogue with the applied spots of colour. Moreover Vandercam's method of shaping the clay is less emotive than that of Jorn. Indeed Vandercam often simply takes a flat slab of clay and folds it – sometimes cutting or tearing it – like a piece of cardboard or paper to produce a shape (fig. 149 and 151).

In common with many Cobra artists during the Cobra years, Vandercam (coincidentally born in Copenhagen from a Belgian father and a mother of Italian origin) was drawn to Scandinavia. On his travels there in 1962 he was struck, like his fellow artists, by the strong sense of the past. One particularly vivid symbol of that past, Tollund Man, became a recurring motif in several of his works. Vandercam not only used the name as a title for a series of paintings but he also used this man (dating from around 1800 BC and discovered in perfect condition in the peat bogs of Denmark) as a subject for his three-dimensional ceramic creations (fig. 168-170). One of the works that he realised in 1962 and which he called Man van Tollund consists of a tall vase which appears to be being forced open at the top by a sinister creature trying to wriggle its way out (fig. 147). Hugo Claus wrote a poem about this man who was strangled to death which he dedicated to Vandercam.[39] Although there was an element of the lugubrious in Jorn's work, with Vandercam this aspect tended to be extremely pronounced; so much so that around 1970 it began to dominate his paintings. His pictures are increasingly peopled by creatures that are reminiscent of phantoms, and recall the work of the Norwegian painter Edvard Munch.[40] He also gave his ceramics a sinister tone by adorning his figures with skull-like heads, such as Self Portrait, 1964 (fig. 152) and Détournement (Darkening; fig. 149), Tire la langue (Stick out your Tongue, 1971; fig. 151), or even by using an animal's skull, as we see in L'Écorché (Anatomical Model 1964; fig. 148).

Since 1972 Vandercam has regularly worked with Struktuur 68, a ceramic studio in The Hague, making miniature sculptures, tile panels and decorative plates. In the 1980s he also started making his hallucinatory-like fantasy creatures out of folded paper, sometimes coating them with a thin layer of clay. The resulting objects were far from permanent. In contrast, his latest work, in addition to clay, includes objects in wood and marble.[41]

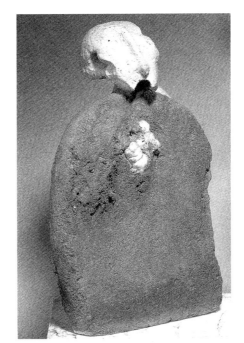
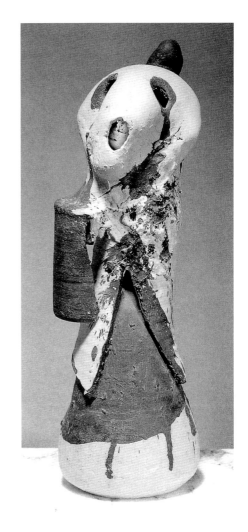

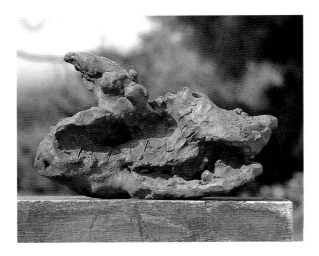

Serge Vandercam

147 Homme de Tollund (Tollund Man),
1962, ceramic, h. 95 cm. Oscar Schellekens
collection, Brussels.

148 L'écorché (Anatomical Model), 1964,
ceramic, 55 x 19 x 35 cm. Property of the
artist.

149 Détournement (Darkening),
c. 1970, ceramic, 48 x 20 x 22 cm.
Property of the artist.

Serge Vandercam (sculpture)
Christian Dotremont (inscription)
150 Rafale (Gust), 1958, so-called 'Boue'
(Slush) in which Christian Dotremont
wrote a text.

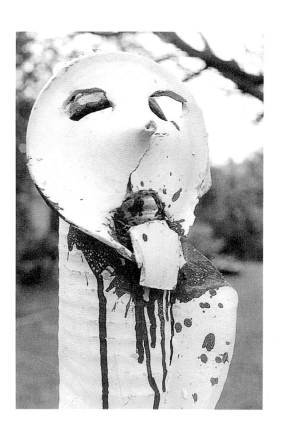

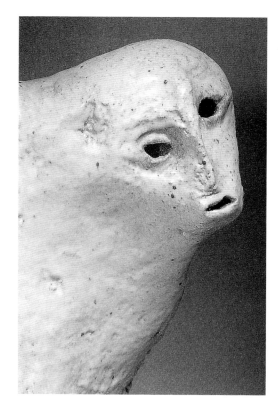

Serge Vandercam

151 Tire la langue (Stick out your Tongue), 1971, (detail) ceramic, h. c. 33 cm. Property of the artist.

152 Autoportrait (Self Portrait), 1964, (detail), ceramic, 40 x 55 x 35 cm. Property of the artist.

Pierre Alechinsky (painting)
Christian Dotremont (logogram)

153 Abrupte fable, (Abrupt Fable), 1976, Indian ink and acrylic on paper, pasted on canvas, arranged as screen, 284 x 475 cm. Pierre Alechinsky collection, Paris.

Pierre Alechinsky

154 Chocs et bris (lave émaillée), 1988, cube with tile panels on five sides, 130 x 130 x 130 cm. Galerie Lelong, Paris.

Pierre Alechinsky

It might seem strange to leave an artist who occupied such a prominent position in the Cobra movement in Belgium till last. But throughout his career Pierre Alechinsky (b. 1927) hardly produced any three-dimensional work which is, after all, the subject of this publication. The Cobra revival around 1956 was also to have a fundamental impact on Alechinsky. At the time of Cobra and for some years afterwards he and his academy friends formed part of the group Jeune Peinture Belge, which was the focus of attention in Belgium at the time and was modelled on the aesthetic of the young École de Paris, with Bazaine as its chief exponent. Oddly enough they did not seem aware of the fact that this poetic painterly style, with its soft pastel colours which was so acclaimed in the postwar years at the various biennials and salons and which attracted many religious commissions with the renaissance of church building in that period, was precisely the style of painting which the 'northern barbarian' Danish and Dutch Cobra members were consciously rejecting. Moreover in the early 1950s Alechinsky became deeply involved with his great passion, Japanese calligraphy. It was not until around 1956 that the dramatic expression of Jorn's work, which was at its height at that point, really impinged on Alechinsky. Although he was aware of and applauded the Albisola ceramic experiment, he did not join Jorn and the others who were working with clay; neither did he go to Albisola later like Vandercam.

Nonetheless many years later Alechinsky, who had decorated china services for the Sèvres porcelain factory on several occasions,[42] did create three-dimensional objects in ceramics. These however were of an entirely different nature from those of Jorn. In fact he hardly ventured beyond the flat plane when, in 1985 with the help of Hans Spinner in the ceramic studio of the Lelong gallery at Grasse, he started making large tile panels – the so-called 'Laves émaillées'. These were fixed to five sides of a cube, such as Chocs et bris (1988, fig. 154), or to a wall as in Album et Bleu (Album and Blue; 1985). The latter consists of two large two-by-three-metre walls placed next to each other in a corner which he and the architect Claude Strebelle realised in the Sart Tilman open-air museum near Lille University.[43] And in 1990 in the same studio in Grasse he produced a series Pains de terre émaillé (glazed terracotta rolls), lumps of clay roughly fashioned into a bread-shape then covered in calligraphy and fired in the kiln (fig. 171).[44] Some years later in Grasse he gave humorous expression to his love of literature and books (he had compiled several books himself) when he made an extensive series of books in clay, which he 'filled' with illustrations and texts (fig. 158, 158).[45] Under the appropriate title 'Livres de Pierre' (Books of Stone) Daniel Abadie wrote in the catalogue that accompanied the exhibition of these books in 1994: 'Analogous to editing a haiku, the space that Hans Spinner has allocated to the painter requires a restraint of thought and gesture, whereby the illustration is reduced to a few strokes of the brush and the spirit.' These objects in particular recall his passion for writing and Eastern calligraphy which, together with the far-reaching influence Asger Jorn had on his work, form the basis of his personal painting style.

Finally, I would also include the screen L'Abrupte Fable (The Abrupt Fable, fig. 125 and 153) – a magnificent free-standing painting which he and Dotremont realised together in 1976 – among the three-dimensional Cobra products.

Pierre Alechinsky (painting)

Reinhoud (sculpture)

155 La mutation (The Mutation), 1961,
ink wash on paper on blockboard, chased
and welded copper, h. 152 x 697 x 7 cm,
marking the joint exhibition at Amsterdam's
Stedelijk Museum in 1961 and donated to
the museum.

156 Detail of La mutation, 1961, with
Reinhoud's sculpture fixed onto
Alechinsky's painting.

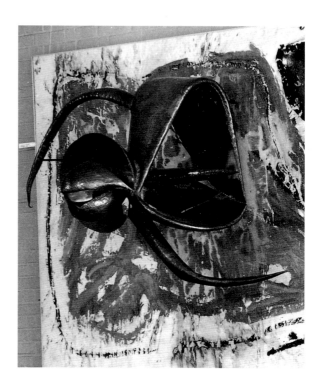

Pierre Alechinsky

157 Aucun regret (No Regrets), 1994, enamelled chamotte.

158 Pile de dessins (Pile of Drawings), 1994, enamelled chamotte.

1 In this connection see his circular protest letter Quelques observations au sujet d'une exposition 'COBRA', (stencil) targeting the show Cobra 1948-1951 which I compiled and introduced in the summer of 1966 in the Museum Boymans van Beuningen in Rotterdam, and which was showcased with the accompanying texts later the same year in the Louisiana Museum in Humlebaek, Denmark. This letter, which was brought to my notice by Erik Slagter in 1968 when he sent me a copy, was published in an abridged form under the title 'Observations au sujet de Cobra', in Phases, vol. 15, no. 1, 2nd series, May 1969, Paris, pp. 67-72. Moreover in my opinion an artists' group which owes its existence solely to the fact that it is a collaborative venture and which does not profile itself in any specific way is not historically interesting, except possibly as a political movement.

2 See K. Marx and W.F. Engels, Die Deutsche Ideologie (orig. 1848) Berlin, 1960, pp. 30-33, a passage used by Constant for his New Babylon project (see Chapter 2 on Constant). In the aforementioned work Marx and Engels expressed the firm belief that the future would see a society where general production would be centrally organised and that the automatisation of work would leave people free to develop as they wished. This in turn would counterbalance the sense of alienation which, in their view, was the result of the enforced specialisation of present-day society. People would then be 'free to hunt in the morning, fish in the afternoon, tend the cattle in the evening, and after the dinner engage in critical analysis, should they so wish, without ever having to become hunter, fisherman, shepherd or critic.' Asger Jorn subscribed to the same view. See Graham Birtwistle, Living Art. Asger Jorn's comprehensive theory of art between Helhesten and Cobra (1946-1949), Utrecht, 1986. I gave a brief summary of this book in my critique: 'De theorieën van Asger Jorn. Een correctie op het Marxisme', NRC Handelsblad, 9-5-1986.

3 Dotremont's trenchant views frequently divided opinions. I learnt this from various sources, and the letters that Dotremont wrote to Constant in the Cobra years makes this very clear. See the Constant Archive, Rijksbureau voor Kunsthistorische Documentatie in The Hague.

4 These include, for instance, the Englishman Stephen Gilbert, the American/Japanese artist Shinkich Tajiri, the Romanian-born Madeleine and Zoltan Kemeny and the French painter Jean-Michel Atlan. It was particularly Jorn and Corneille who set up these contacts. See Stokvis 1974, op. cit. in Introduction (note 4).

5 See Stokvis 1974, op. cit. Introduction (note 4), pp. 139, 140 and 317 (ill. 115); also Introduction op. cit (note 3) in which I give an extensive definition of the 'Cobra language'. For the debate on how the Cobra Movement should be historically viewed see also Graham Birtwistle, 'Cobra: Polemik, Rezeption, Nachleben', in Hubert van den Berg and Ralf Grüttemeier (ed.), Manifeste: Intentionalität, Amsterdam/Atlanta, GA 1998, pp. 290-317. Birtwistle takes as an important basic premise Dotremont's vindictive circular letters of 1966 (see note 1). For the relationship with Mortensen see also the chapter Denmark below (note 68).

6 For the way in which Dotremont (together with Alechinsky) finally left the Communist Party in 1949, see Stokvis 1974, op. cit. Introduction (note 4), p. 233, note 1 and pp. 232 and 233.

7 The work of Hieronymus (Jerome) Bosch, who came from 's-Hertogenbosch, is regarded as a continuation of the Flemish primitives; Pieter Bruegel the Elder (referred to here) was active in Brussels and Antwerp for the greater part of his life.

8 See Guy Atkins, Asger Jorn, The crucial years: 1954-1964, pp. 20, 98 and 104.

9 See Stokvis 1974 op. cit. Introduction (note 4), p. 161, where this part of the letter is reproduced. (Here again there is a suggestion of a style!).

10 In 1910 in Tervuren the Musée Royal de l'Afrique was founded under the name 'Musée du Congo Belge'. See Eugénie de Keyser, La sculpture contemporaine en belgique, Brussels, 1972, pp. 48 and 48 note 25.

11 The majority of the artists that Dotremont asked to contribute knew next to nothing about the Cobra Movement. See also my thesis (1974) op. cit. Introduction (note 4), where I discuss in depth the background to the Belgian contribution to Cobra.

12 See Chapter 2 under Constant. Dotremont was aware, however, that Constant and Appel were making assemblages in that period, as his article 'Cobra, la peinture et l'object', published in the weekly Beaux-Arts, no. 1281, 28-3-1970, pp. 12-13, shows. In this article he rightly points out that Cobra was not just confined to painting, and talks of Heerup, Appel and Constant's experiments with objects. In his opinion artists went much further in this field in Belgium, as was shown in the exhibition under discussion L'Objet à Travers Les Âges. See also Graham Birtwistle, 'Broodthaers vóór Broodthaers. Een object uit de Cobra tijd', in Jong Holland, vol. 7, 1991, no. 1, pp. 4-9.

13 See op. cit. Introduction (note 4), p. 143; also the catalogue Cobra 1948-1951, Musée d'Art Moderne de la Ville de Paris, Dec. 1982- Feb. 1983, et. al. French museums, in which the organisers and occupants of the Ateliers du Marais are listed on page 57.

14 Jean Raine who from Belgium had participated in Cobra as a film-maker, took up in 1962 the 'Cobra jargon' in his paintings which he had just started. See Stokvis 1974, op. cit. Introduction (note 4) p. 229.

15 For an exact and, in my opinion, the most reliable account of the foundation of this centre, see: K.J. Geirlandt et.al., Kunst in België na 45, Antwerp, 1983, p. 267, which draws on material from the catalogue TAPTOE 58, Brussels. I also found interesting information on Taptoe in Piet de Grooff, 'TAPTOE, Brussels centrum van de avant-garde (1955-1957)', published in Taptoe dicht, that accompanied the exhibition Hoogtepunten uit Taptoe: een Brussels avant-garde centrum (1955-1957), in the Flemish Cultural Centre 'de Brakke Grond' in Amsterdam, 11 Nov.-12 Dec. 1998. The artists participating in the 1956 Taptoe exhibition were: Pierre Alechinsky, Karel Appel, Enrico Baj (the Italian artist from the group Arte Nucleare with whom Jorn had come into contact and under whose instigation he had gone to work at Albisola in Italy), Asger Jorn, Rein and Roel D'Haese, Walasse Ting (a Chinese artist who had struck up a friendship with Alechinsky in Paris), Maurice Wyckaert (who was to develop a very close relationship with Jorn) and Christian Dotremont. On the poster for the exhibition a direct connection with the Cobra Movement was pointed-up by the collage of newspaper cuttings (reproduced on the poster) from the Cobra years, in which in the first place the Cobra

exhibition of 1949 in Amsterdam's Stedelijk Museum was highlighted, and where the name Dotremont constantly recurs, as well as the names of Alechinsky, Appel, Constant, Corneille and Jorn. The layout of the poster was designed by the painter and tapestry designer Corneille Hannoset, also an old pupil of La Cambre, who had taken part in the Atelier du Marais and who was now involved again. (Cobra no. 10 reproduced a fragment of one of his 'tapisseries'). For the period round Taptoe see also Jean Clarence Lambert, Cobra un art libre, Antwerp, Paris and English ed., New York, 1983, Dutch ed., Antwerp, 1983, chapter 3, Cobra na Cobra, pp. 222 ff.

16 Christian Dotremont, 'Notice autobiographique', published in the book Encres à deux pinceaux, (d'Appel et Alechinsky), 1978, for which Dotremont wrote the introduction. It was also included in the publication of the exhibition mounted by Alechinsky (with a foreword by Jean Clarence Lambert), Dotremont peintre de l'écriture, Centre culturelle de la Communauté française en Wallonie-Bruxelles, Paris 1982. For Dotremont's development as an artist, see also Stokvis 1974, op. cit. Introduction (note 4), pp. 218-220.

17 See below (note 15).

18 The Belgian poet Joseph Noiret, co-founder of Cobra, wrote an introduction to the exhibition catalogue entitled 'Description de Cobra'. For a more extensive discussion of these exhibitions, see Stokvis 1974, op. cit. Introduction (note 4), p. 233 and p. 233 (note 4).

19 See op. cit. (note 10) chapter V: 'La céramique ou l'appel à l'imaginaire', pp. 82-88 and p. 220.

20 Artists who were producing ceramic fantasy creatures – some of whom were pupils of Pierre Caille – based on the human figure, include Jan Heylen, Carmen Dionyse and Octave Landuyt. See op. cit. (note 10), pp. 83-89; also K.J. Geirlandt op. cit. (note 15), p. 77.

21 See the publication Maeght (ed.), Ubac, with articles by, among others, Jean Bazaine, Paul Eluard, Paul Nougé, Michel Ragon and Raoul Ubac himself, and a biography, Paris 1970; also Stokvis 1974, op. cit. Introduction, p. 40 and the catalogue for the exhibition Cobra '48, '51, '74, mounted at the Hôtel de Ville in Brussels, 4-28 April 1974, p. 140.

22 This does not refer to the Abstraction Lyrique movement of which Georges Matthieu was the author. See op. cit. in Chapter 2, note 110. For Ubac and the École de Paris, see also Michel Ragon, Michel Seuphor, L'Art Abstrait (3) 1939-1970 en Europe, Maeght Editeur, Paris 1973, pp. 12, 29, 31, 35 and 52, and Michel Ragon, 'De lyrische abstractie – van explosie naar inflatie', in Sinds 45. De Kunst van onze tijd I, Bruges-Utrecht, 1970, (published in French, Brussels 1970) pp. 73-104.

23 R. Ubac Notes sur l'ardoise, 1968, was published in op. cit. (note 21), p. 137.

24 For an illustration of this work, see M.R. Capellades O.P., 'Hedendaagse gewijde kunst in Frankrijk', in Katholiek Bouwblad, vol. 24, 1956-57, p. 11.

25 See op. cit. (note 10), p. 101 and ill. 74, 75 and 247.

26 Cobra no 6 carried a reproduction of a ceramic female figure by Strebelle. For his further development as an artist, see op. cit. (note 10), and the catalogue mentioned (note 13).

27 See Jo Verbrugghen, Reinhoud, Schelderode, 1978, pp. 5-8, and Bert Popelier, Roel D'Haese, Ham, 1987, p. 6.

28 See Frédéric Baal, Reinhoud, Antwerp 1989 (pages un-numbered). Extensive use was made of this book for this section.

29 For this and the previous passage see idem. For Corneille Hannoset see below (note 13).

30 See Baal op. cit. (note 28) where his Vogel (Bird), 1951, iron, his Stier (Bull), 1952, iron, and his Kerkuil (Barn Owl), 1953, iron, are reproduced. See also Luc De Heusch, Reinhoud, Turin 1970.

31 See op. cit. (note 15) and text (note 15).

32 Baal op. cit. (note 28) discusses each period of Reinhoud's work, giving a summary of what the artist was reading at the time; among the authors are Rabelais, Butor, Kafka, Proust, Dante, Susuki, Dostoevsky, etc.

33 As he must have told Marjolijn Oostingh whose graduation thesis for her art history degree at the University of Utrecht (1989), was entitled Reinhoud D'Haese (unpublished). She based her thesis on the sources that I have quoted here and on several interviews with Reinhoud himself.

34 Idem.

35 The Belgian town of Dinant has always been famous for its production of copper articles, and has given rise to the word dinanderie, a general term for cast brass and for engraved copper articles. See the Grote Spectrum Encyclopedie, vol 5, Utrecht/Antwerp, 1975, p. 120.

36 See Stokvis 1974, op. cit. Introduction, (note 4), p. 108, p. 108 note 1, and p. 44.

37 He was twice awarded the Antwerp Film Festival prize: in 1954 for his film 1933 and again in 1958 for his film Un autre monde, which he made in collaboration with Christian Dotremont after Granville's drawings and engravings. See also note 21 the Cobra catalogue, etc., p. 142.

38 See Geirlandt et. al., op. cit. (note 15) p. 121.

39 See the catalogue of the exhibition De man van Tollund, schilderijen 1962-1963 alsmede ceramiek van Serge Vandercam, April/May 1963, Galerie Delta, Rotterdam, in which Hugo Claus's long poem was printed.

40 See the catalogue of the exhibition Serge Vandercam, Musée d'Ixelles (Elsene Museum) 15.5 to 20.7 1986.

41 See the exhibition catalogue Serge Vandercam, Feb.-Mar. 1998, in 't Elzenveld vzw, Sint-Jorispand, Antwerp.

42 See the publication Porcelaines 1990: la manufacture Nationale de Sèvres, p. 6 ff.

43 See the catalogue of the exhibition Alechinsky. Laves émaillées, with a foreword by Jaques Dupin, Galerie Lelong, Paris, 1988.

44 See the catalogue, Pierre Alechinsky, New York: Pains de terre émaillé. Flora Danica drawings. Revalorisations, André Emmerich Gallery, New York, May 1991.

45 See the catalogue, Alechinsky. Toiles, grès et porcelaines with a text by Daniel Abadi, Galerie Lelong, Paris, 1994.

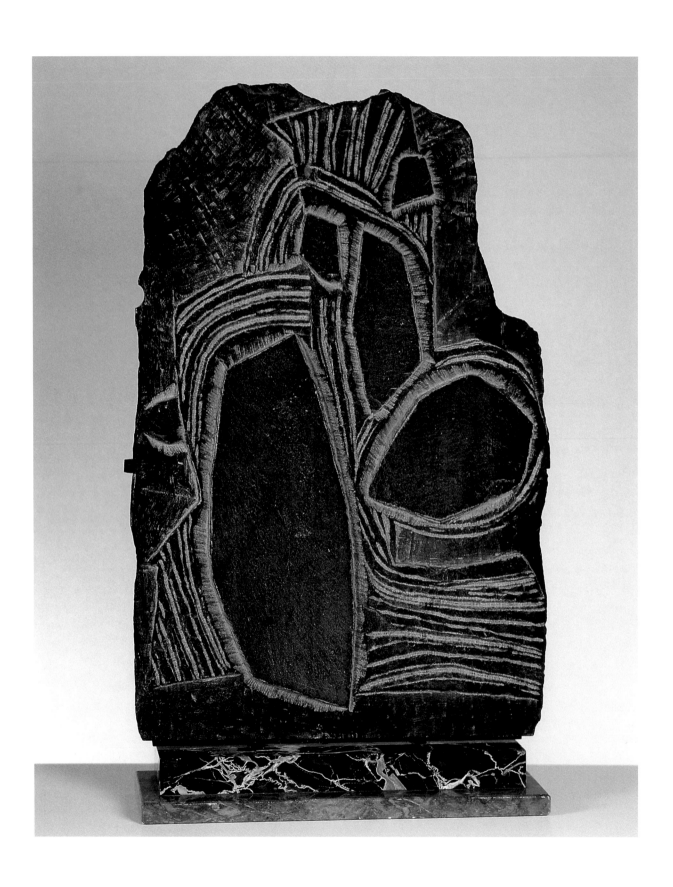

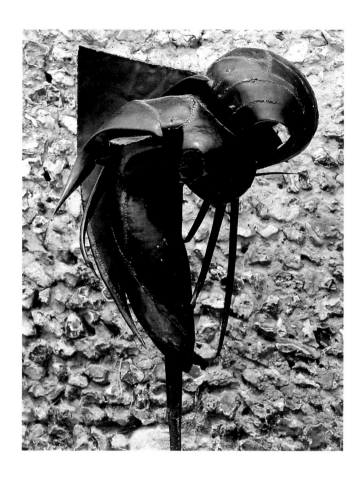

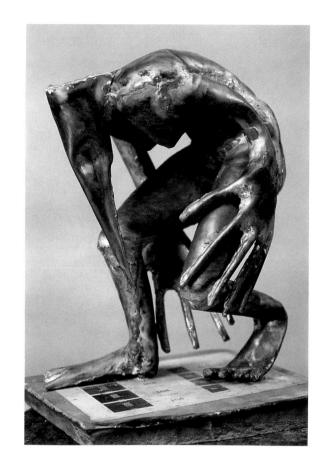

Raoul Ubac

159 Untitled, 1950, slate, 60 x 38 cm.
Cobra Museum for Modern Art,
Amstelveen.

Reinhoud

160 Haut perché (Perched High), 1961,
copper, 132 x 76 cm. Property of the artist.
161 Fourbue (Exhausted), 1981, tin,
29 x 17 x 24 cm. Galerie Nova Spectra
collection, The Hague.

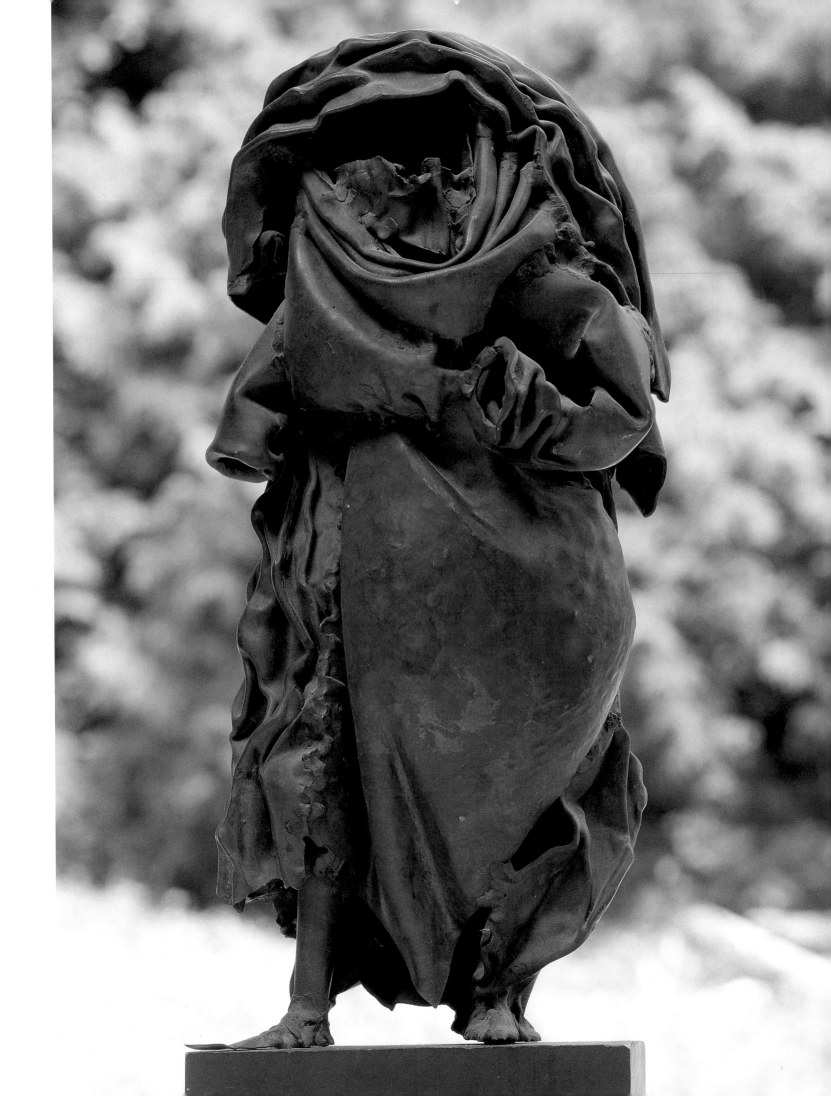

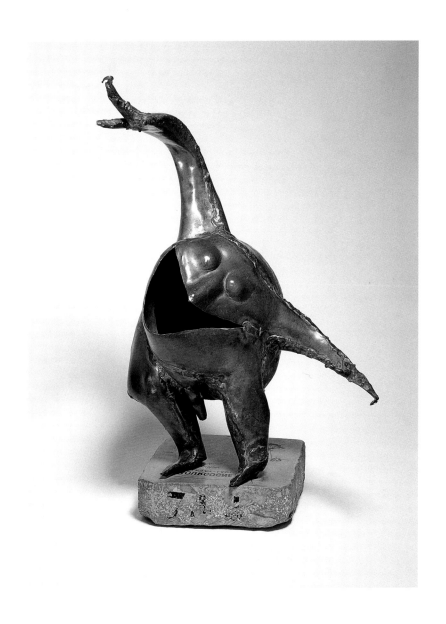

Reinhoud

162 Burnous, 1963, copper, 44 x 21 cm.
Property of the artist.
163 Personnage ayant trouvé son
titre (Person who found his title), 1970,
brass, 38 x 26 x 23 cm. Ellen and Jan
Nieuwenhuizen Segaar collection,
Antwerp.

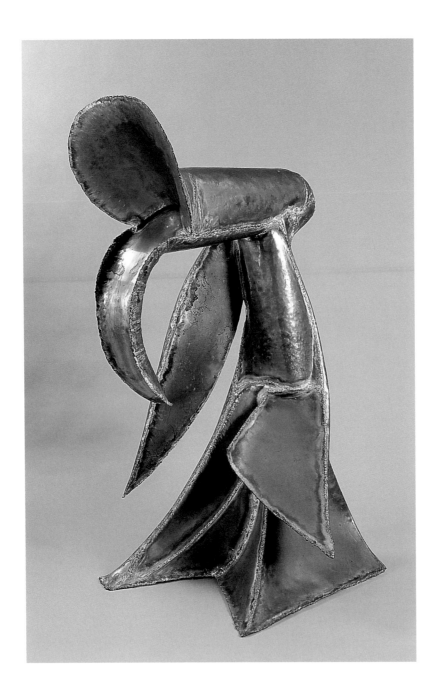

Reinhoud

164 Reinhoud, Poke-bonnet (Spout Hat)
1988, copper, 143 x 84 x 72 cm. Cobra
Museum for Modern Art, Amstelveen.

165 Reinhoud, Ce monsieur ne s'est
pas douté que je l'avais sans
remords échangé contre un basset
(The man had no doubts that I had
exchanged him without the least regret
for a basset), 1990, red brass, 213 x 90 x 80
cm. Cobra Museum for Modern Art,
Amstelveen.

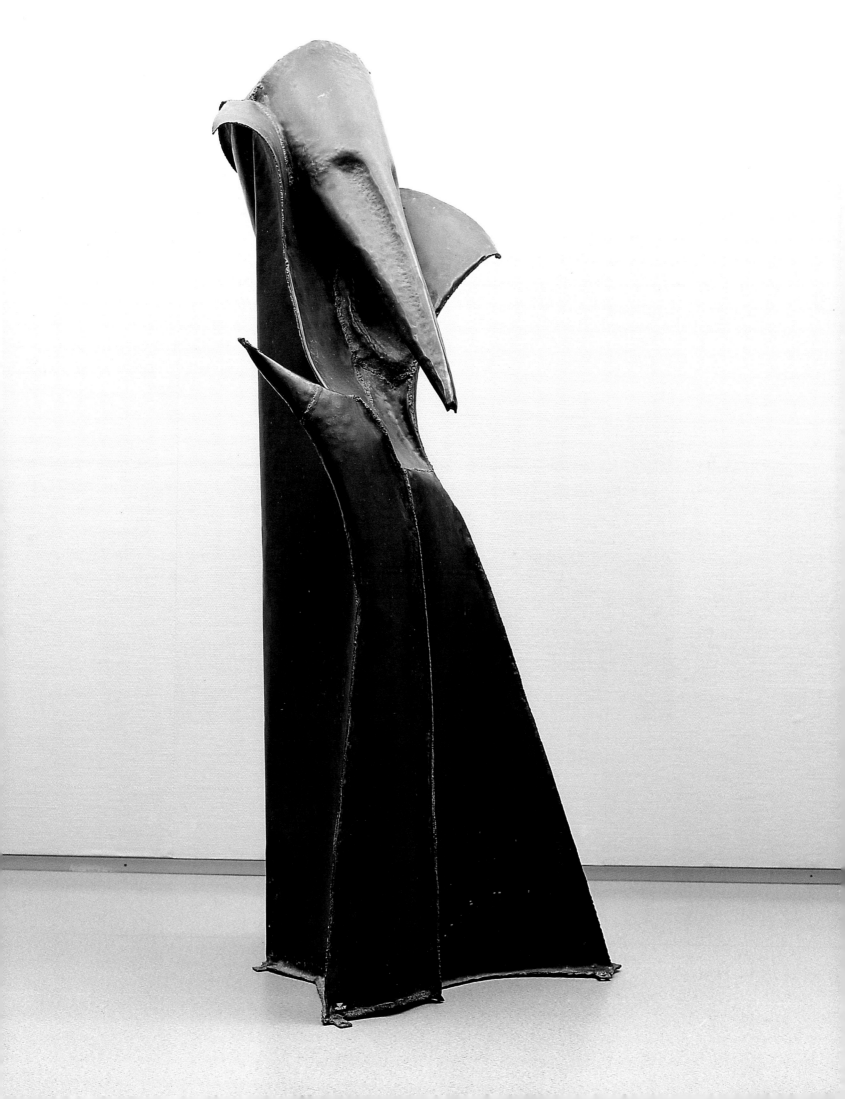

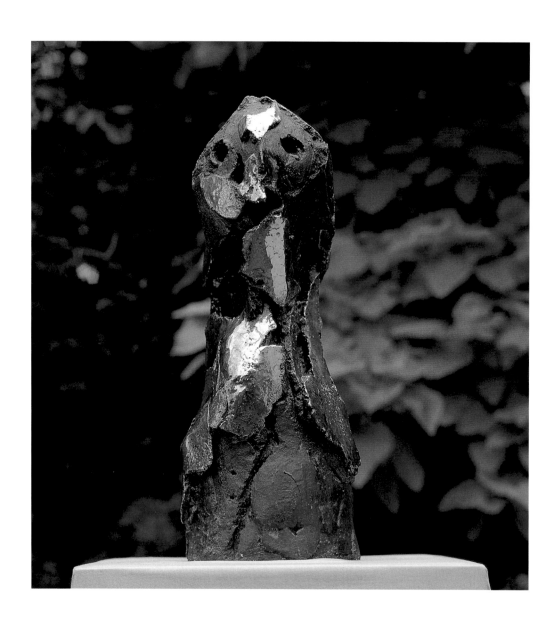

Serge Vandercam

166 Le guerrier (The Warrior), 1972,
ceramic, 60 x 25 x 31 cm. Property of the
artist.

167 Détournement (Darkening), 1992,
ceramic, 43 x 23 x 17 cm. Property of the
artist.

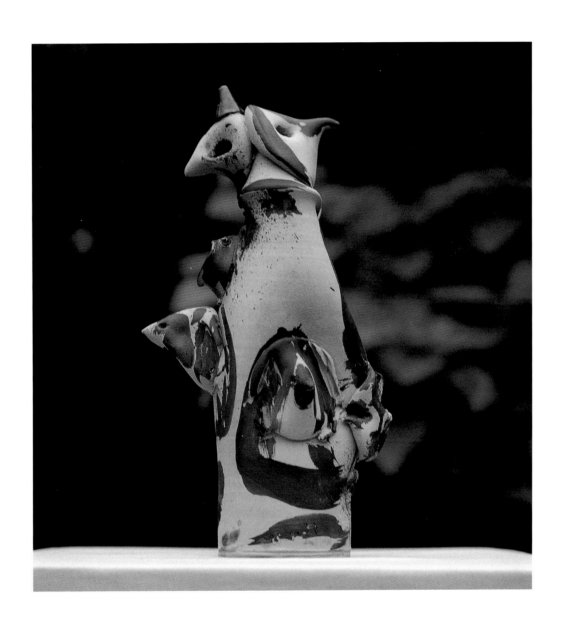

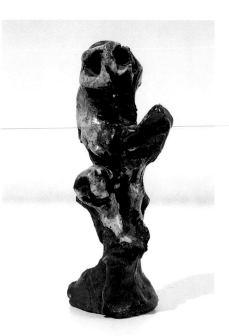
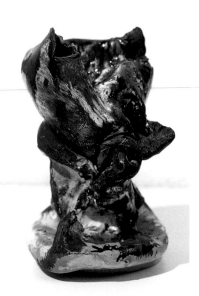
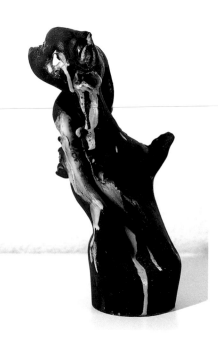

Serge Vandercam

168, 169 and 170 Three ceramic figures
each called Tollund Man, h. 35 cm, h. 15
cm and h. 35 cm. Made in 1962-1963 in
Albisola. Hans Sonnenberg collection,
Rotterdam.

Alechinsky

171 Temps de reflexion – Pain de terre
émaillé – (Time for Reflection – enamelled
earth-bread), ceramic, h. 31 cm.

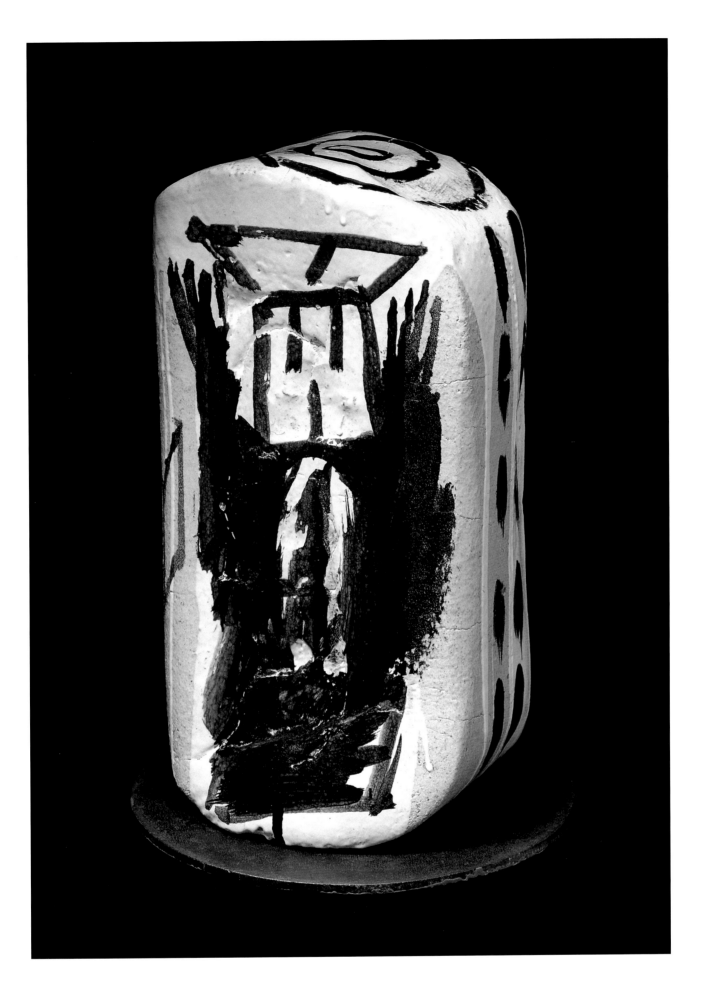

Conclusion

Artists of the Cobra movement were involved in three-dimensional art on a far wider scale both before and after, as well as during the years of the group's existence than has generally been recognised. That little was known about this aspect of their art is due primarily to the international recognition acquired by leading Cobra artists, such as Karel Appel, Asger Jorn and Pierre Alechinsky in the late 1950s with works on canvas and paper. Remarkably, this was also a period in which collage and assemblage enjoyed an international popularity, reaching its height with the Art of the Assemblage show at New York's Museum of Modern Art in 1961. Only Robert Jacobsen and Tajiri participated with welded-iron objects. No one seemed to notice the assemblages of found objects by for example Karel Appel and Corneille: during the postwar years in which they explored this medium neither they nor their public considered it of any real consequence. Indeed, many pieces were subsequently lost. On the other hand, there were some sculptors who joined Cobra, although these never formed part of the central core of the movement. They were also overshadowed by the attention given to the successful painters and were eventually to make their names along quite different routes.

It is perhaps hardly surprising that it has taken until now for interest to develop in the three-dimensional art of the Cobra movement, particularly their assemblages and their ceramic art. While Picasso's assemblages had appeared in publications about sculpture for many years, it was only gradually that the art world began to accept that it was possible to make serious sculpture from other materials than just stone, wood or metal. That the Cobra artists now exhibit and publish earlier and recent assemblages and ceramic art is due largely to a significant change in the climate of the art world. Over the last ten or twenty years, the multi-disciplinary approach has dominated in many areas of art while in new forms of sculpture it is clear that a sensitivity exists towards the poetic effect of all kinds of materials. Meanwhile, ceramics has now emerged in various countries as a mature artistic medium in sculpture.

All this was reason enough to take a closer look at the three-dimensional work of Cobra artists. An enormous amount of material emerged, opening up new perspectives. This enabled a new light to be cast on artists who had been predominantly active in sculpture. It was once again clear how the fantasy idiom of Cobra had actually developed in stages. Danish artists had first ventured into the new terrain in the 1930s; Dutch artists took up the thread in 1947 and 1948. And in Belgium it was only in 1956, with the Cobra revival that accompanied the opening of the Taptoe art centre in Brussels, that the idiom emerged in the work of a number of visual artists.[1]

In this volume I have focused on artists from the three countries that originally gave birth to the Cobra movement. Of the artists from other countries involved in Cobra, few produced three-dimensional works in the Cobra jargon. One such artist is Zoltan Kemeny (1907-1965), originally from Hungary. His relief-like paintings, mixing paint with, for example, sand, and his objects of the postwar years fitted in well with Cobra, with which he was associated for only a short while. He subsequently abandoned his Primitivist approach and began making aesthetic reliefs as a sculptor. British artist Stephen Gilbert, originally a painter, moved into sculpture in the 1950s, but his abstract work in polished metal objects belong to a different world from Cobra.[2]

In fact, it was only natural that the overwhelming drive to find expression which characterised Cobra artists should lead to multi-disciplinary art. In this, Picasso was their towering example. And of course, the international contacts and collaborations between Cobra artists were a further stimulating factor. Their spontaneity, on the other hand, required no theories. Their leaders, whose initiative had been born of a driving enthusiasm, claimed to be against theory in principle but eventually built up a complex of theories to show the need for direct, spontaneous expression. In their Marxist vision of the future, they saw the creation of a style and the concentration on a single discipline as a bourgeois phenomena that belonged to a past age. Yet in practice they clearly did choose a style. And it was with that style that Cobra gained its greatest reputation and, in my view, made its greatest contribution to art history. Moreover, it was the tremendous vitality of the work of these Cobra artists, especially those who eschewed theory, such as Karel Appel, that proved so infective and encouraged so many others to express themselves spontaneously in paint or some other material. It was therefore by a quite different route

than originally envisaged that something of the original objective was realised: a new form of popular art.[3]

Cobra's infectious, spontaneous idiom included three-dimensional work by members of the movement. A receptive approach to the material was something they shared with many artists in the postwar period. And typically for Cobra, they let their myth-oriented fantasy loose on this medium too, delving, like the Surrealists, into the human subconscious.

A review of the remarkable quantity of three-dimensional works reveals that it was the stone, metal, wood, objets trouvés, clay and other media that inspired these artists to venture into new forms of free expression. It seemed to provide an even greater potential than paint to give vent to their incredible humour and to its corollary, a sense of the tragic, as well as to allow the artists to become totally absorbed in the eccentric, the coincidental and the poetry of the material itself.

1 It is possible to trace the line even further to a German group inspired by Jorn and founded in 1957: Gruppe Spur. This in turn gave birth to other movements producing (in addition to paintings) three-dimensional work primarily reminiscent of Appel. However, it would be too much of an exaggeration here. On this German continuation of Cobra, see my article of 1990 op. cit. in Chapter 1 above.

2 See the section on Constant in Chapter 2 above and notes 93 and 94; also the catalogue Stephen Gilbert, Galerie Nova Spectra, The Hague, 1984 containing a bibliography.

3 See my article of 1984 op. cit. in Chapter 2 above (note 11), p. 30 in which I connect the Cobra movement's belief in people's spontaneous creativity with the development in art education in the 1950s towards free expression. See also Vera Asselbergs-Neessen, Kind, kunst en opvoeding: De Nederlandse beweging voor vrije expressie, Amersfoort/Louvain, 1989.

Index of names

Colophon

Coordination
Cees de Jong, V+K Publishing, Blaricum

Project assistance
Lieke Fijen; Cees List; Elmyra van Dooren; Margot Welle

Translation
Lynn George; Nicoline Galehouse; Sam Herman

Photography
Henni van Beek, Amsterdam; Tom Haartsen, Ouderkerk a/d Amstel; Zeger Hartgers, vbf fotografie en vaklab, Amsterdam; Nico Koster, Amsterdam; Arthur Martin, Bussum (cover); Ru Melchers; Serge Vandercam; archive Henny Riemens; archive Willemijn Stokvis

Photocredits
Serious efforts have been made to trace the names of the photographers involved. Those meaning to have claims to certain rights are kindly requested to contact the publisher.

Graphic Design
Jan Johan ter Poorten, V+K Design, Blaricum

Lithography
Nederlof Repro, Heemstede

Printing
bv Kunstdrukkerij Mercurius Wormerveer

With special thanks to
Pierre Alechinsky; Karel Appel; Eugène Brands; Constant; Corneille; Sidsel Ramson en Carl-Henning Pedersen; Reinhoud; Serge Vandercam; Shinkichi Tajiri; J. Karel P. van Stuijvenberg; Ellen en Jan Nieuwenhuizen Segaar; James Coxson; Museum Boijmans Van Beuningen, Rotterdam; Bonnefanten Museum, Maastricht; Galerie Lelong, Paris; Instituut Collectie Nederland, Rijswijk; Haags Gemeentemuseum, 's-Gravenhage; Karel Appel Foundation; Museum Het Kruithuis, 's-Hertogenbosch; Stedelijk Museum, Amsterdam; Silkeborg Kunstmuseum, Silkeborg (DK); Carl-Henning Pedersen og Else Alfelts Museum, Herning (DK); Louisiana Museum of Modern Art, Humlebaek (DK)